ARCTIC EDEN

JOURNEYS THROUGH THE CHANGING HIGH ARCTIC

JERRY KOBALENKO

ARCTIC EDEN

David Suzuki Foundation

GREYSTONE BOOKS
D&M PUBLISHERS INC.
Vancouver/Toronto/Berkeley

To Thomas Kitchin

Greystone Books
An imprint of D&M Publishers Inc.
2323 Quebec Street, Suite 201
Vancouver, British Columbia · Canada v5t 4s7
www.greystonebooks.com

David Suzuki Foundation
219–2211 West 4th Avenue
Vancouver, British Columbia · Canada v6k 4s2

Cataloguing data available from Library and Archives Canada
ISBN 978-1-55365-442-1

SOURCES FOR QUOTATIONS:
Epigraph on page v, by Margaret Atwood, *Strange Things: The Malevolent North in Canadian Literature*, 1995.
Epigraph on page v, by T. Hodgson Liddell, *China: Its Marvel and Mystery*, 1909.
"...their eyes fixed on their vacations' palm trees," quoted on page 5, is by Louis-Edmond Hamelin, 1988.
"...roar which lies on the other side of silence," quoted on page 15, is by George Eliot, *Middlemarch*, 1874.
"...gold, pure, shining, unalloyed," quoted on page 20, is by Apsley Cherry-Garrard, *The Worst Journey in the World*, 1922.
"Braving the cold . . .," quoted on page 150, is from the Chinese classic, *The Dream of the Red Chamber*.

A NOTE FROM THE AUTHOR ABOUT SPELLING: The old explorers spelled the names of their
Inuit companions in zany and unpredictable ways, but modern orthographies often render these
historic figures unrecognizable. To avoid frustrating the reader, I've used traditional spellings.

Editing by Nancy Flight
Copyediting by Lara Kordic
Jacket and text design by Jessica Sullivan
Jacket photograph by Jerry Kobalenko
Map by Steven Fick courtesy of *Canadian Geographic*
Printed and bound in China by C&C Offset Co., Ltd.
Text printed on acid-free, FSC-certified paper
Distributed in the U.S. by Publishers Group West

We gratefully acknowledge the financial support of the Canada Council for the Arts, the British
Columbia Arts Council, the Province of British Columbia through the Book Publishing Tax Credit,
and the Government of Canada through the Canada Book Fund for our publishing activities.

Mixed Sources
Cert no. SGS-COC-003548
© 1996 FSC
FSC

"Exploration has become a metaphor for a spiritual journey, because the real, physical puzzle has been solved and the way made easy; but it's been solved by the dead explorers, who are somehow there, incarnate, in the routes they helped to trace."

MARGARET ATWOOD

"I felt as though I was in dreamland, so real it seemed."

T. HODGSON LIDDELL

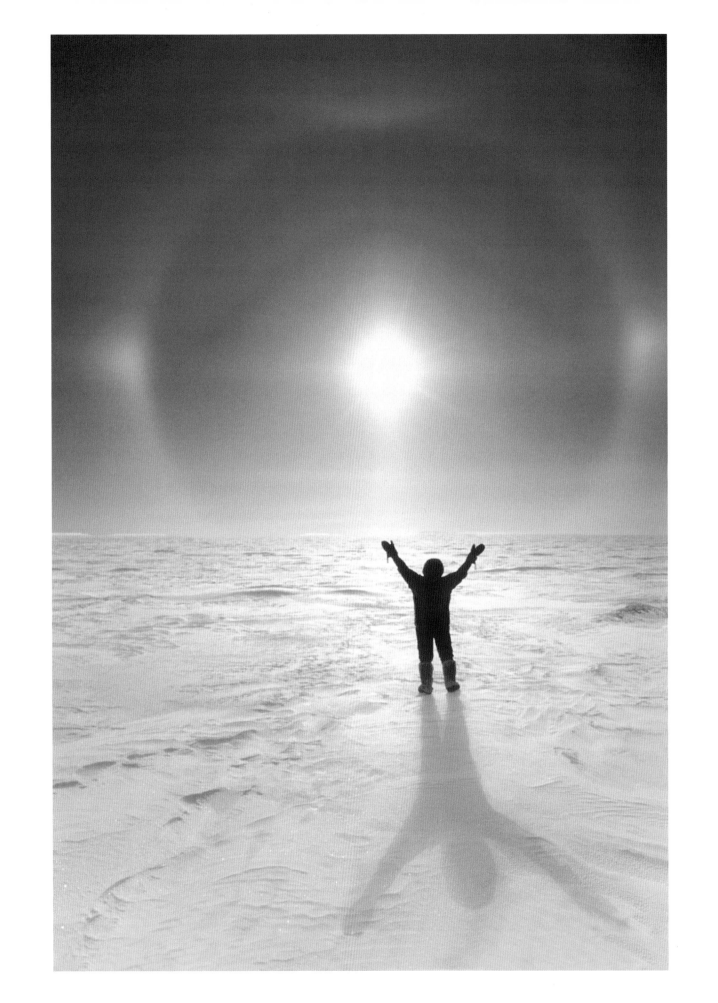

CONTENTS

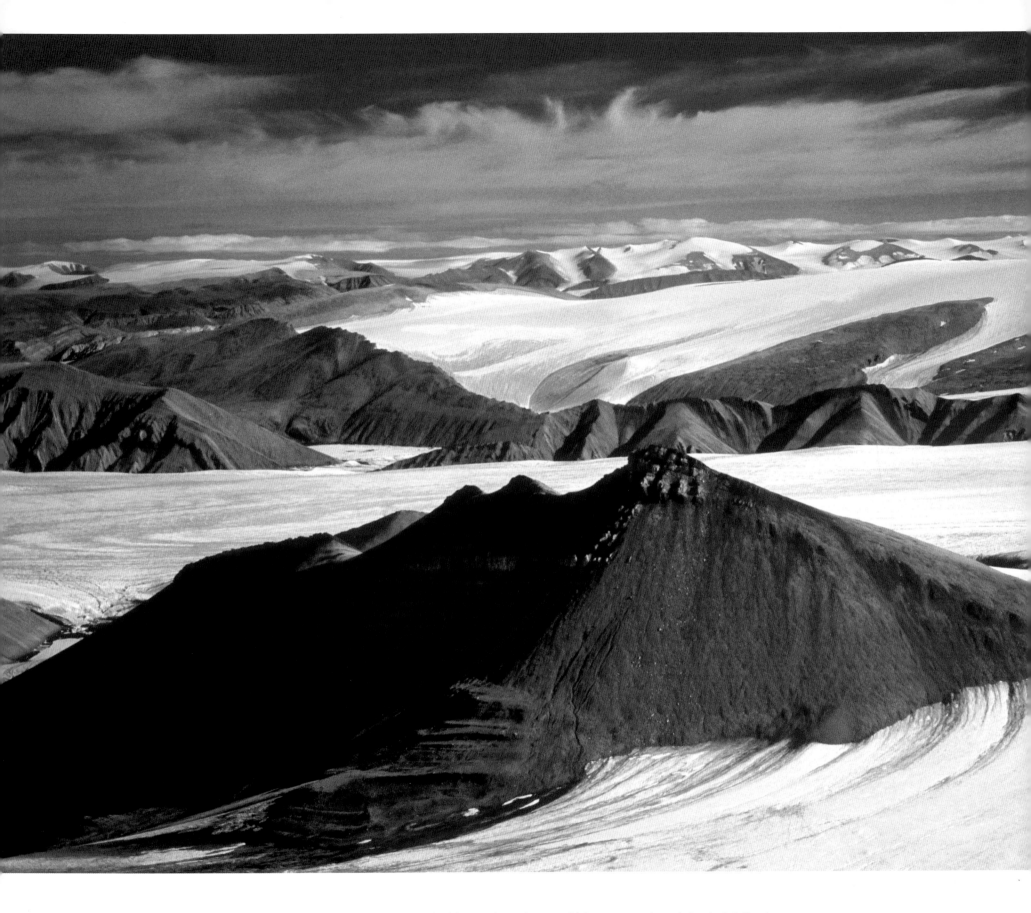

A WHITE and blue world for much of the year, the High Arctic adds brown to its palette during the brief but intense summer.

INTRODUCTION

T HE FIRST time I went north, I had no idea I'd like it. The notion to go there just came to me. Some people live rationally, while others go where their obsessions lead them. Perhaps I headed north in part because I loved the outdoors but didn't want to walk in others' footsteps. I'd heard that the North was barren, cold, uncomfortable, harsh, empty. These sounded like assets.

Eventually I discovered the Arctic's true gifts: all that open space, the surprisingly sweet life of the snow walker, the endless daylight. Then there's the wildlife: with no night and no trees, animals have nowhere to hide, so they don't bother trying. They share the land with you.

We hear sensible objections to the North. There's the question of danger: all wilderness has its perils, but the North is one of the safest. The old explorers died mainly of two causes: starvation and scurvy. Neither is an issue today. The North appeals to travelers who don't like danger.

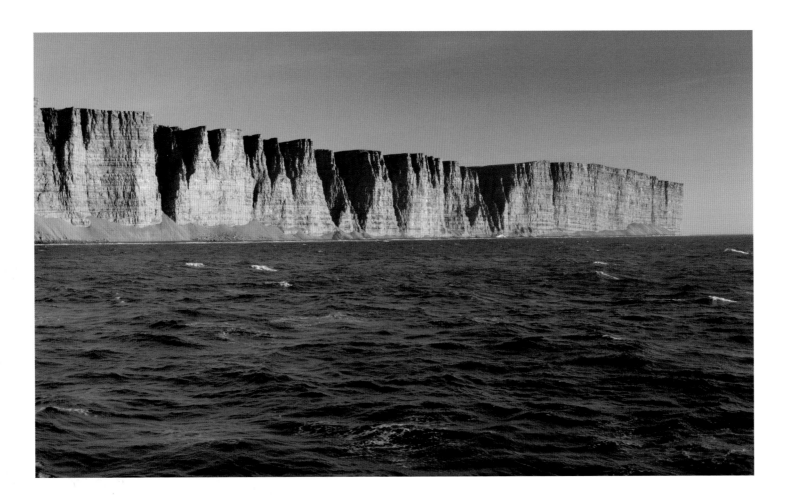

There's the question of insects. In some parts of the North, the total number of mos-
quitoes outweighs, in pounds, every other species, plant or animal. During his travels
in what he called the Arctic Prairies, the naturalist Ernest Thompson Seton devised a
mosquito gauge: he removed a glove, killed the mosquitoes that settled on the back of
his hand in five seconds, and then counted the bodies to measure a pestilence that many
travelers claimed was beyond words. In the tundra north of Manitoba, he achieved his
record: 125 mosquitoes on one hand in five seconds. This tally is grim, certainly, but
the northern canoeists I know seem able to enjoy their time there despite having to
eat, paddle, and sleep in head nets. Besides, flies make for great stories afterward, and

left The ice-free Northwest Passage near Resolute.

below "In the midst of the mountains' barrenness, the sun splashes its colors so that the poverty is ennobled," wrote explorer Knud Rasmussen.

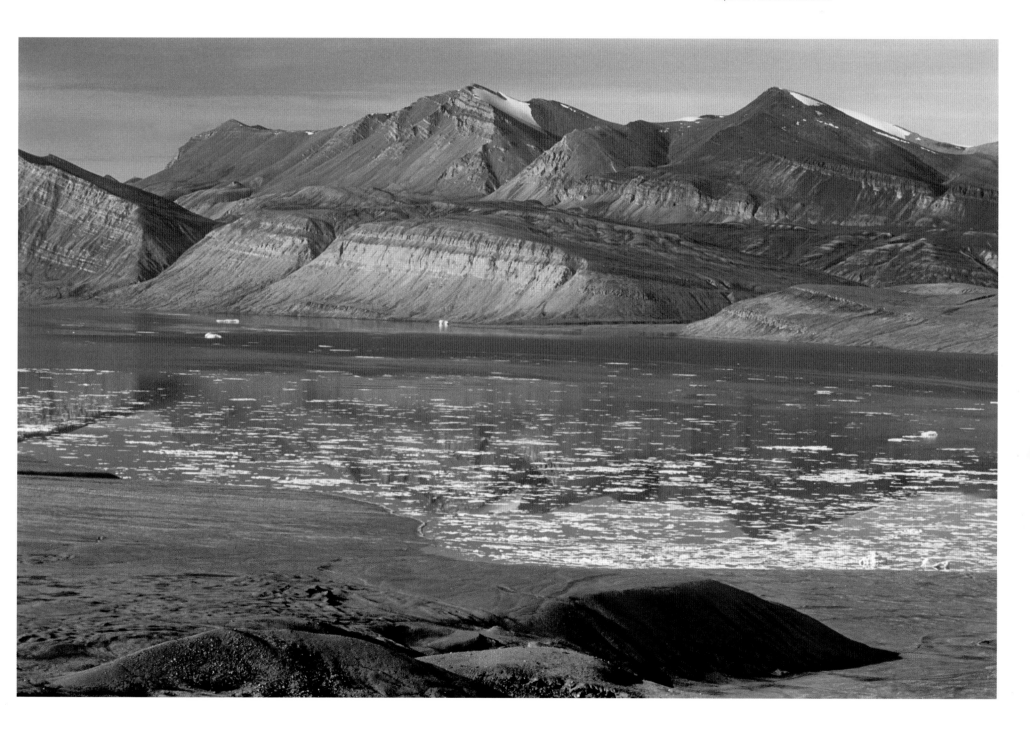

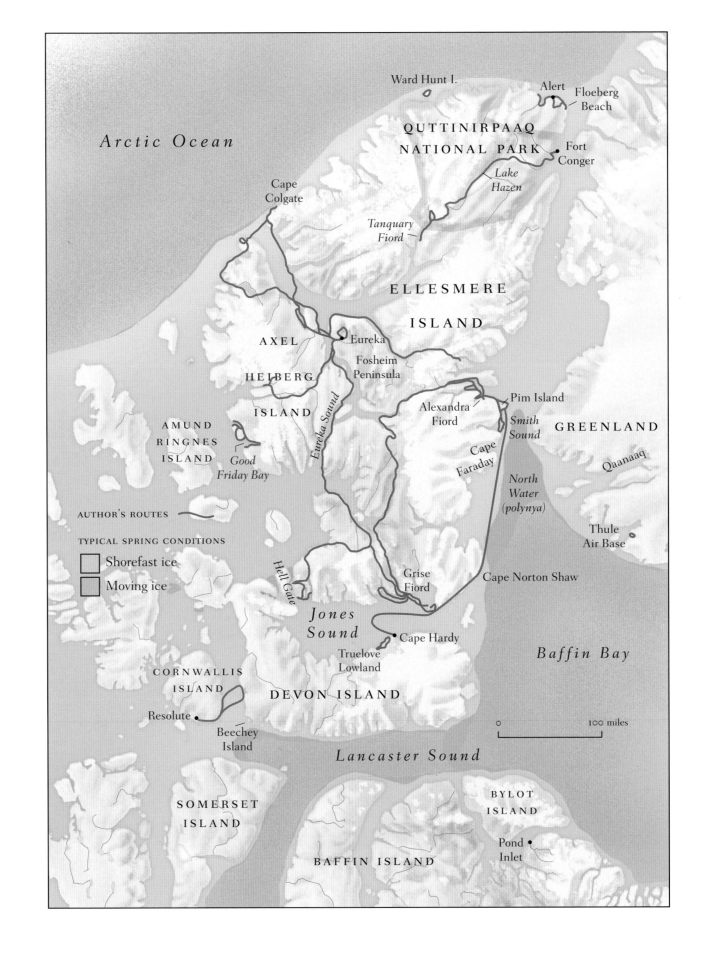

Arctic Ocean

Ward Hunt I.

Alert

Floeberg
Beach

QUTTINIRPAAQ
NATIONAL PARK

Fort
Conger

*Lake
Hazen*

Cape
Colgate

*Tanquary
Fiord*

ELLESMERE

ISLAND

AXEL

HEIBERG

ISLAND

Eureka

Fosheim
Peninsula

Eureka Sound

Pim Island

Alexandra
Fiord

*Smith
Sound*

GREENLAND

AMUND
RINGNES
ISLAND

*Good
Friday Bay*

Cape
Faraday

*North
Water
(polynya)*

Qaanaaq

AUTHOR'S ROUTES

TYPICAL SPRING CONDITIONS

Shorefast ice

Moving ice

Thule
Air Base

Hell Gate

Grise
Fiord

Cape Norton Shaw

*Jones
Sound*

Cape Hardy

Baffin Bay

Truelove
Lowland

CORNWALLIS
ISLAND

Resolute

Beechey
Island

0 100 miles

DEVON ISLAND

Lancaster Sound

SOMERSET
ISLAND

BYLOT
ISLAND

Pond
Inlet

BAFFIN ISLAND

delayed gratification lies at the core of Arctic travel. But I have very little experience with insects because my chosen corner of the North, the eastern High Arctic, is above the Mosquito Line.

There's the question of cold. That I do have experience with. Over thirty-five Arctic expeditions, I've accumulated three years in an unheated nylon tent at temperatures down to −65°F. I sleep as well at −40° as at home in bed. Cold is a bogeyman. No polar explorer ever died of cold.

Finally, there's the question of barrenness. I don't consider my North barren. The eastern Arctic has what may be the most dramatic scenery in the country. Picture a wilder Rockies, with fiords and ice floes and no trees to block the view. Admittedly, there are parts of the Arctic where the beauty and fecundity is, shall we say, more subtle. But subtle minds can find great beauty in this kind of landscape.

Ultimately, the North is a matter of perception. Maybe those who shun cold and keep "their eyes fixed on their vacations' palm trees" are the ones who see the North straight. But common sense is overrated, and those of us who love the North can identify with Don Quixote's unshakable conviction that a homely village girl was his fair Lady Dulcinea: "I behold her as she needs must be."

ANYTHING ABOVE THE tree line qualifies as Arctic; the High Arctic refers to regions north of 74°, where plants have thinned almost to nonexistence. It encompasses the triangle of islands bounded by Devon and Ellesmere to the east and Prince Patrick and Melville to the west. Most of this archipelago belongs to the Barren Wedge, a collection of earthly asteroids marked by poor weather, gravelly terrain, and none of the mountains, ice caps, and glaciers of the eastern sector.

This book links several voyages around the three easternmost jewels: Ellesmere, Axel Heiberg, and Devon Islands. These islands transcend the others. All psychrophiles feel their allure. They are the purest northern experiences. Only in the High Arctic do hares form herds. Only here are noon and midnight almost equally bright. And only here

left The eastern High Arctic, showing the author's main routes.

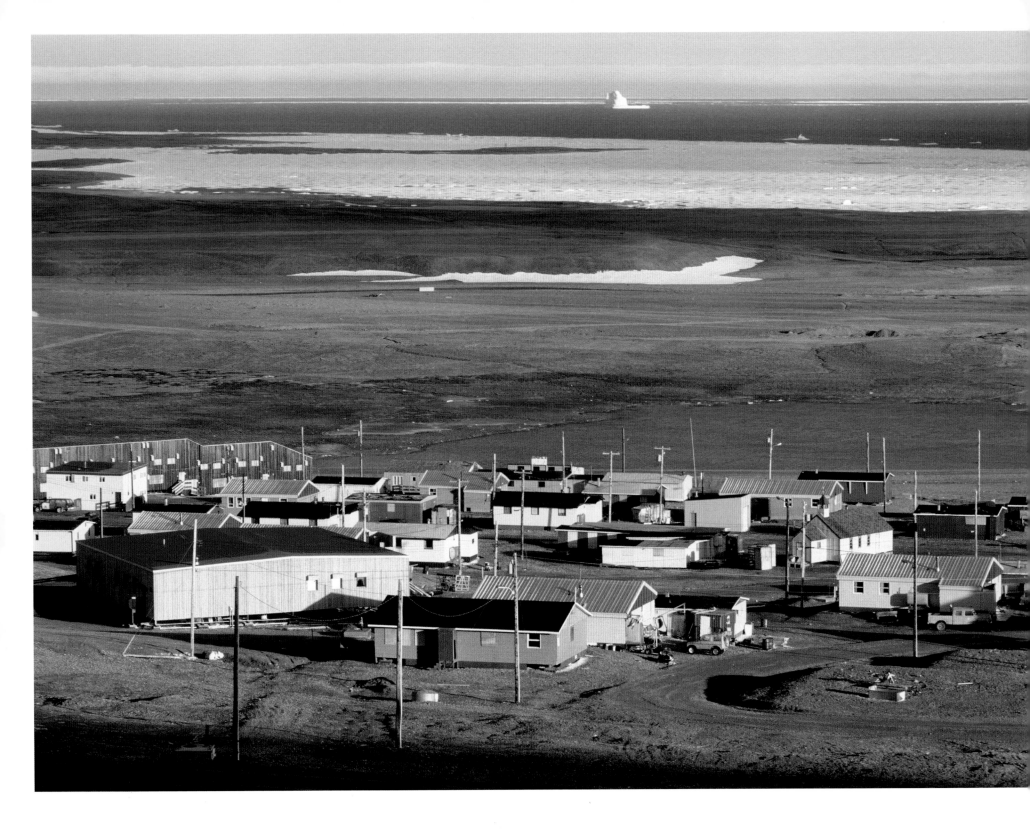

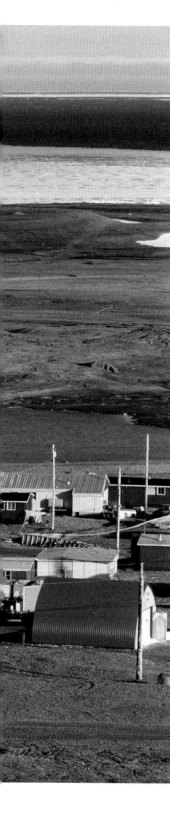

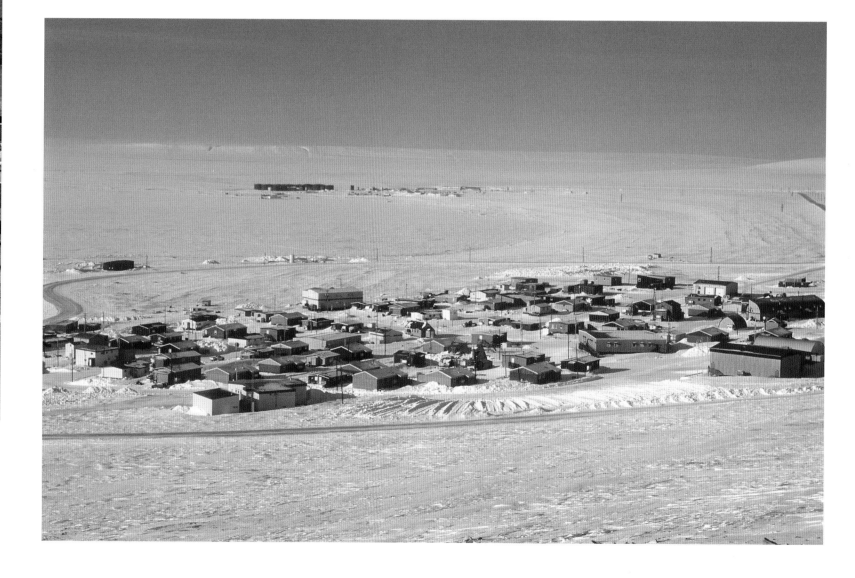

left and below Overlooking Lancaster Sound, desolate Resolute marks the last stop for planes from the south and the starting point for High Arctic travel.

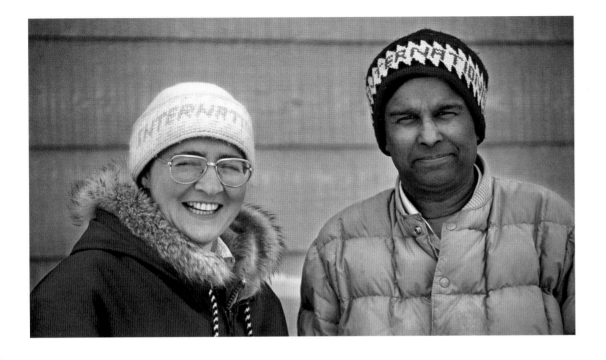

does a trek unfold amid 8,000-foot peaks and the largest ice caps and in North America.

Only here, as well, do you still find famous explorers' messages in bottles or the bully beef cans they opened the old-fashioned way, by cutting a cross in the lid with a knife and peeling back the corners. At first, history didn't interest me—I just loved adventure, Arctic scenery, and the athletic life—but these artifacts eventually awakened my curiosity about the past. They hinted at mysteries. What happened to that explorer who disappeared? Why did those starve? Now I often travel to reinterpret old sagas from the perspective of an experienced traveler.

An Inuit friend calls me the Ghost Hunter. "Be careful out there," he says with that sly Inuit wit, "or you may become a ghost yourself." The human history of the High Arctic spans four thousand years, but modern residents are few; ghosts are its most conspicuous inhabitants.

If my journeys have a theme, it is to express, as well as I can, an evolving love of this High Arctic. I love everything about it: the forbidding weather, the zany characters of Resolute Bay, the openness, the light, the wildness, the explorers' signs, the fat walrus with their vampire-red eyes, the silence. In most places, silence is the absence of noise, but in the Arctic, silence has weight and shape. You can almost photograph it. Many of us also acknowledge the lure of the Arctic Perverse: we love the place because most people don't.

I bought my first camera for my first northern expedition. I wanted to write a magazine article about it, and articles demand photos. The expedition succeeded, and my first words-and-pictures story sold. More than twenty years later, I continue to do a mix of hard and easier journeys. On the grueling ones, I have to devote so much energy to moving forward that I return home with only a handful of good images. The easier treks are photographically richer.

Some images in this book look simple, but I had to walk four hundred miles to get them. Others tell stories—about mirages, queer stone crystals, explorers' camps, Paleo-Eskimo artifacts. I've tried to showcase these photos in the sidebars to each chapter. On the first manned mission to Mars, every shot will be revelatory, and a photographer experiences some of that same excitement a few hundred miles from the North Pole.

Although I shoot wildlife as the opportunity presents, I'm not a wildlife photographer. I'm too restless to spend hours or days letting animals get used to me. I have a greater affinity with landscape shooters, who tend to be fit and active, whereas wildlife photographers are sedentary and patient. But unlike landscape specialists, I often want to "complete" a scene by putting a person in it. Maybe that is because in this wild and inhuman place, a small figure feels friendly. Once, even a piece of yellow plastic garbage made my day, because it was the first sign of humanity I had seen in five weeks. I touched it, my eye drank in its unusual artificial color, and as I skied on, I thought about it affectionately for hours. If I specialized in more accessible nature like the Rockies, perhaps I too would prefer to render it without people.

For practical reasons, most of my journeys end up being either lines or circles. Taken together, they have added up to a 6,000-mile circumnavigation of the High Arctic. Some adventurers go out for years at a time and cover half the circumference of the globe in one shot. My trips last three to eight weeks and cover 250 to 500 miles. Longer than two months, and the intensity is hard to sustain. When poetry becomes prose, it's time to go home.

left The late outfitter Bezal Jesudason, shown with his wife, Terry, was Resolute's most famous citizen. Originally from India, he spoke fluent Inuktitut and often joked about planning an expedition to the North Pole by elephant.

JUST AS THE path to heaven lies, so some say, through purgatory, the only way to the High Arctic islands is through Resolute Bay. You can fly from Toronto to Beijing and back twice for what it costs to fly to this barren village of two hundred souls. Its gray summers give little respite from the long, dark winters. An icy wind blows much of the year. Because of the poor weather, little grows there. You have to be a botanist to notice that anything grows at all.

But Resolute Bay has its charms. It is the last stop of the big planes from the south and the staging point for all science and adventure in the High Arctic. You never know who you're going to meet. Recently, I shared a coffee with Zacharias Kunuk, director of the great Inuit film *Atanarjuat: The Fast Runner*. Another year, I met the Princess of Thailand. They had special nibbles flown in for her. She left most of them, and then we hungry vultures descended.

Neil Armstrong, the first man on the moon, visited here and probably felt right at home. The late Sir Edmund Hillary. Even the Grammy-winning alternative rock band the Red Hot Chili Peppers. (They liked the town because no one knew who the hell they were and everyone ignored them.) The whole world, it seems, comes to Resolute at least once. And for most, once is enough.

Resolute was created in 1953 when the Canadian government transplanted several Inuit families from northern Quebec and Baffin Island. The hunting in that part of Quebec seemed tapped out, and the relocation was supposed to give the struggling residents a fresh start. A new village in this location also strengthened Canada's Arctic sovereignty.

At first, the Inuit in the village and the southerners, who lived four miles away near the airport, were not supposed to mix. This separation seems still to exist informally today. In most northern hamlets, you quickly get to know the residents. But despite some thirty visits to Resolute, I've met few local people. Except for the kids, the entire community seems in a permanent state of hibernation.

To reach the village from March to May—the High Arctic's best travel season—you must first fly for four to six hours over a frighteningly white world. More than any map,

right Resolute's ten-plex, an architect's failed utopia, stood boarded up for years before a local entrepreneur turned it into a hotel.

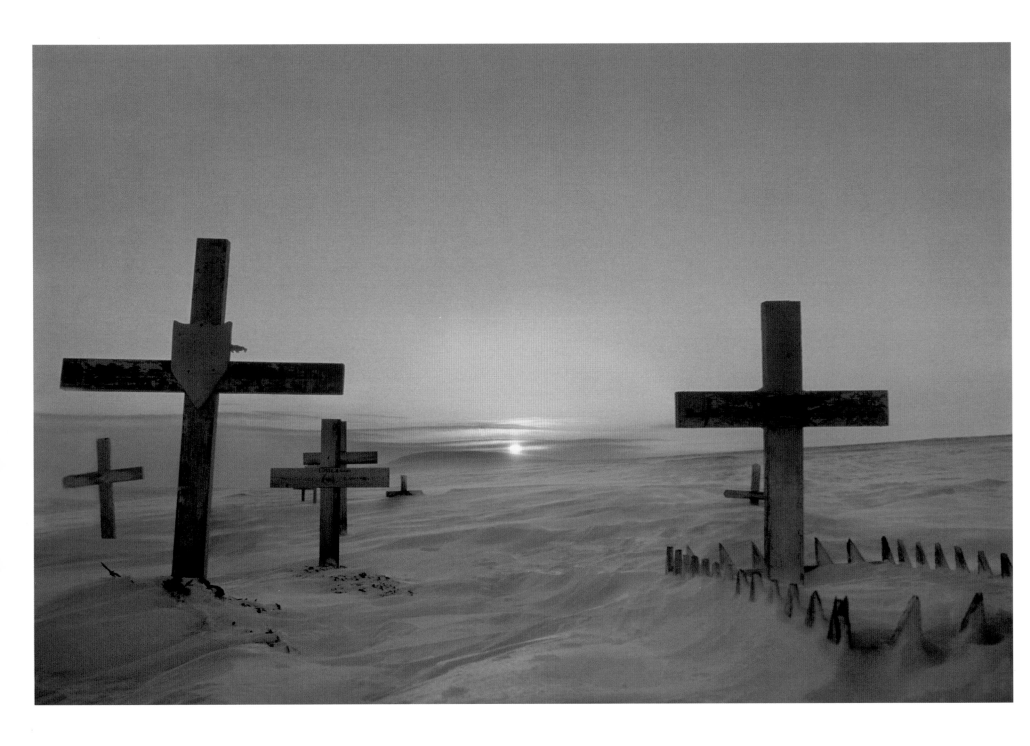

the flight to Resolute makes you grasp that Canada is an Arctic country, less than five hundred miles shorter from north to south than it is from east to west.

Incredibly, in the early 1970s an avant-garde architect named Ralph Erskine planned to transform Resolute Bay into a futuristic utopia. His sketches show what looks like a walled medieval town, above which gaily float hot-air balloons and whirlybirds. Within the walls, white people and Inuit were to live together in units resembling lunar modules.

Builders completed a section of this project, called the 10-plex, before escalating costs doomed Erskine's quirky vision. For years, the 10-plex stood boarded up on the edge of town. Then a local entrepreneur bought it and turned it into a hotel. Of the three hotels in Resolute, this is where most adventurers now stay. Although no utopia, it is homey and has lots of room to spread out gear. In spring, when the sledding expeditions take place, it is awash in dreamers seeking the mystical Arctic and hustlers posing as adventurers and hoping to make the Snakes-and-Ladders jump to celebrity by skiing to the North Pole or some facsimile.

A few of these expeditions are well-conceived athletic endeavors; others are merely loopy. One guy walked around the hotel with wires taped to his bald noggin in some sort of experiment. At the same time, a know-it-all German swaggered about, his name emblazoned in 100-point characters on the crest of his parka and the parkas of his unfortunate teammates. For years, an eccentric British physician came north almost every summer to wander the tundra alone for weeks, eating rock tripe and wearing a school tie. A Swedish pair aborted their megajourney after they discovered they didn't know how a camp stove worked. A British novice trumpeted his expedition as "the most significant exploration of the Arctic ever undertaken" but lasted three days before falling through the ice and calling for evacuation. Unhumbled, he sent out press releases back in Resolute blaming global warming, insisting that in all his years in the Arctic, he had never seen such bad conditions.

On my first visit to Resolute, one member of our group shook his head and muttered, "God, what a place." Although I had to agree with him, the door doesn't need to be attractive. It's where it leads that matters.

left Many of Resolute Bay's early residents are identified only by their first names and government-issued "Eskimo numbers" in the local graveyard.

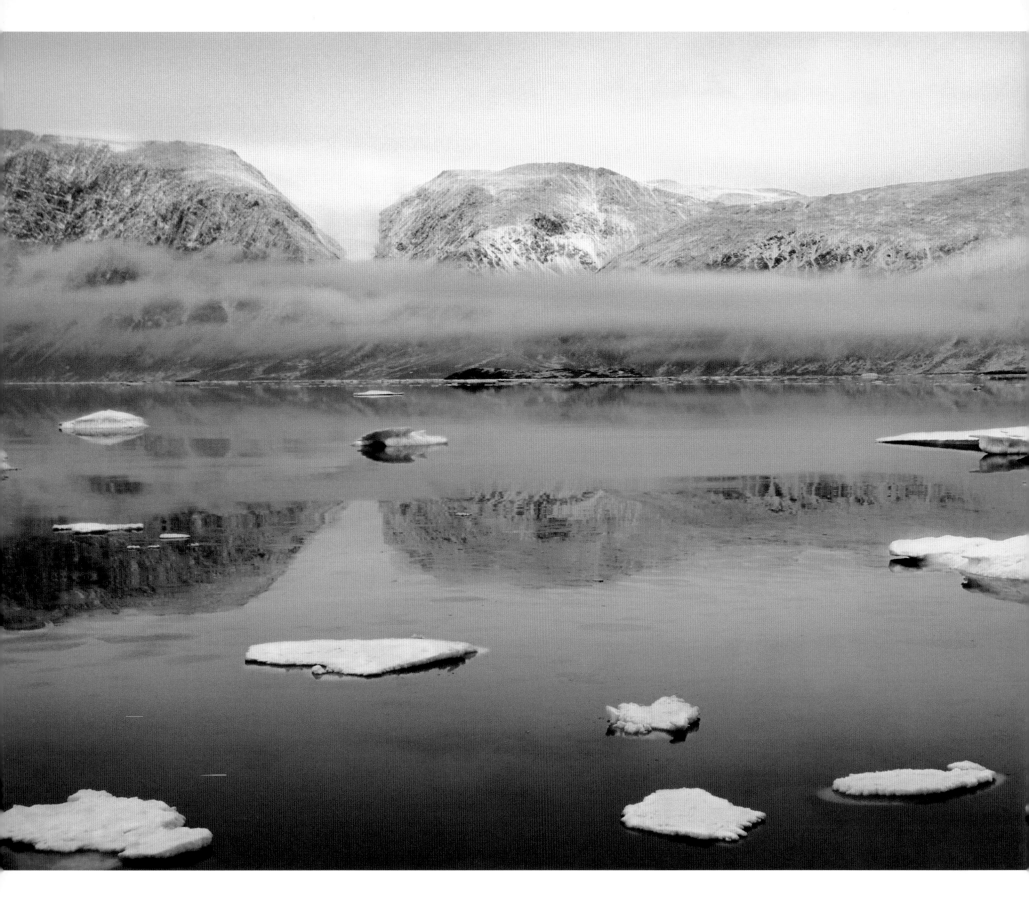

ALEXANDRA FIORD was "the nearest approach to an Arctic paradise that we saw during our sojourn in the Polar Regions," wrote its discoverer, George Nares.

1 | LOVE AT FIRST SIGHT

WHEN I listened closely, I could hear a distant roar. Not the "roar which lies on the other side of silence," but a real sound, on this side of the imagination. The roar floated four thousand feet above the calm of Alexandra Fiord on Ellesmere Island. It took form in lengthening fingers of snow that streamed off the ice cap. Moments later, an avalanche of wind hit. Snow sandpapered my face. I could barely stand.

Yet the power of the wind comforted me. Feeling small and insignificant made the world that much larger and more wonderful. I had just finished a month of hard sledding. I set up my tent by a sheltered cliff and dove inside out of the wind. Using my sleeping bag as a backrest, I reclined against the tent wall. For half an hour, while the wind raged outside, I was in such a state of well-being that I didn't dare twitch. Even shifting positions might shatter the mood.

The wind died, and a band of golden light lit the ice of Flagler Fiord to the north. The glow intensified and acquired height and depth. Filaments of ivory cloud hung over distant

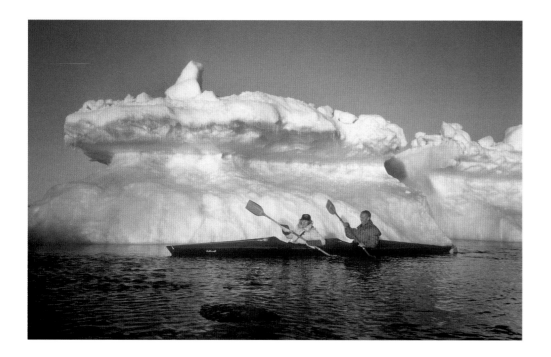

above Rising and falling tides eat away at grounded ice floes and create mushroom-topped sculptures.

right Fox tracks explore the edge of a meltwater pool in early June.

Cape Camperdown. The softest blue powdered the westerly mountains, while rose tinted the Twin Glaciers. It occurred to me—it sounds like a stoner's banal vision now—that angels spoke in light. Tonight, the angels were talking to one another.

YEARS EARLIER, ALEXANDRA FIORD had given me my first taste of the mystic Arctic. By then, I was a full-time magazine writer and I had joined a kayak tour to do a story. We landed at midnight in early August. I had already completed two expeditions in the subarctic, but this was my first whiff of Ultima Thule. Exquisite light flooded the meadows. Terns hovered, chittering. Unseen walrus grunted in the fiord. A physician in our group recalled how his first-year biology professor waved a two-foot-long walrus penis bone to the class and declared, "Ladies and gentlemen, life in the Arctic is a stiff proposition."

I was too stoked to sleep and ran around all night in a state of hyper-excitement. Maybe the midnight sun captivated me. Maybe I was a victim of the same scenery that had pried enthusiasm from the usually staid George Nares, a British explorer who wrote in 1875: "We soon found ourselves in a beautiful inlet enclosed by high land, but bounded on one side by one of the grandest sights it is possible to behold: two enormous glaciers coming down from different directions, but converging at their termination. They reminded us of two huge giants silently attempting to push and force each other away."

You don't exactly get sleepy under the midnight sun, but you begin to wilt from fatigue. Around 6 AM I laid my foam pad on the tundra and napped for a couple of hours before the guides rose to prepare breakfast.

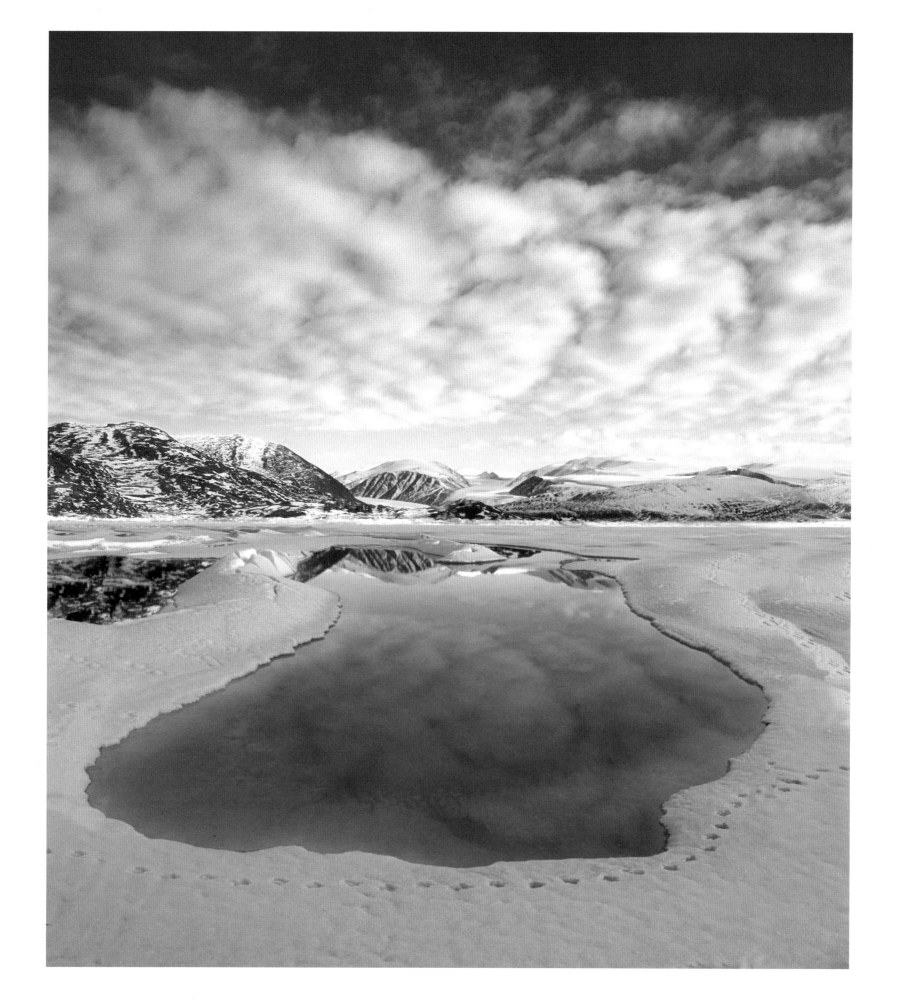

right and below In 1875, an artist sketched two explorers hiking past a boulder. Today, the Twin Glaciers in the background have melted back and no longer touch.

far right Blending into the Arctic landscape, two abandoned RCMP buildings stand silently on guard.

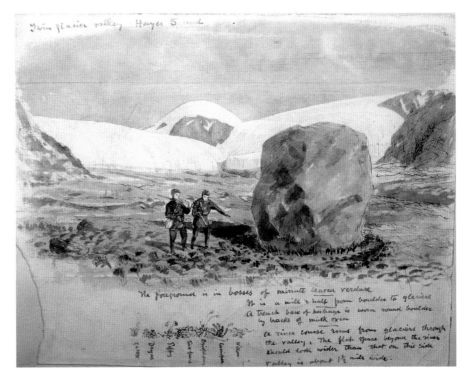

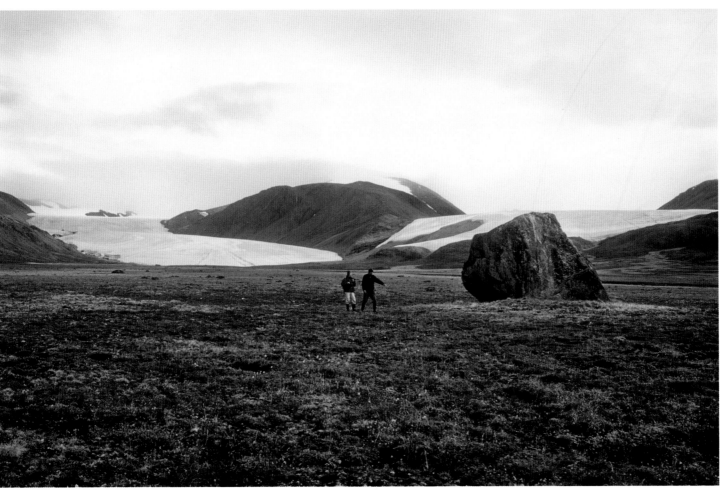

Ellesmere hooked me that first night. For the next eleven days, we paddled the sheltered coastline. Irrigated by three vigorous streams, the meadows of Alexandra Fiord basked in warmth. Ancient Inuit shelters, called *qammaqs,* half-igloos made from stacks of rocks and bowhead whale vertebrae, dotted nearby Skraeling Island. Bones took centuries to rot. Even a one-night campsite left a near-eternal circle of stones. "It's a strange place," mused one of my companions. "You build something, and a thousand years later it's still there." It was no real surprise when we discovered a couple of empty crates from Otto Sverdrup's 1898 expedition. By High Arctic standards, that happened yesterday.

At the time, I knew only one traveling speed: full bore. But to my surprise, I enjoyed the tour's laid-back pace. It let me focus on photography for the first time. I shot too many photos, most of which were bad, rather than work a few good ideas enough to ensure that I nailed the image. But now photography became more than a professional commitment done hastily while straining to ski or paddle hundreds of miles.

THE FOLLOWING SPRING, I hurried back to Ellesmere, doing back-to-back sledding trips with different partners for two months. Since then, I've returned to Alexandra Fiord half a dozen times to enjoy its rare collusion of history, wildlife, and scenery.

A few summers ago, I led my own kayak tour to Alexandra Fiord. By then I'd traveled the High Arctic so much that even some of the Inuit in Grise Fiord called me Mr. Ellesmere. I enjoyed the company of tourists, but I regretted that no new adventurers bonded with the place as I had. No one had discovered sledding, either, as a lifelong sport. Most Arctic expeditioners do one or two well-publicized treks and then retire.

It's never easy to find partners for a long, hard endeavor. Ernest Shackleton reportedly advertised for volunteers to explore Antarctica and received eight thousand applications, despite warning "Safe return doubtful." On one of my first expeditions, I tried the same strategy, taking out a notice in a local newspaper. The ad garnered a handful of such clueless replies that I longed for an era when only gentlefolk knew how to read. Where were the likes of Bowers, Wilson, and Oates—the companions who might be "gold, pure, shining, unalloyed"?

right Summer warmth nourishes a rich meadow of poppies, heather, and avens at the Arctic oasis of Alexandra Fiord.

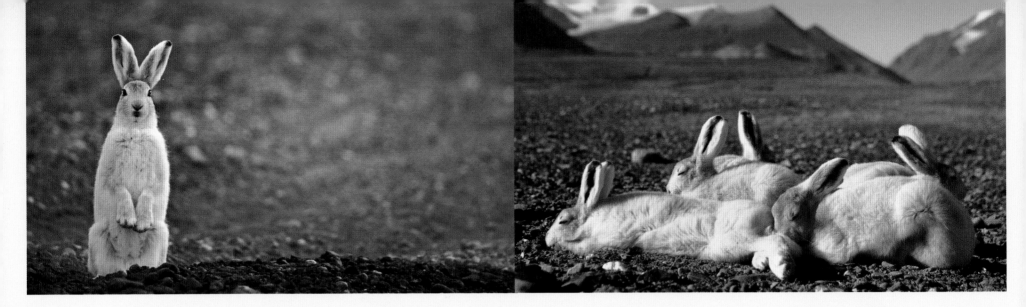

HARUM SCARUM

THE FIRST TIME I saw an arctic hare, my legs jellied with fear. A white animal was approaching over a dry riverbed. The High Arctic's lack of trees or houses and therefore any sense of scale made it impossible to tell whether it was a small mammal three hundred yards away or a larger creature—a polar bear, say—one mile distant. Eventually, the hare lifted its ears and its identity became clear.

Although it is the most commonly seen mammal in the High Arctic, the arctic hare often causes such double takes. Explorers couldn't believe their eyes when they saw a hare stand on its hind legs and bound away in six-foot leaps, a form of travel called ricocheting but perhaps better described as kangarooing. The explorers accepted what they had seen only after inspect-

ing the tracks in the snow. Wonder pervades their reports of the incident, as if they'd seen the hare take a watch from its vest pocket, look at it, and hurry off.

The size of the hares likewise surprises witnesses. A hunter reported one that weighed eleven pounds, dressed. They are so large relative to the little arctic fox that residents joke that in the High Arctic, the hares prey on the foxes.

But the most astonishing trompe l'oeil is caused by the hares' habit of forming large herds. A dozen, and even a hundred, individuals together is fairly common, but lucky travelers occasionally hit the jackpot. In 1971, an estimated 25,000 hares overran five square miles near Ellesmere's Eureka weather station. Some years later, near Lake Hazen in Quttinirpaaq

National Park, a warden on a helicopter patrol saw a mountain covered with snow—which was strange, because in midsummer, none of the other hills had snow. What's more, the snow was moving.

Biologists believe that herds makes it harder for predators such as gyrfalcons, snowy owls, wolves, and foxes to target a single individual. When disturbed, the hares zip around madly in a kind of lagomorph shell game. I've tried to keep track of one hare in the melee but have never succeeded.

Very lost hares sometimes turn up on ice caps and even on the frozen Arctic Ocean, but the less directionally challenged prefer areas rich with saxifrage, cottongrass, and willow. Young hares, or leverets, nurse from their mother only a few seconds a day, returning to the same spot every eighteen and a half hours or so. After nursing, they become exuberantly silly, leaping in the air and lashing out with their hind legs or boxing each other with their forepaws. Then they settle down to the more mundane task of nibbling the ground-hugging Arctic willow.

High Arctic summers are so brief that the hares stay white year-round, unlike southern populations, which turn brown. So in the snowless weeks from mid-June to late August, they stand out like snowballs on the tundra, as visitors fooled by their apparent size debate whether or not to retreat.

far left An arctic hare stands on its hind legs, the better to view a potential threat.

left Young hares kill time sociably while awaiting their mother's return.

below Adults may relax together, but they never huddle with contact.

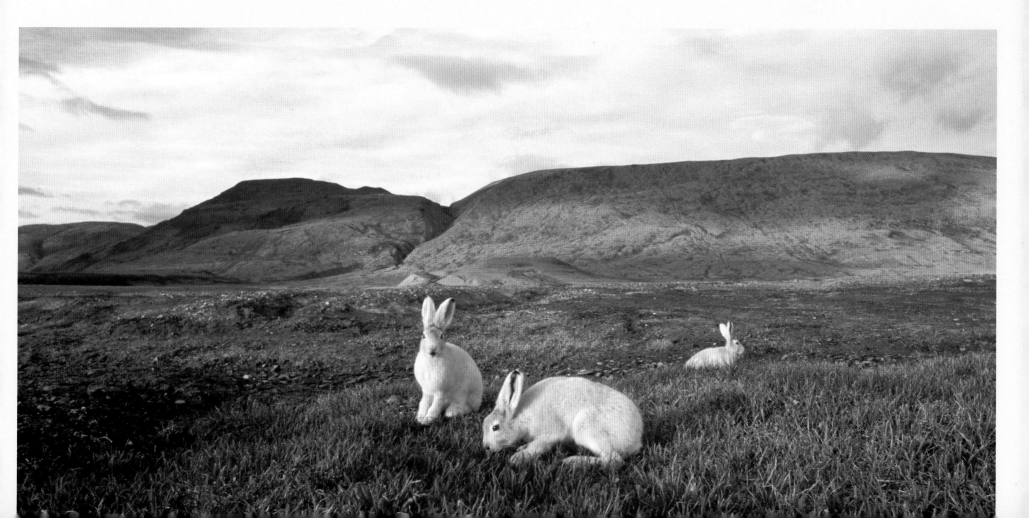

below Young arctic hares nurse for barely a minute a day. The rest of the time, they browse like adults.

right As summer approaches, expanding pools of meltwater hinder but don't halt sea ice travel.

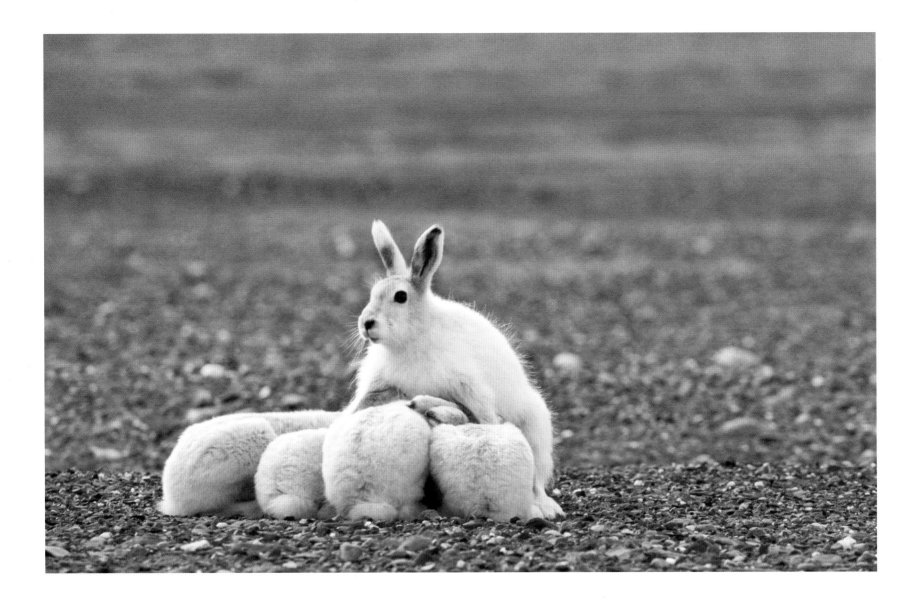

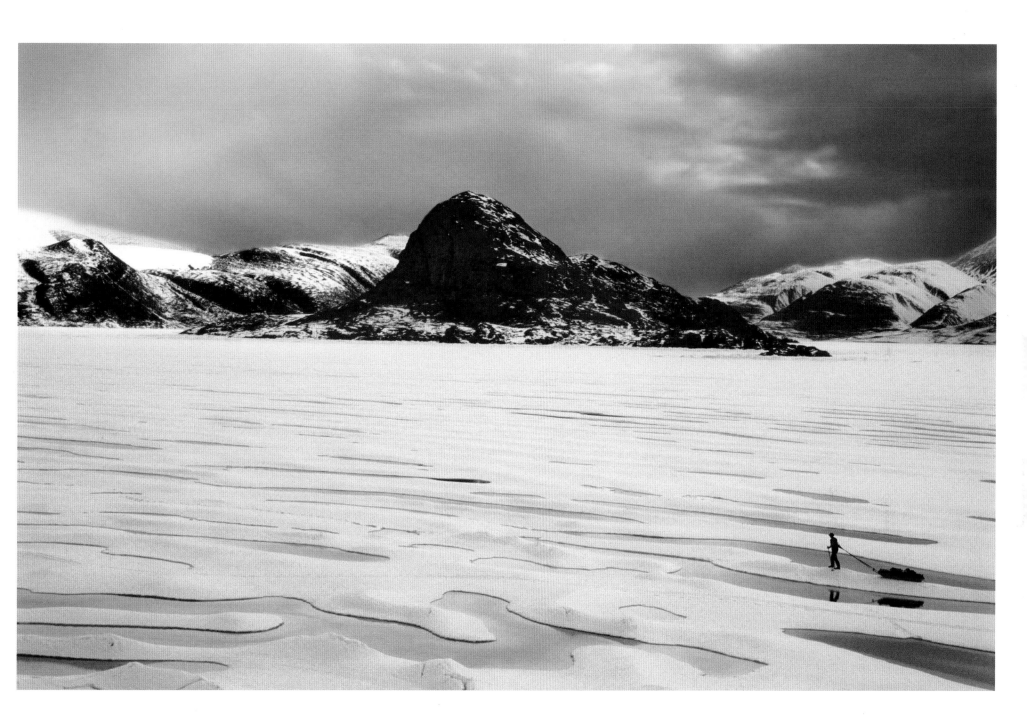

below Greely's starving men ate these "miserable shrimp" (in fact, copepods) by the dozen. The six survivors owed their lives to the animals' fat content.

right Lieutenant Greely issued this secret order to execute a man for repeatedly stealing food at Camp Clay.

In an 1876 essay, Robert Louis Stevenson opined that "a walking tour should be gone on alone, because freedom is of the essence . . . and because you must have your own pace." Most northern journeys are no harder alone, except psychologically. Although British explorers such as Shackleton and Robert Scott, and Americans such as Leonidas Hubbard, left a romantic legacy of camaraderie, High Arctic figures were not as successful. Adolphus Greely's men disliked his fussiness, with cause. Otto Sverdrup's democratic style failed to patch the divide between his scientists and his sailors. Robert Peary preferred young, non-threatening apprentices—an approach that many veteran travelers mimic today. The apprentices coolly serve their time as able bodies, then begin organizing their own expeditions. Since ambition dooms many partnerships, the best long-term partner may be someone who enjoys the journey but isn't driven to organize.

above Dramatic tokens, like these matches Greely's men used to light their stove, still litter the camp more than 125 years later.

A CLOUD CAP hung over ever-evil Cape Sabine as our group paddled nearby. Jutting east toward Greenland, Cape Sabine is a kind of anti-oasis, where storms prevail even when everywhere else is sweetness and light.

Small numbers of walrus submerged with hip flips as our kayaks glided past. "Walrus are ugly customers," declared one early visitor to this region. Issues of pulchritude aside, these hippos of the sea have unpredictable tempers. A few years ago, in these

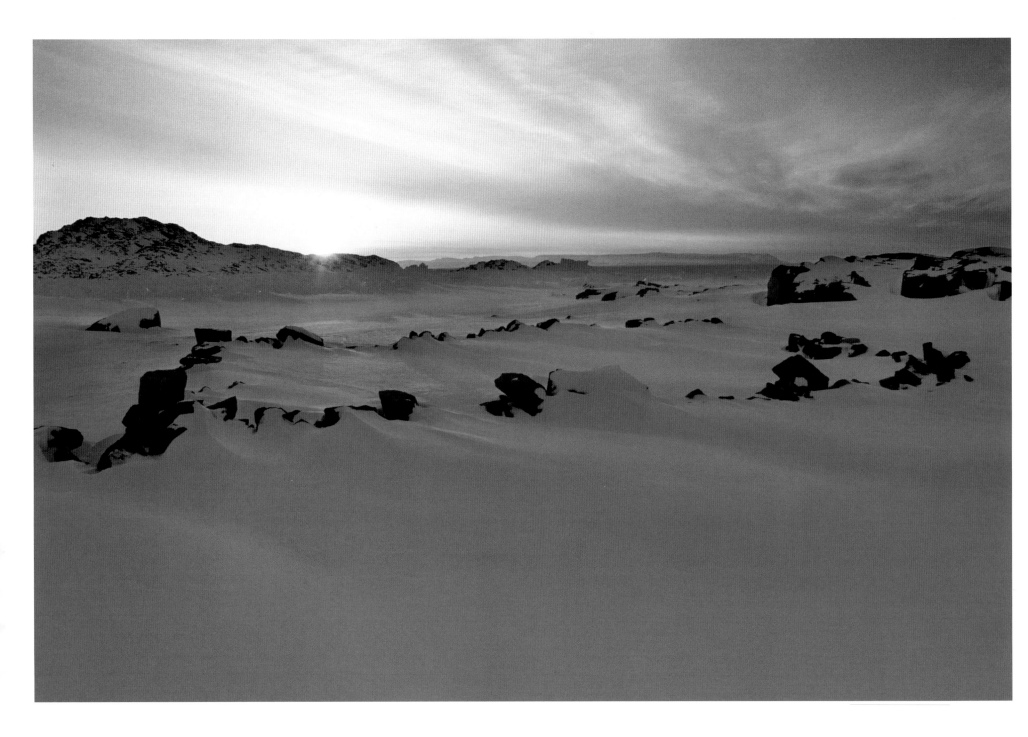

ARCTIC EDEN

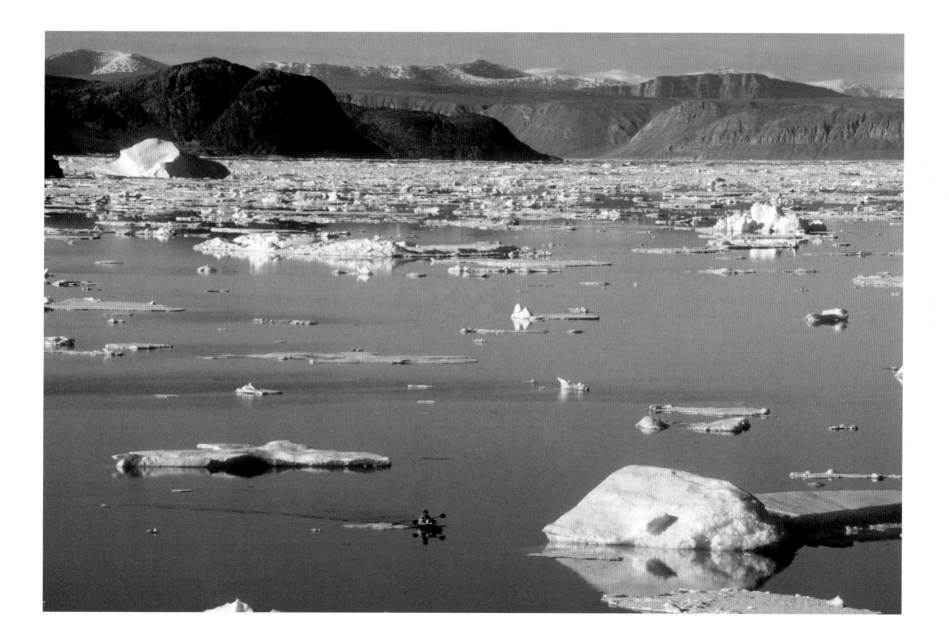

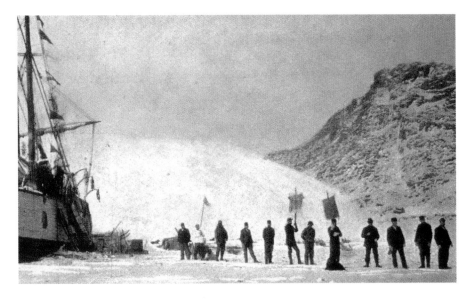

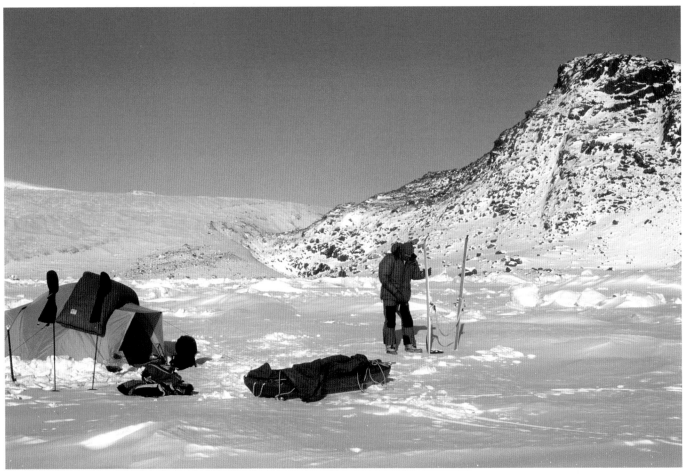

very waters, one tried to crush the nose of a kayak in its flippers; another punctured a Zodiac with its tusks. The explorer David Haig-Thomas warned that a walrus could pluck a victim from a boat and suck the flesh from his face. Overdramatic, perhaps, but calamitous entanglements with solitary male walrus did happen. The Inuit used to carry bits of blubber to plug tusk holes in their kayaks. It was always a good idea not to squeeze walrus between you and the shore, but to keep them on the outside. This particular herd let us pass in peace.

Our group included the usual eclectic mix: a strong, experienced Swiss woman; a slender, thoughtful couple in their late fifties; a retired auto worker. One unusual participant came from southern California. Bob didn't say much, but what he did say usually made you take notice. When we first met, he asked me whether Peary's wheelhouse was still at Payer Harbour—a piece of historical trivia so obscure that maybe ten people in the world know about it.

One evening, he and I hiked to the top of nearby Cocked Hat Island. On our way down, a polar bear chased us back into our kayaks. We hurried to camp, paddles flying like windmills. "I've had more fun in the last three hours than I've had in the last year," Bob commented. When we visited Fram Haven, where Otto Sverdrup wintered in 1898, he called it Fram Heaven.

Bob remained wide-eyed for the entire two weeks. I'd never met anyone else who responded to the place like this. To watch him was to relive my own first night on Ellesmere. Every evening, when the others went to sleep, I took photos and Bob wandered the tundra, smoking a stogie and reading Homer. He didn't mind when the group ran out of food in the last two days and we had to parse the final crumbs with the same exactitude that Greely's starving men had. We landed back in Resolute to several inches of blowing snow. Even that seemed to delight him.

left The glacier at the head of Fram Haven has shrunk dramatically in the century since Norwegian explorers celebrated their country's independence day there.

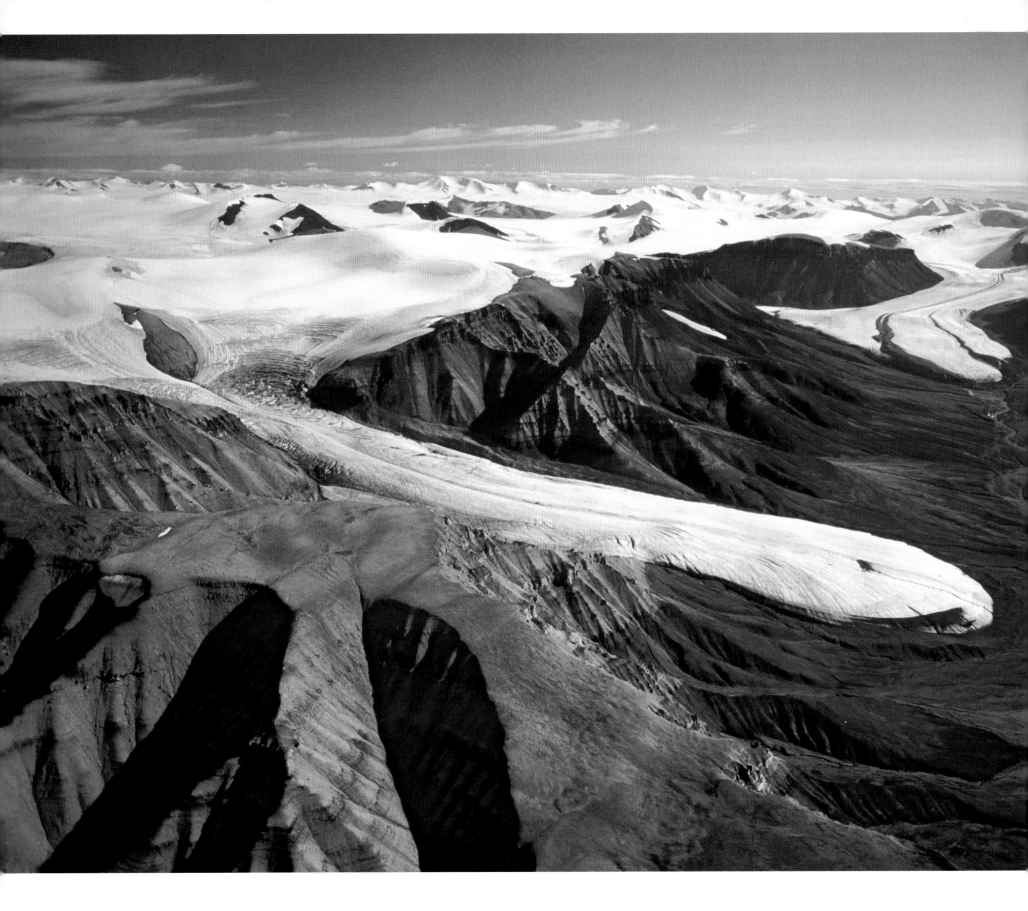

ICE CAPS ending in slender piedmont glaciers cover most of Axel Heiberg Island's interior.

"Follow me;

I seek the everlasting ices of the north."

MARY SHELLEY, *Frankenstein*

2 | EVERLASTING ICES

FELL IN love with Axel Heiberg Island on one of those April days when the air is cold and sharp as diamonds. Its deeply indented south coast appeared below the wingtip of our plane, an hour and change north of Resolute. Far below, toothy peaks lined both sides of a narrow valley. Between each pair of peaks, a small, perfectly formed glacier spilled onto the flats. There must have been twenty of those little masterpieces on both sides of the valley. One day, I thought, I'd ski past that honor guard of ice.

Arctic travel follows what you might call the Glacier Principle: even if it feels as if you're going nowhere, keep inching forward and slowly you'll wear down the obstacles in front of you. It's not uncommon for travelers to obsess about glaciers. They dominate and obstruct and awe in a way that earth and rocks do not. As Mark Twain wrote, "A man who keeps company with glaciers comes to feel tolerably insignificant by and by."

Although I still haven't skied that magical valley, I've spent months in the company of Axel Heiberg Island's glaciers. During the ice ages, when a great sheet of ice covered most of Canada, everything was glacier and so, in a sense, nothing was. It was just so much

whiteness, like the interior of Antarctica. Years from now, the island's glaciers may come to resemble those fragments that nestle today in shadowed cirques in the Rockies, like the stubs of amputated fingers. But right now, aesthetically, the glaciers of Axel Heiberg Island have it all—beauty, shape, mass, and power.

Half an hour later, our plane landed at the Eureka weather station on Ellesmere Island. My partner and I planned to ski six hundred miles around Axel Heiberg, which lay just six miles across the frozen sound. But after one day on the trail, he decided that sledding was boring and uncomfortable, and he didn't want to do it for two months. When he flew home, I abandoned the circumnavigation and grabbed a short flight to the Colour Lake camp on Axel's west side. Scientists have been going there for fifty years to study two local glaciers. The researchers weren't due for another month.

The camp consisted of a lab and a small bunkhouse, the only structures on an island the size of Denmark. A set of monographs of the work produced there lined a plank shelf. Lighter reading included a thriller called *White Death,* where "deep in the frozen wasteland of the north … a research party is stranded." Even a skin magazine that touted itself as "Home of the D-cups" and trafficked in such inflated prose as "her mountainous twin flesh ovoids" contained one nonporn article on, of all things, Ellesmere Island as an adventure destination.

Hanging around the empty camp for days, I marveled as absolutely nothing happened. Emptiness is rarely this pure. Once an arctic fox wandered like a line of haiku through the scene. Then nothing for several more days.

When the charms of meditation gave way to flipping restlessly through descriptions of mountainous ovoids, I knew it was time to ski the seventy miles back to Eureka. Glaciers and ice caps make most crossings of Axel Heiberg Island too dangerous for one person. Even with companions, hazards lurk; in the 1970s, a member of a military expedition died on Axel Heiberg in a crevasse. His teammates fished him out, but he had fatally struck his head during the fall—the island's only known glacier victim. I didn't want to be the second.

right Some arctic foxes scavenge polar bear kills, but most live mainly off lemmings and arctic hares.

But just south of Colour Lake lay an almost-chink in the ice barrier, called Strand Fiord Pass. Only a six-mile section of glacier barred the way, and government air photos taken in summer revealed no crevasses. Still, I proceeded cautiously, removing the basket from one ski pole and probing every step. Weird clouds hung above nunataks of pressed gravel, presaging a violent wind the following day. In the end, it did not take me long to reach Eureka safely.

BOTH EXPLORERS AND Paleo-Eskimos struggled on western Axel Heiberg. Rough ice girdles the storm-pounded coast, while deep snow bogs down the inner fiords. Glaciers and multiyear sea ice create a white desert, in which hunting is poor. Animals, like my fox, are single notes rather than a chorus.

The gentler east side of the island feels oddly civilized in places, thanks to the nearby Eureka weather station. From the hyper-refined sensibility of a High Arctic traveler, anything less than about 125 miles from a community qualifies as almost urban.

For a sledder, travel on this quasi-civilized coast approaches perfection. Axel Heiberg's peaks catch the prevailing westerly blizzards, and north winds pack the sparse snowfall into a concrete highway over which a sled pulls easily. I rarely make fewer than twenty miles a day here and often up to thirty miles. Mountains like petrified whitecaps grace the Axel Heiberg side, while herds of muskoxen and hares forage on Ellesmere's low brown hills. With this effortless travel, I sometimes daydream so much that I don't

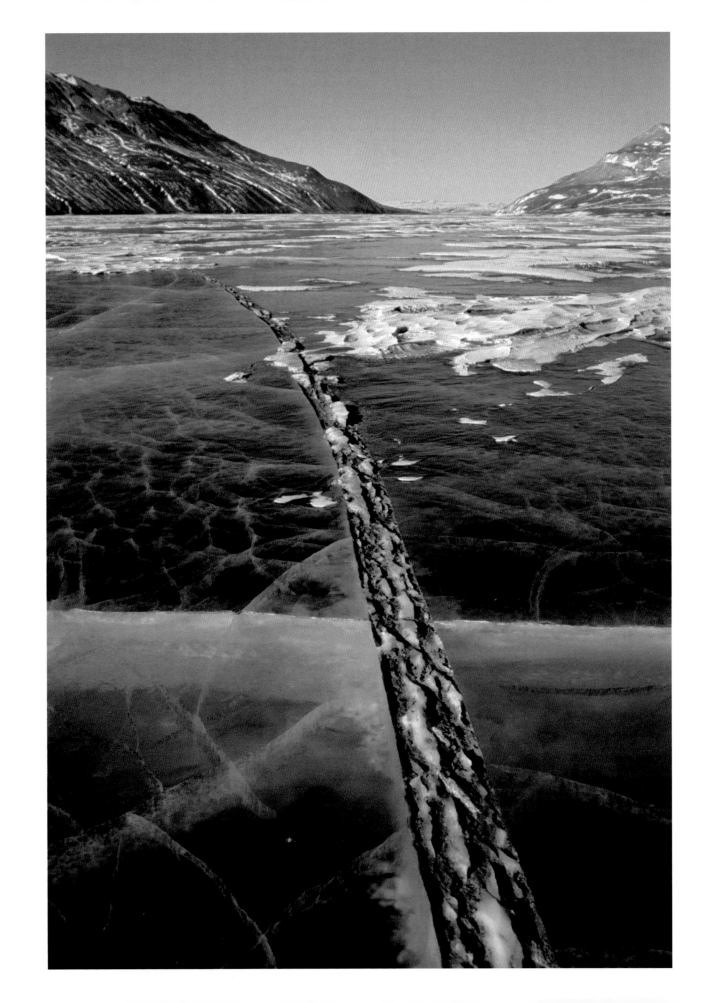

left Snow rarely clings to the eight-foot-thick ice on Axel Heiberg's windy Buchanan Lake.

below Though rare in the High Arctic, avalanches can occur where enough soft snow accumulates.

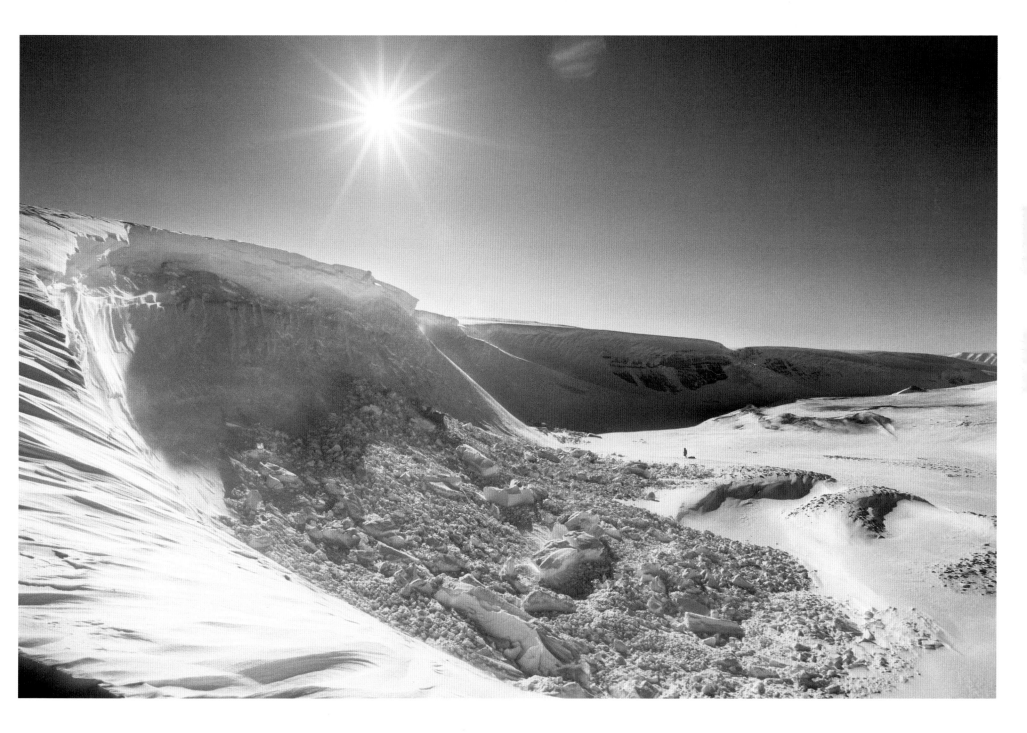

right Alexandra Kobalenko hop-
scotches the ice floes of Good
Friday Bay.

below The lonely, seldseen, but
nakedly beautiful northern tip of
Axel Heiberg Island.

far right A bay on western Axel
Heiberg, hours before its ice
disappears under the 24-hour sun.

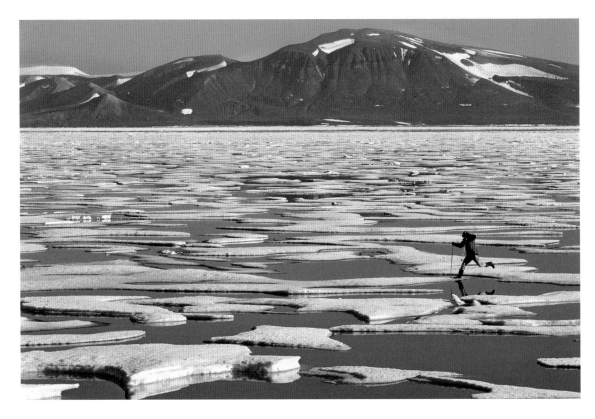

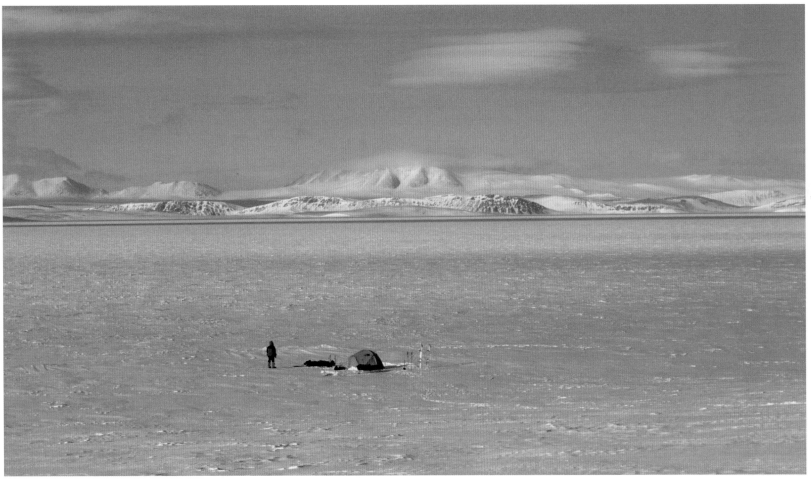

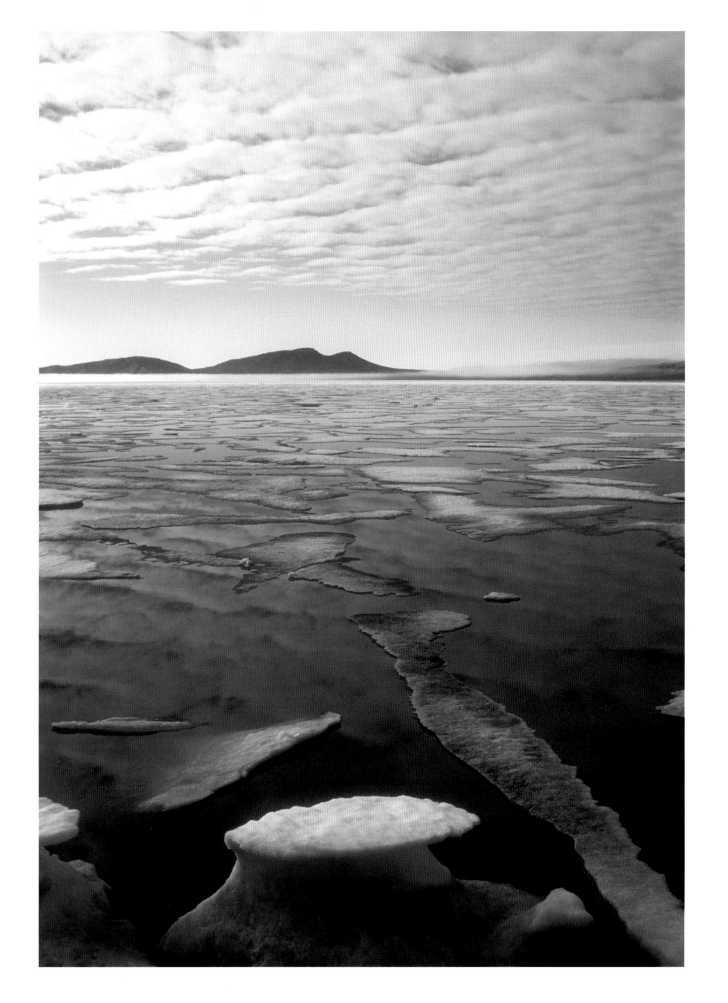

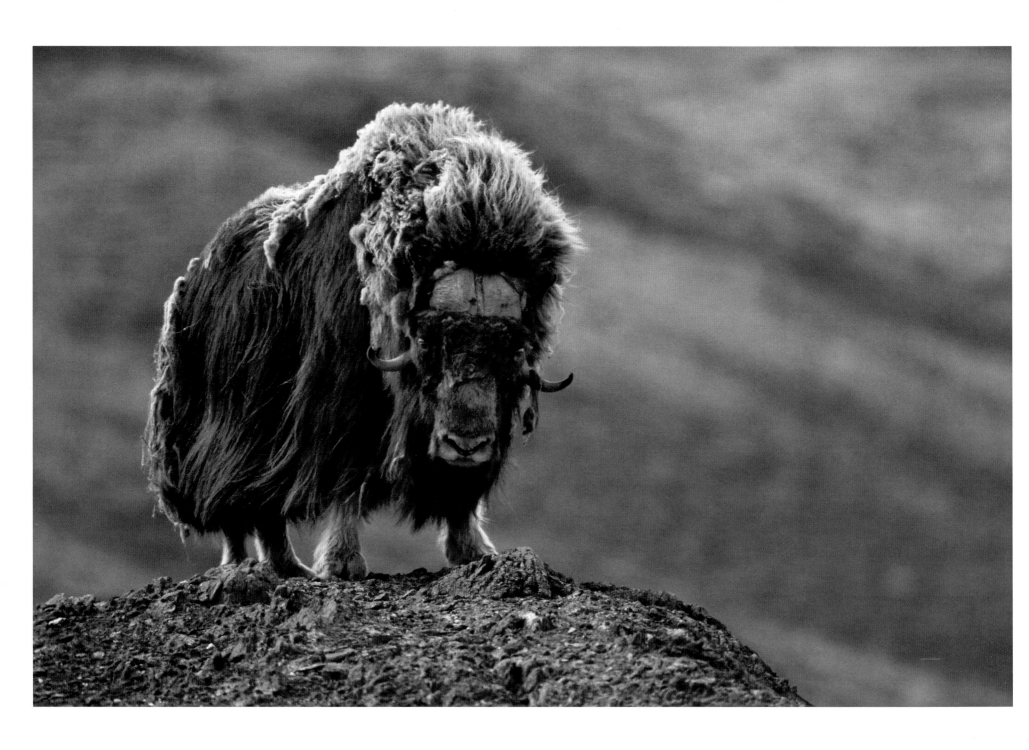

notice a nearby muskox herd until it is almost behind me. Occasionally I try to approach them for photographs, but in the sledding season, the females have just given birth, and the herds are skittish.

Polar bears den in the lower half of eastern Axel Heiberg, and this threat makes for uneasy sleeps. The bears mostly disappear north of Eureka, as the number of ring seals dwindle. Just before Axel Heiberg ends at Cape Thomas Hubbard, the black cliffs of Svartevaeg rear up. According to Frederick Cook, who camped here in 1908, Svartevaeg's "face of black scarred rocks frowns like the carven stone countenance of some hideously mutilated and enraged Titan savage. It expresses more than a human face could of the unendurable sufferings of this region of frigid horrors. It is 520 miles from the North Pole."

On a flattish dome above Cape Thomas Hubbard, a wind-blasted cairn built by Robert Peary in 1906 gazes toward that elusive North Pole. Standing beside the cairn, which maybe a dozen people have seen, I felt that I'd reached a limit of wildness that I'd never equal. Beyond lay only the Arctic Ocean, its skin of ice riven with cracks of open water, like the stuff of broken dreams. The scene was haunted and fabulous, not beautiful so much as sublime—that intriguing word that takes awe and adds overtones of horror.

ONE OF THE handful of people who visited this cairn was the German geologist Hans Krüger, in 1930. Krüger was one of many inspired by Vilhjalmur Stefansson's concept of the Friendly Arctic. The Canadian-born Stefansson had lived off the land, Inuit-like,

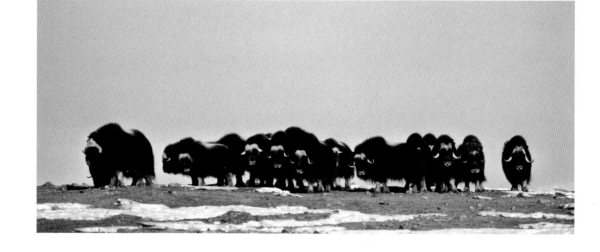

left The muskox, which once inhabited Great Britain, is now confined to Arctic reaches.

above In May, the presence of young calves makes herds of normally mellow muskoxen skittish.

TRAVEL THROUGH THE SEASONS

A WEAK SUN creeps above the horizon in mid-February after four months of darkness and twilight. Now the coldest weather begins. Throughout March, the sun hangs small and pale, as it might appear from the edge of our solar system. Typically, the air is −22° to −30°F along the coasts and colder inland.

Below a certain temperature, the microthin layer of water that friction creates underneath a gliding sled runner or ski doesn't form. Without this subtle lubrication, the hard snow crystals grate like sand against the runners. Although the temperature at which this happens depends on speed, weight, and runner material, dragging a sled becomes noticeably harder to do below temperatures of about −13°F. The colder the snow is, the greater the friction.

At night, the moisture in breath condenses on the tent ceiling above your face and builds into a long crystal earring. Once or twice a night, the earring grows too heavy and drops refreshingly onto your face. You wake up, sputtering. Other than that, a warm sleeping bag—and three or four layers of clothing inside it—allows a good night's sleep, even at fifty below.

In early April, seven weeks after that nominal sunrise, the twenty-four-hour day begins. On calm afternoons, the sun and the warmth of exercise make it possible to sled in just an undershirt. The year's six best weeks of travel ensue. Infinite light, good hard snow, and perfect temperatures for walking. Sweaty boots, left outside overnight, dry in the sun. Nonphotographers prefer traveling during the day, when it

is warmer, but photographers prefer traveling at night, when the light is less harsh.

In Antarctica and Greenland, many skiers use a kite to tow themselves and their sleds in a wind. They cover amazing distances, sometimes 120 miles a day. Such reliable winds do not blow in the High Arctic. I use my old-fashioned sail maybe twice a month.

Brown patches appear on the land by mid-May. Sometimes, the snow lasts weeks longer.

Other times, the sledder drags over bare ground in April. The heavy sled screams in agony as gravel claws into the gelcoat.

By the end of May, the sea ice disappears at the outlets of flowing rivers. The thin ice in the shallows also melts, creating a shore lead—a ribbon of open water between ice and land. It's sometimes hard for a sea-ice walker to get ashore. I may switch to amphibious travel, towing a kayak as a sled but hopping into it to cross open water.

far left By mid-May, there is only one F-stop difference between midnight, shown, and noon.

left Long cracks, called leads, begin to form in the sea ice by late May. Narrow at first, they soon become too wide to hurdle.

below We think of icebergs as drifting in open water, but for much of the year they are frozen in.

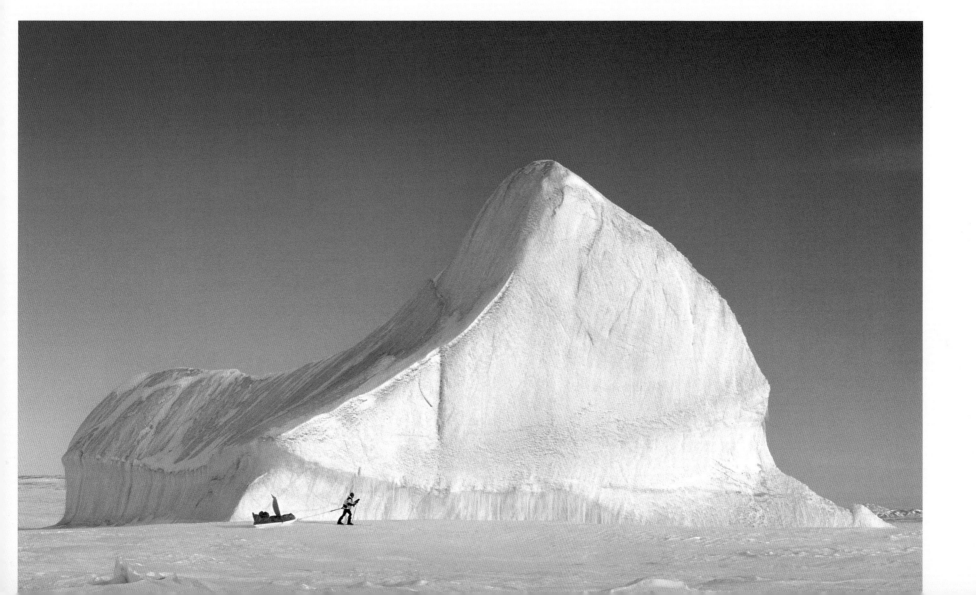

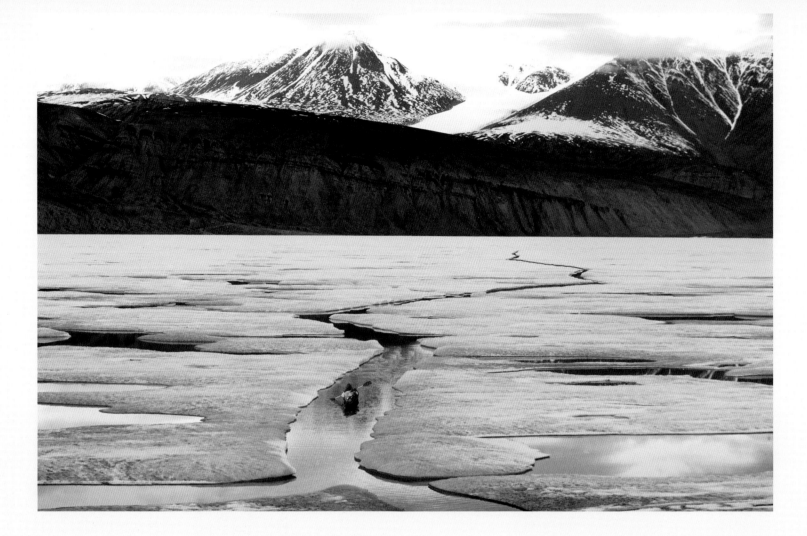

Shin-deep meltpools gradually form on the sea ice. To the uninitiated, these pools look scary, but solid ice lies beneath. With waterproof boots, you just slosh through.

This puddling eventually eats away the sea ice until finally only floating pans remain. Sea ice is thinner in our era, but a sledder doesn't notice if ice is three feet thick or five feet thick. For the time being, it remains thick enough.

Along steep shores, a shelf of intertidal ice known as the ice foot, about as wide as a side-walk, adheres to the slopes. Where tides run high, this ice foot forms an impenetrable barrier to an early summer kayaker. It rings an entire island with what from the air looks like a ballerina's tutu. Because it attaches at the high-tide level, it overhangs at low tide and blocks the way onto land. As the summer

advances, the shelf begins to flake off, allowing access through the gaps.

Rivers form the main obstacle to summer hiking. High Arctic rivers are never wide Missouris but rather a series of narrow channels, or braids. During warm spells, glacier-fed rivers remain high. Fording a twenty-foot channel coursing with thigh-deep ice water strong enough to wash you away is a high-intensity commitment in the otherwise gentle hiking at the top of the world.

In August, the sunlight begins to model the land rather than just drench it in intense brightness. Soon, the first thin snowfall sticks on the cooling peaks. Freshwater streams form a brittle skin of ice on the surface of quiet saltwater bays. The brief summer has ended. The light keeps getting better, enhanced by wild storm clouds, until the sun disappears in October. By this time, most birds and travelers have abandoned the High Arctic until the New Year.

left Avid kayakers can use leads to push the paddling season ahead by several weeks.

below left Known as the Arctic boulevard, the ice foot allows painless walking after the sea ice breaks up.

below right Icy streams present the main challenge to summer hiking.

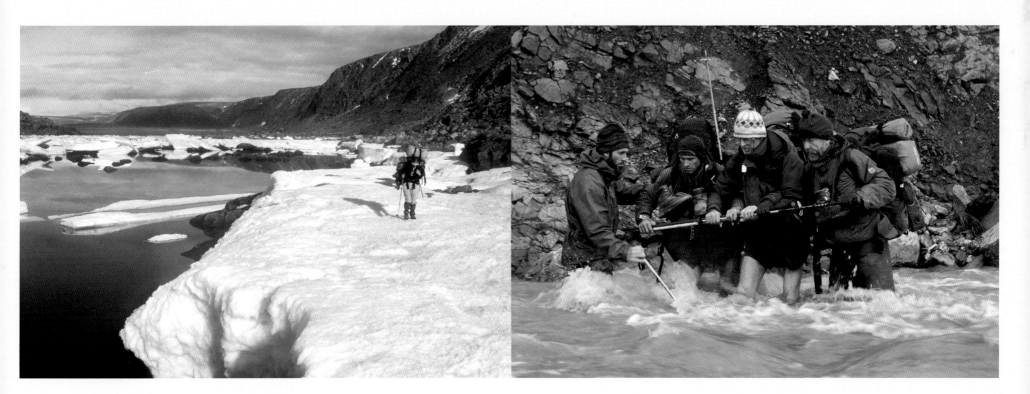

above At midnight, long shadows stretch over the desert-like badlands near Good Friday Bay.

right From the Arctic Ocean off northern Axel Heiberg, a snow trekker looks toward the North Pole.

for several years. In his many books, he dismissed the idea of the North as empty or hostile. He made it seem like a land overflowing with game. This notion appealed to dreamers on a budget, because it seemed to open up the Arctic to daring individuals. You no longer needed to be part of a government bureaucracy, like the British, or to fundraise for years to support an elaborate supply system, like Robert Peary. In the Friendly Arctic, you could wangle your way north, then hunt as you went. All you really needed was an Inuit guide to do the hunting until you acquired the skills to do it yourself.

But Krüger and his two companions found death rather than a Friendly Arctic. During his journey, Krüger left three "all's well" notes, including one in the cairn at Cape Thomas Hubbard. Then they vanished, and what happened to them remains a mystery.

I'd always kept watch for signs of Krüger on Axel Heiberg. One August, my wife, Alexandra, and I prepared to visit Good Friday Bay, near the southwestern corner of the island. From Krüger's trail of cookie-crumb notes, he and his partners would have stopped in this area next, if they had survived this far.

Just before we left Resolute for Axel Heiberg, I mentioned our quest to a graduate student in town. He told us that a couple of weeks earlier, a geographer I knew had found several artifacts twenty miles south of our proposed destination, including underwear with German writing on it. I tracked down the geographer in Resolute to ask him about the rumor. "That was a joke!" he thundered. "I was playing a trick on one of my grad students." He had not heard of Krüger. I let it pass and we flew to Good Friday Bay, as planned.

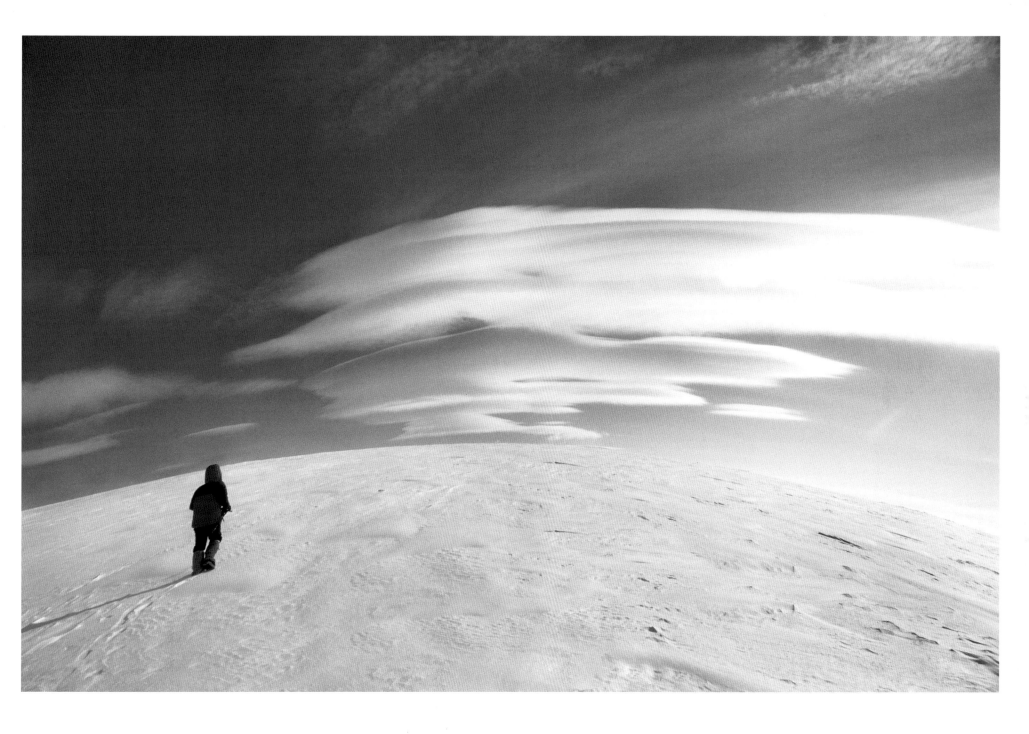

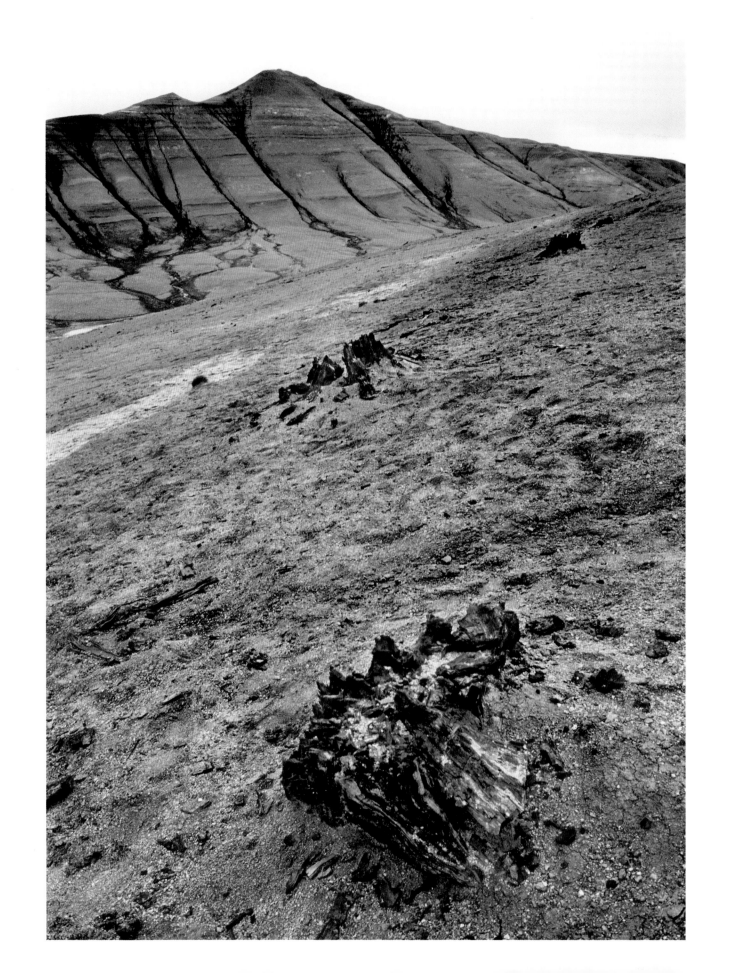

Otto Sverdrup first discovered Axel Heiberg Island in 1899 and dogsledded past this inlet on Good Friday, 1901. Since then, Axel Heiberg has not exactly been a popular destination. From 1901 until the late 1940s, precisely nine parties after Sverdrup visited it, including Krüger and the two Royal Canadian Mounted Police patrols searching for him. Imagine being able to trace like this the entire human record of a large island from its discovery to modern times! A university administrator I once shared a trip with remarked how "more people pass through my office in a single day than have passed through here in all history."

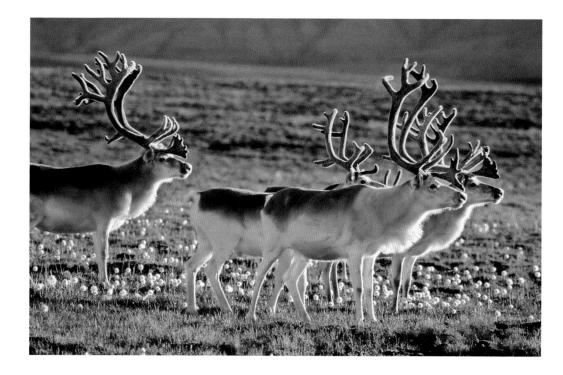

Forty-five million years ago, cypress trees flourished on Axel Heiberg in a climate similar to that of present-day Louisiana. The well-preserved fossil stumps and logs lie in dark veins on a badland hillside opposite Eureka. Recently, the ninety-million-year-old fossil of a freshwater turtle turned up elsewhere on the island. In the turtle's era, Axel Heiberg lay about six hundred miles farther south and had an average yearly temperature of 57°F. Since then, it has become an icebox, with a current mean temperature of around −2°F.

But our visit coincided with the warmest Arctic summer on record. We seemed to have been transported back to the time of the turtles. We wore T-shirts nearly every day, sometimes as late as 11 PM, when the sun hangs just three or four diameters above the horizon. The ice of Good Friday Bay broke up quickly under this round-the-clock sunshine. I'd often experienced stable, warm May weather, but in summer, open water

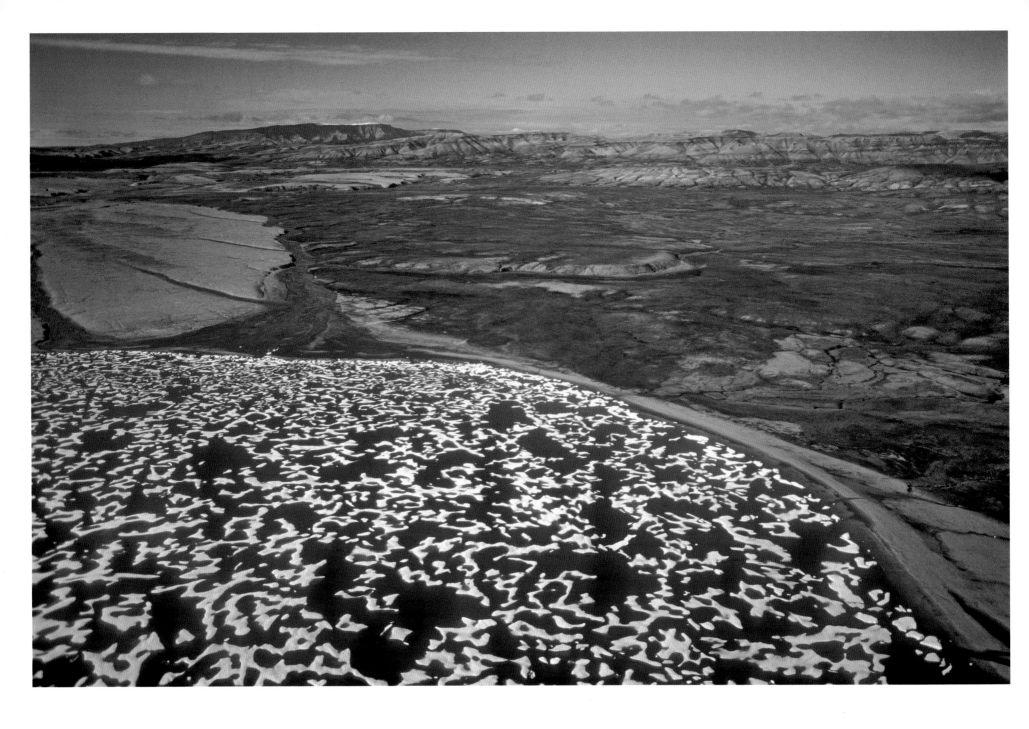

left Beyond ice-choked Good
Friday Bay, lowlands lead to hills,
which rise inexorably to ice caps.

below Floating ice dampens
waves like the lane ropes of a
swimming pool, and even big
bodies of water typically enjoy
flat conditions.

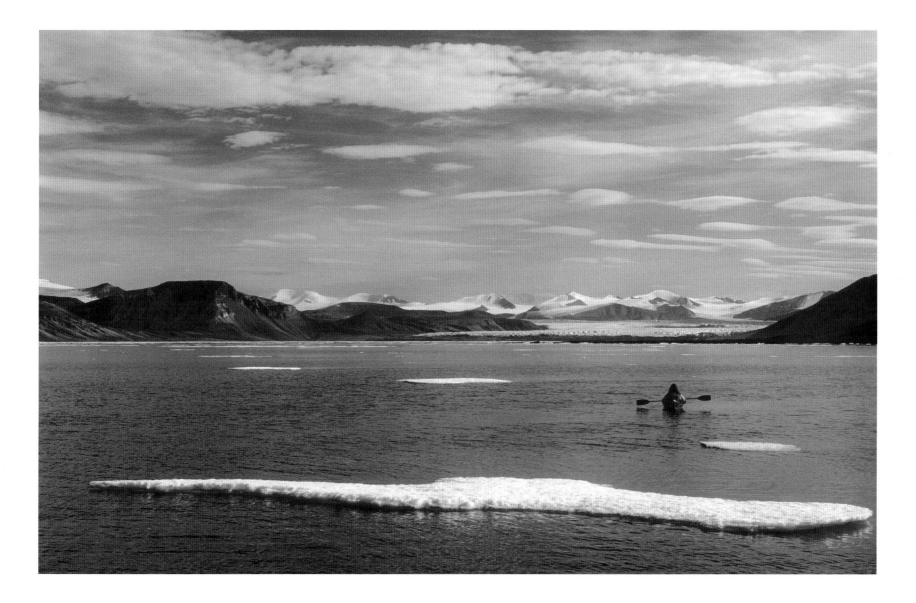

Everlasting Ices 51

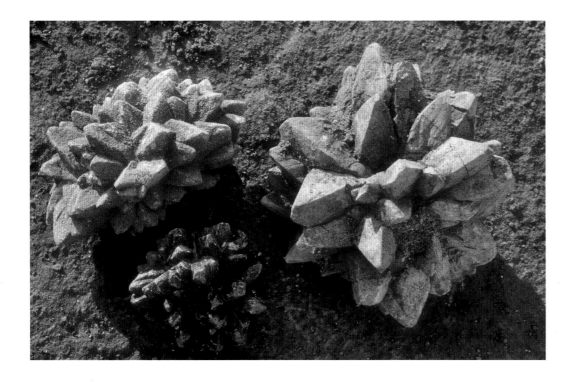

usually creates cooler and cloudier conditions. That August, Axel Heiberg Island enjoyed higher temperatures than Vancouver, eighteen hundred miles south.

In three weeks, we hiked and kayaked the entire bayshore, plus the neighboring bays to the north. Krüger's party would not have gone inland, except briefly to hunt. We found no trace of him along the coast but made other discoveries: rose rocks—rare crystals formed in cold seawater—and an old Thule sled runner, the first Paleo-Eskimo artifact to turn up on western Axel Heiberg. We also spent hours in the company of rare Peary caribou, a diminuitive variety that is white most of the year but brown and fat in late summer. While muskoxen are uncommon on the austere west coast, Peary caribou can subsist on poorer fare and turn up in small numbers. As we stood watching the caribou, a lemming ran between Alexandra's boots and cowered there, as a snowy owl wheeled above.

At the head of Good Friday Bay, a titanic glacier had surged since our map was published and filled the final three miles of fiord. An almost hysterical violence accompanied its growth. Rotting seracs collapsed before our eyes. The ground shook. In the heat, a meltwater river of insane force issued from the bowels of the glacier and ate into the ground itself, which sloughed away like dead skin into the brown roil. Huge unseen boulders, pummeled by whitewater, rolled downstream with a basso rumble. How many summers had this been going on? The cosmic events that take place unseen . . .

Krüger, it turned out, had been in this area. The geographer in Resolute had concealed his discovery from us; the site he'd stumbled upon twenty miles south of Good Friday Bay had been genuine. Besides the labeled underwear, he took away a theodolite of German origin dating from that era. A box of rock samples that Krüger had painstakingly collected led to speculation that he had already perished; the ambitious geologist would likely not have abandoned these prizes.

This first news of the expedition in forty years eliminated a few old theories. The party had not succumbed to carbon monoxide poisoning in their tent nor fallen into open water between Meighen Island, where Krüger left his final note, and Axel Heiberg. But no bodies turned up at this new site, no tent. They had simply stashed some gear here. Their last camp remains unfound.

But if some of Krüger's party had survived, why had they failed to reach the RCMP post on eastern Ellesmere Island? By now, they had left behind the Starvation Coast for a region of ample food and good travel. Vilhjalmur Stefansson may have oversold his Friendly Arctic, but from southern Axel Heiberg onward, that concept applied.

Near the end of our stay on Axel Heiberg Island, Alexandra and I hiked up to the snout of another glacier for a few photos. The evening was so warm that she wore just a sports bra on top and I had no shirt at all. As we stood next to the glacier, a gentle wind blew off it—and the wind was hot.

I was a slow convert to the idea of global warming. Too many fellow adventurers paid lip service to it. Their self-important and inaccurate statements made me cringe. What could my few years of experience say about something like climate, which moved in geologic time? Besides, when I began reading about the outdoors in the 1970s, scientists were debating whether a series of recent cold winters presaged a new ice age. People jump to conclusions far too quickly.

But as we stood there, bathed in the hot wind off a glacier at 79° north, it seemed hard to deny that the opposite of Mark Twain's reflection about glaciers was also true: if such weather persisted, glaciers that kept company with men would themselves become tolerably insignificant by and by.

left Rose rocks, or hedgehog rocks, are found in only a few circumpolar sites, including Axel Heiberg.

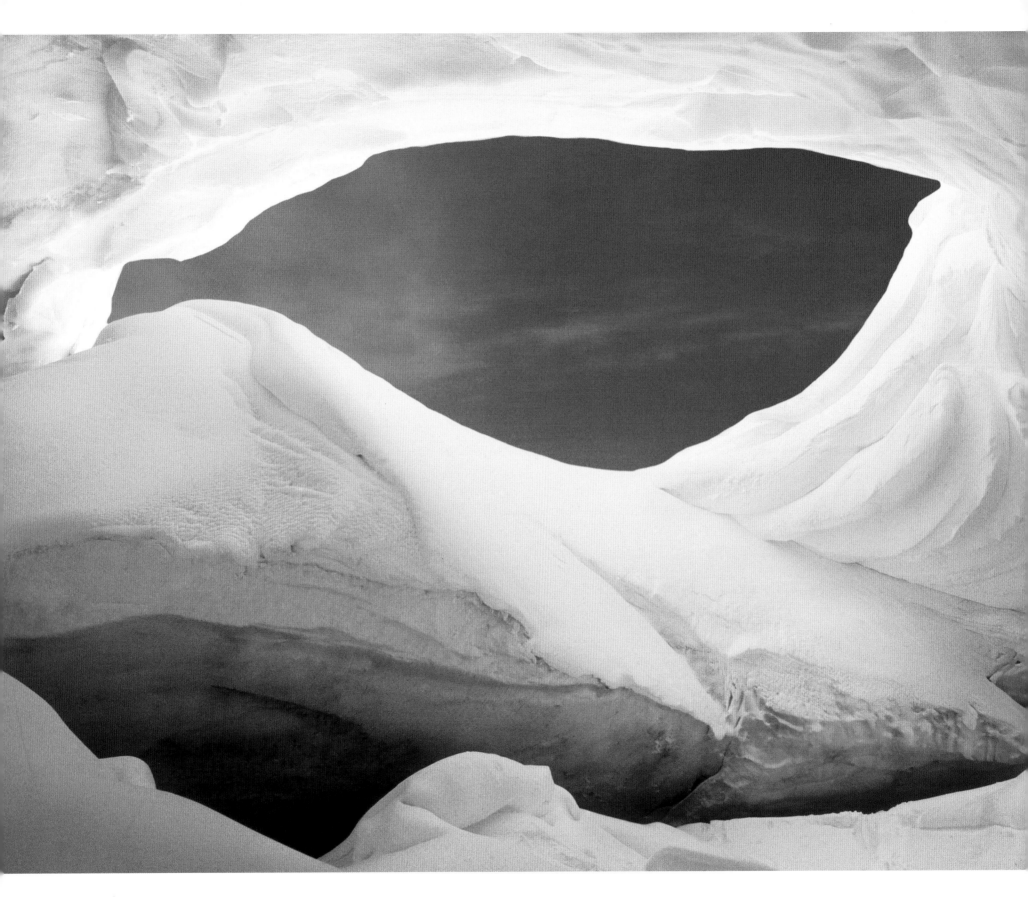

LIT BY skylights where the roof has collapsed, an ice tunnel extends a quarter-mile underneath a glacier.

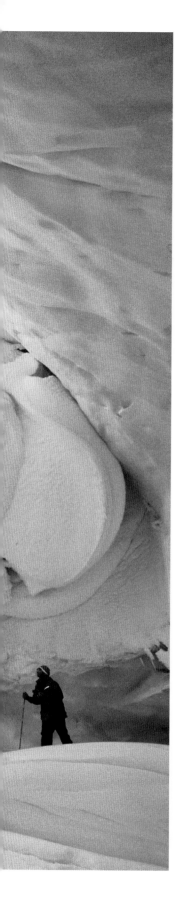

"When we stop to analyse the expression,

'a good climate,' we find that what we really

mean is a good climate for loafing."

VILHJALMUR STEFANSSON, *The Northward Course of Empire*

3 | A GOOD CLIMATE FOR LOAFING

BOB COCHRAN had never skied or worn a toque before, which made him a strange candidate for a 250-mile ski expedition near the North Pole. If Bob had ever worn a hat of any kind, it was probably a sombrero during some tequila-fueled weekend in Mexico. Bob lives in Los Angeles, where he works as an assistant principal at an adult school. He is an urban dude who likes to wear a suit to the office, gel his hair, and eat in restaurants a lot. Apart from a stint in the Marines thirty years earlier, he had never traveled much. At fifty-five, he was not exactly the ideal age to begin this hard travel nonsense.

But Bob had other qualities. He had to be one of the only people in L.A. who didn't own a television. In his spare time, when he wasn't chasing younger women, he liked to sit on his veranda and read such authors as Balzac, Ariosto, and Pablo Neruda. Intellectually at least, he had been obsessed with the Arctic since the age of ten, when he read a serialized account of the doomed Greely expedition in a men's magazine.

55

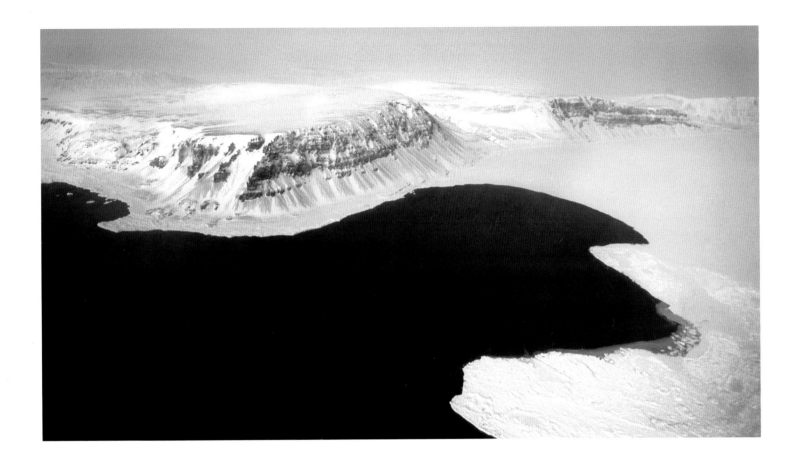

"I saw who survives, who dies, who becomes a criminal, who emerges as a hero," recalled Bob. "I felt the story showed me everything I needed to know about life, except how to deal with the opposite sex." He identified, in particular, with Sergeant David Brainard, who joined the army on a whim, after losing his wallet. Brainard distinguished himself at whatever he faced—sledding journeys, the starvation winter on Pim Island, and later, the army bureaucracy, where he rose to the rank of general. He was, as Bob put it, a master of destinies he did not choose himself.

An L.A. guy obsessed with the Greely expedition? And who, even more remarkably, was not writing a screenplay about it?

It was Arctic history that first brought Bob and me together. Two years earlier, on the kayaking tour I led to Alexandra Fiord, Bob had come to see what had obsessed him for so long. That was his first adventure tour, his first time in Canada, and his first vacation in a decade. Among the group, he became known as The Man Who Does Not Sit. He even ate standing, looking around, as if he didn't want to miss anything. One night, he

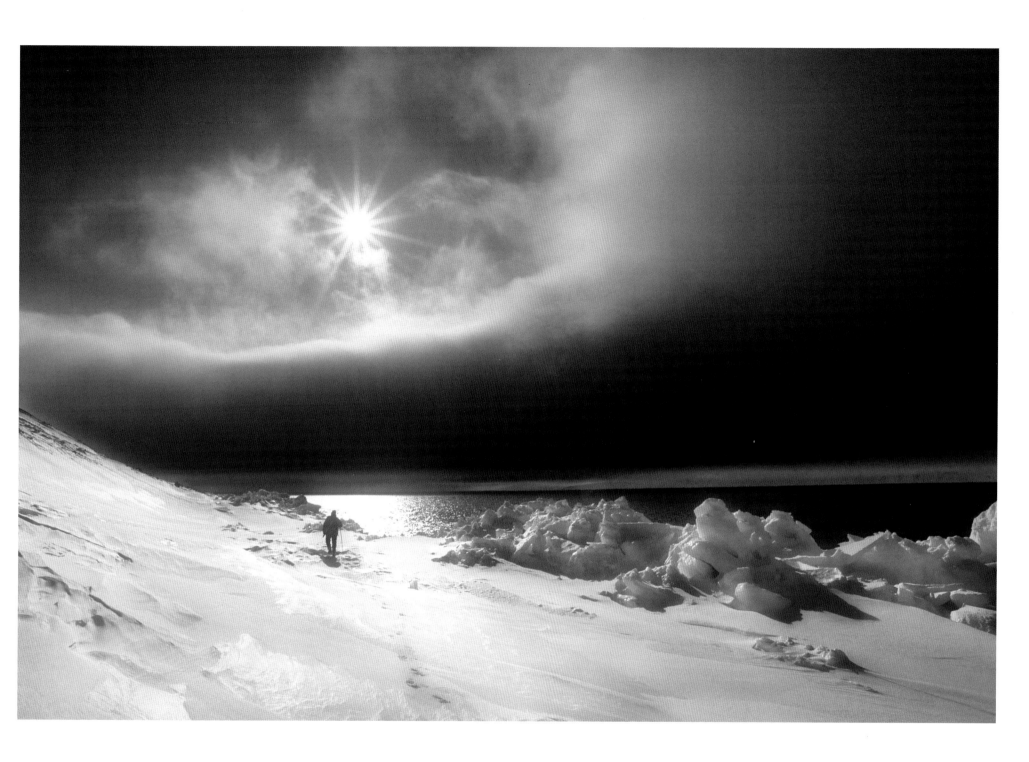

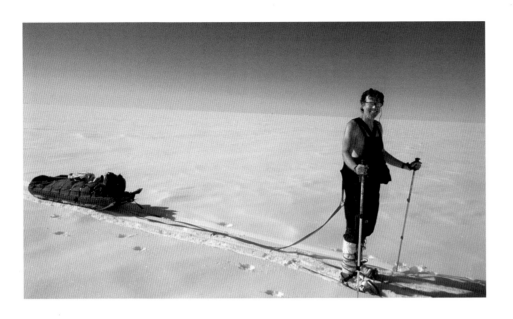

above "L.A. Bob" works on his tan while crossing Norwegian Bay.

right A walrus sunbathes beside its *aglu*, or breathing hole, near the Hell Gate polynya.

and I wandered the remains of Greely's Camp Clay for hours, poking around on our knees for bits of sailcloth, rusted cans, and other talismans in which lurked the ghosts of the place.

After the tour, we kept in touch. Bob was keen to see more of the Arctic, maybe even try sledding. Bob kept in shape by running and working out at a club, but such an expedition—in which we would ski and manhaul 140 pounds each in temperatures down to −22°F—was a very different beast from a commercial kayak tour. Years before, I'd had problems with novice companions. But more recently, my wife, Alexandra, had loved her introduction to Arctic travel and now often came north with me, so I felt I was on a roll with partners. Most important, I knew that the Arctic is not as hostile as its reputation suggests. You don't even have to know how to ski because you are just shuffling on flat terrain. All you really need is a little fitness, an equipment list, and a positive attitude. This last item may sound like motivational shtick, but it's true.

Still, it was a leap of faith for both of us in May 2005, when we stepped down the little ladder of our chartered aircraft onto frozen Walrus Fiord, on Ellesmere Island. Ahead of us lay 250 miles of sea ice and mountain passes en route to our destination— Grise Fiord, Canada's northernmost village.

The currents of the nearby Hell Gate polynya flush nutrients down the channel and nourish rich populations of birds, seals, and walrus. On this sunny spring night, a lone walrus basked on the ice beside its breathing hole, its thick hide scarred from conflicts with rival tusks. Clouds generated by the open water hung low in the distance, reflecting the black sea on their undersides. This water sky was an important visual cue for travelers. If icebound sailors saw this indicator of open water, they tried to maneuver toward it; dogsledders sought to avoid it.

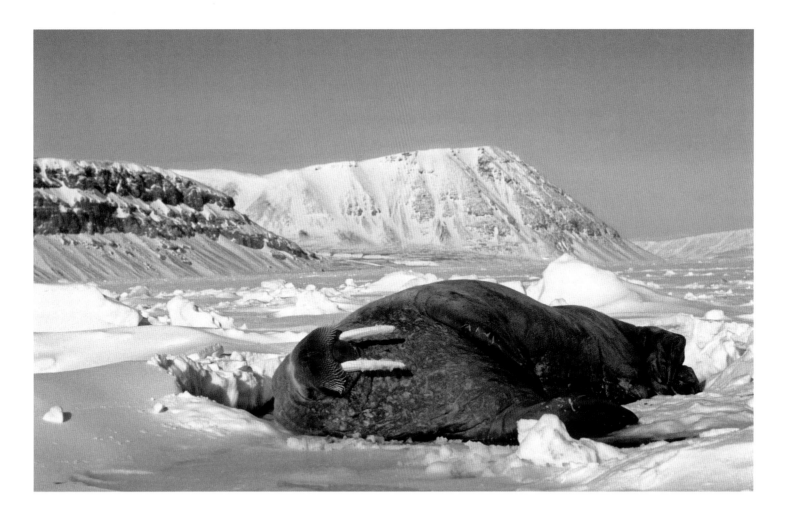

While I got supper ready, Bob stood outside in the −4°F temperature, drinking a cup of hot soup and watching with intense interest as the steam froze on his glove. Later I offered him a thimble of tequila, his favorite drink, but he didn't recognize it. "I've never had it cold."

In the twenty-four-hour sunshine, there is always time, if you have the energy, and after supper we explored the peninsula that separates Walrus Fiord from neighboring Goose Fiord. Explorer Otto Sverdrup spent four years on Ellesmere Island, including two in this area. The middle of this peninsula constricts to a wasp waist that Sverdrup called Outer Isthmus. In September 1901, one of his men, Edvard Bay, camped on this gravel patch for several weeks, guarding a cache of walrus meat until the sea froze and they could dogsled it back to the ship. One night, several polar bears raided the camp and splintered a wooden box of fossils before Bay shot one and scared the others off.

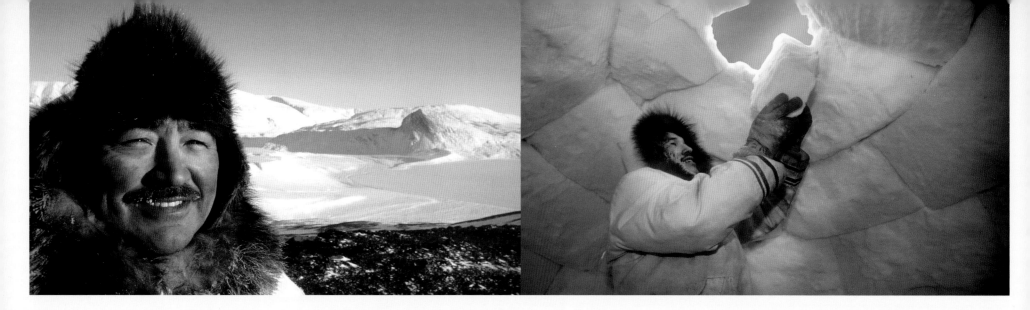

GRISE FIORD

GRISE FIORD, POPULATION 141, unless someone gave birth last week, began like Resolute, with quasi-volunteers from northern Quebec and Baffin Island in the 1950s. Cupped by two-thousand-foot cliffs, the hamlet juxtaposes modern and traditional; residents in sealskin boots surf the Internet over plates of Kraft Dinner and minced caribou. On a sunny May afternoon, the village may be almost deserted, as everyone snowmobiles to nearby Devon Island to fish for char.

The change from dog teams to snowmobiles came in the mid-1960s. Two or three teams remain for white polar-bear hunters, who legally must chase their quarry on this traditional conveyance. *Komatiks,* the wooden sleds attached behind snowmobiles, can only carry about a week's worth of gasoline, so Inuit hunting excursions last at most a few days. Meanwhile, the Polar Inuit of Northwest Greenland still travel with dogs and can stay out for weeks by hunting to feed themselves and their transportation.

Most people in Grise Fiord work at part-time jobs that keep the hamlet running. One person plows the airstrip. Two drive the water truck. There is a mayor and a wildlife officer. All but about ten residents are Inuit. The non-Inuit serve as police officers, schoolteachers, the nurse, or the store manager. Few stay longer than two years.

In a community where everyone knows everyone, privacy can be hard to find. "Jeanie fell and got thirteen stitches in her knee on Saturday, but look at her go," I heard one resident comment while gazing out her picture window. The analysis continued: "Flo is wearing those

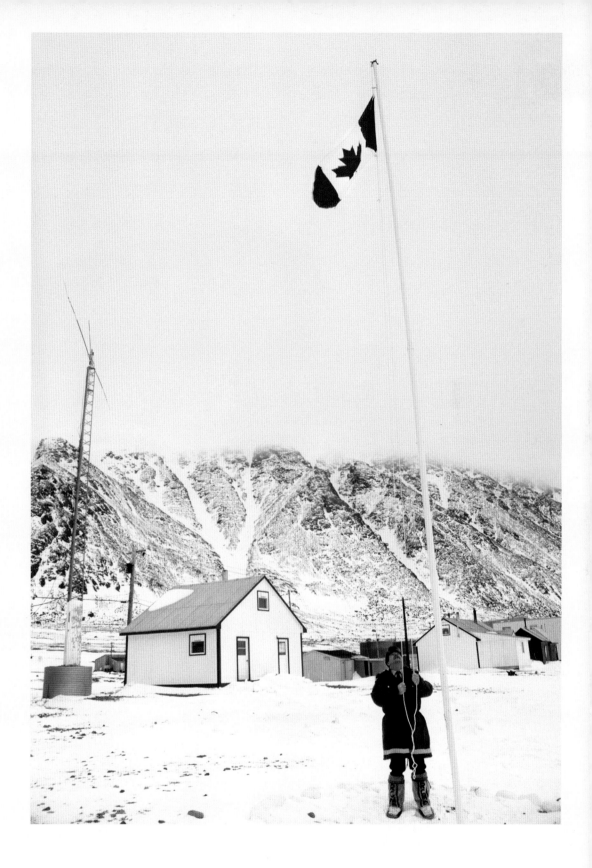

left Nunavut-government workers Seeglook Akeeagok, *left,* and Jeffrey Qaunaq, *right,* have retained many traditional skills, including hunting their own food.

right Mounties have been in the High Arctic since the 1920s, helping to secure the islands for Canada.

tight jeans again—she can barely walk." Her partner replied: "Joe is at the generator. He's got a wrench in his hand. I wonder if that means electricity problems."

A Twin Otter shuttles supplies and people from Resolute Bay twice a week. The two Royal Canadian Mounted Police officers handle mainly domestic disturbances. Once, a tourist reported that his backpack had been stolen. The officer was skeptical. The hamlet's isolation and the rampant sport of window gazing make theft rare. "I'm telling you, I left it on the hotel veranda, and now it's gone," insisted the tourist.

"Have you seen this man's backpack?" the officer asked a passing boy.

"Yeah," said the kid. "The wind blew it down to shore. Want me to get it?"

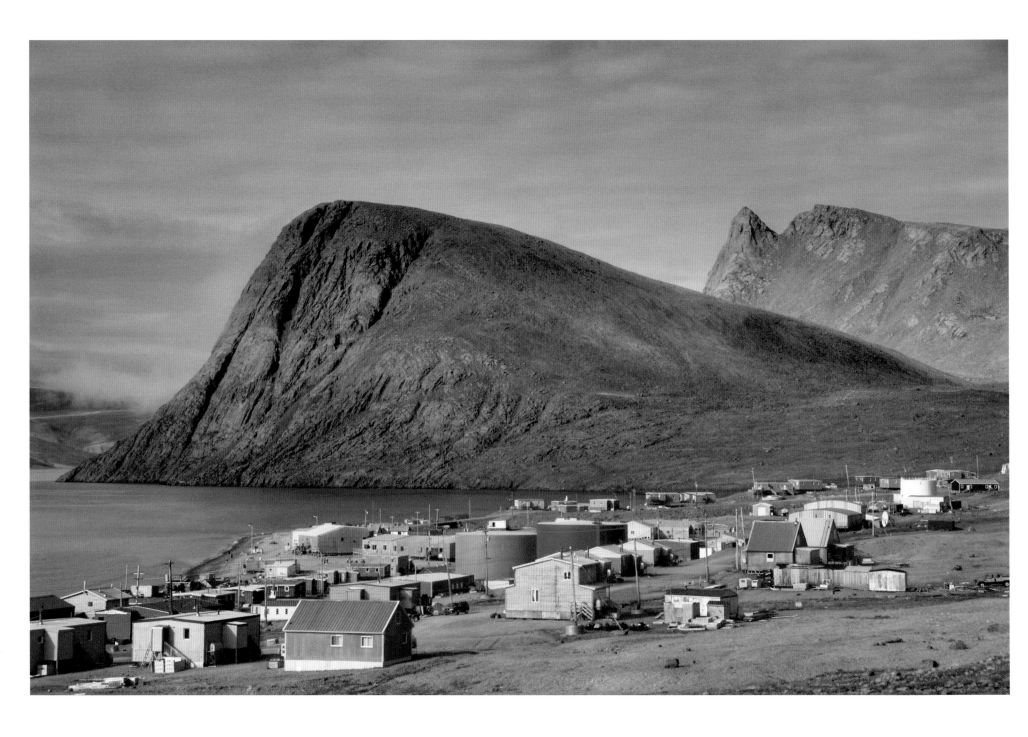

A hundred years later, we could reconstruct Edvard Bay's adventure from start to finish. A slight depression in the windblown gravel marked the outline of his tent; nearby we saw three spent shells and, a little farther, splinters from the box of fossils where the bear had jumped on it. Armed or not, Bay must have found it a daunting experience, since his rifle had needed reloading after every shot. After this encounter, Sverdrup assigned Bay a companion for the remainder of his watch.

OUR FIRST SLEDDING day was challenging: a long climb through narrow, bouldery canyons in which we often had to take off our skis and help each other's heavy sleds over snow-drifts. "My normal day doesn't resemble this at all," said Bob. Although the May sun-shine beat down, and I was hot in underwear and Spandex, Bob remained encysted in his balaclava, ski bibs, and fleece jacket. We made six miles—excellent progress for this picky uphill.

The sledding became easier over the following days, when we reached the endless white meadows beyond the height of land, then made our descent to the frozen sea. Sledding, unfortunately, does not promote conversation. The guy in front can hear the guy in back, but not the reverse. So we skied silently for a couple of hours, daydreaming or crafting comments to air during the next rest stop. We traveled about seven hours and averaged ten to twelve miles a day.

Bob's L.A. friends back home didn't know what to make of his new northern pas-sion. An Arctic sled journey was beyond the ken of most Los Angelinos. A few thought it was "trippy" and waxed rhapsodic about campfires and pine trees. Others asked why he wanted to go to Alaska, anyway. The topic of penguins came up more than once.

WHERE I LIVE in the Rockies, cross-country-skiing parents often tow their kids on small fiberglass sleds. But as a form of long-distance travel, sledding (also called sledging or manhauling) is so obscure that only two or three of us in North America do it regularly. Dogsledding is similar but more complicated. For starters, you need your own dogs. The so-called Eskimo dogs for Arctic travel are different from the ones that race the Iditarod.

left Two-thousand-foot cliffs swaddle Grise Fiord on three sides.

right "When I stay in one place, I can hardly think at all," wrote French philosopher Jean-Jacques Rousseau. "My body has to be on the move to set my mind going."

Eskimo dogs are a tough and semiwild northern breed. They are not pets. Because they sometimes attack kids and drunks, they are typically chained at the edge of villages. They're big animals with a high metabolism and need as much food as a skier. Sometimes, you have to charter a separate plane just for the dogs. Once you're out there with them, it's great; dogsledding is faster than manhauling and full of social subtext. The dogs bicker and maneuver like reality TV characters. But those who travel with them either live in the Arctic or spend their lives raising dogs on backwoods acreages in places like Minnesota.

Besides canoeing and sailing, manhauling is the only form of wilderness travel that allows you to carry six or eight weeks of supplies. But you can't sled just anywhere. The snow is too soft in sheltered woods, and uphills are too hard, except in small doses. Sledding needs flat, open country—Arctic terrain. Here, wind and cold transform powder snow into a hard surface over which a heavy sled glides easily. Ralph Waldo Emerson called this snow the north wind's masonry.

British explorers began the practice of manhauling in the mid-nineteenth century. With the twisted logic for which the British became known in the polar regions, they considered hauling with dogs cruel, so they used men instead. Early manhauling results were encouraging. On John Ross's 1848 expedition, Robert McClure and Francis Leopold McClintock hauled five hundred miles in thirty-nine days. In 1853, George Mecham averaged sixteen miles a day for seventy days, with a light sled. (He hunted en route.)

The British made little attempt to minimize loads through efficient design, and later expeditions, in which teams of men attempted to drag fifteen-hundred-pound sleds through soft snow and over rough ice, did not fare so well. Norwegian sleds of that era, in contrast, weighed a fraction of British models. The British also carried far too much; instead of cutting the ends off their toothbrushes, they brought the kitchen sink. I noticed the same style in contemporary British travelers. They have a cultural connection to the Arctic that we North Americans lack, but their travel philosophy remains: why bring a four-inch nail when an eighteen-inch one will do?

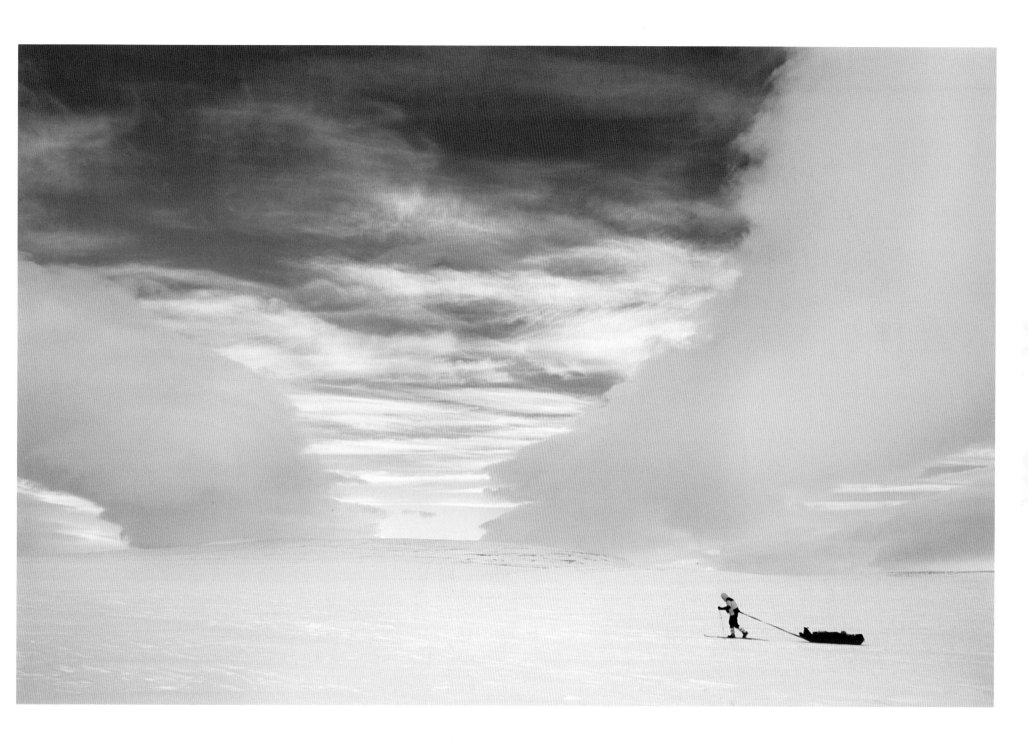

A Good Climate for Loafing 65

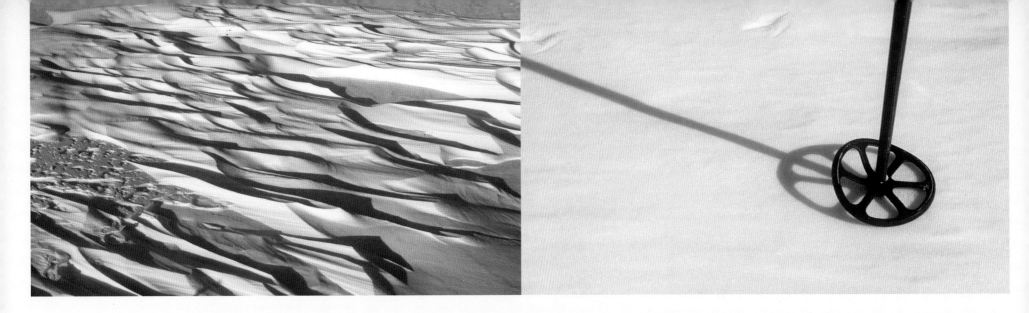

THE THIRTY-THREE SNOWS

WHAT A PITY that the old saying about the Inuit having thirty or fifty or a hundred words for snow isn't true. Inuktitut has the same number of words for snow that English does, about a dozen. English terms include sleet and slush, while Inuktitut has snow on the ground, falling snow, and snow on clothing. None of the Inuktitut words illustrates the cultural idea behind the myth—namely, that the world you live in gives you a specialized perception expressed in language.

Yet even someone like me who merely travels the Arctic recognizes many varieties of snow, beyond generic types such as sastrugi, which is hard, wind-sculpted snow resembling frozen whitecaps. Snowmobilers or even dogsledders might not need so finely parsed a vocabulary, but such nuances are vital to a walker. Here are the thirty-three types of snow that merit their own word.

1. Snow that's windpacked almost as hard as ice. The tip of a ski pole barely makes an impression. It's the best sledding snow—you can easily haul 350 pounds across it—but it's so slippery that falling is common.
2. Hard snow on the upwind side of sastrugi.
3. Slightly softer snow on the downwind side of sastrugi.
4. Breakable crust that's just strong enough to support walking.
5. Breakable crust that requires skis.

6. Snow above 32°F that globs onto the bottom of sled runners and climbing skins.

7. Airy new snow that's easy to pull through, even when deep. Some fresh Arctic snow is 98 percent air and is as light as handfuls of dandelion floss.

8. Two-day-old snow that has settled and, though not as deep, is much harder to pull through.

9. Older snow that has, despite a lack of wind, settled enough that it is no longer an obstacle to travel. Happens after about a week.

10. Soft snow on the sheltered side of blocks of sea ice.

11. Drifted snow that has begun to form sastrugi or windpack but needs more wind to turn fully hard.

12. Snow that conceals cracks in the sea ice, through which your foot plunges unexpectedly.

13. Soft snow that looks hard even to an experienced eye. An irritating variety.

14. The first light snowfall on mountaintops in late August. Some call this termination dust, because it marks the end of summer.

far left Snow 25: The troughs of these wind-sculpted snow waves, or sastrugi, range from a few inches to two feet deep.

left Snow 1: So hard that a ski pole sticks upright and footprints are reduced to faint scuff marks.

below Snow 5: Breakable crust almost supports a walker, but not quite.

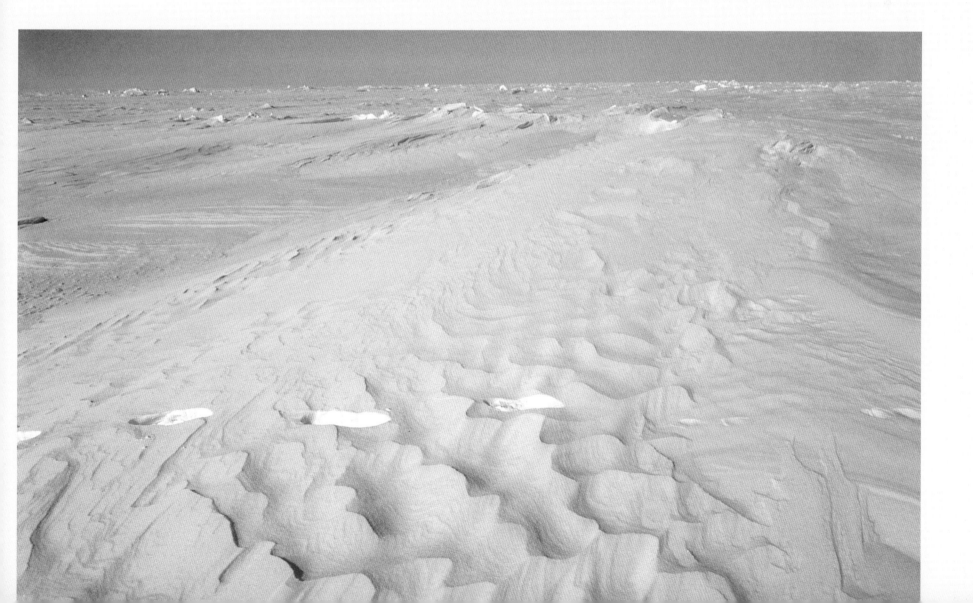

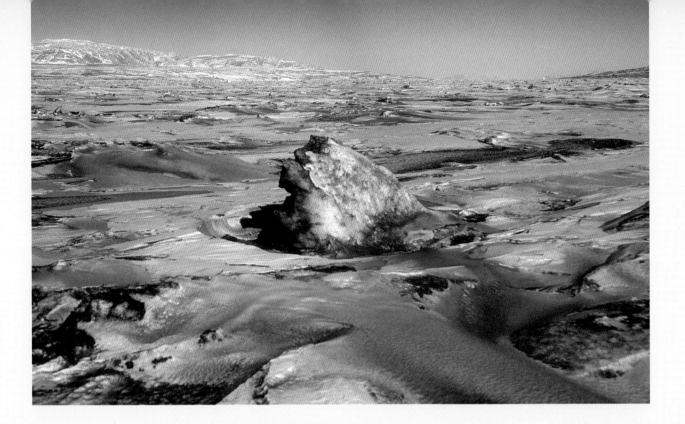

15. A scurf of new snow over hard snow. It doesn't affect sledding except in extreme cold, when the new crystals add serious resistance.

16. The slightly softer snow that a snowmobile's passage creates over hard snow.

17. Snow that disappears from the land prematurely. Common in mountain passes, where dark slopes act as solar reflectors that sublimate the valley snow or where concentrated winds blow it away.

18. Snow that remains most of the summer on north-facing hills. Some explorers mistakenly called these semipermanent snow slopes glaciers.

19. Snow impregnated with windblown sand.

20. Igloo snow: hard, uniform snow that is ideal for staking a tent or block cutting.

21. Saturated snow of a certain density that piles up in front of a sled and is impossible to pull through.

22. Giant low sastrugi, shaped like enormous boomerangs, but without much vertical relief. The angle of the boomerang points downwind.

23. Sharp sastrugi, small and steep-sided.

24. Sastrugi oriented parallel to the direction of travel. Decent sledding by walking along the hard wave crests.

25. Sastrugi oriented perpendicular to the direction of travel. Bumpy going.

26. Granular snow that doesn't hold tent stakes well. Sometimes called sugar snow.

27. Snow on the summits of nunataks that has been polished by wind and glazed by sun into pure ice.

28. Remnant sastrugi at the end of a warm spring, where thin icy crusts, like eggshells, are all that remain.

29. A snowfall that is not followed by a wind when the weather system changes.

30. Snow crystals that fall from a clear sky in early spring.

31. Flat wind-packed snow, without sastrugi.

32. Snow with no shadows to define it. Common on overcast days in the Arctic. The snow appears so featureless that you can't even tell when you're going uphill, except by how hard the pulling becomes.

33. Snow on top of open ocean, concealing an unexpected absence of sea ice. Sometimes the snow is hard enough to walk over until you fall through a weaker section into the sea. Fairly rare but scary enough to keep in mind.

left Snow 19: Windblown sand dirties what explorer Otto Sverdrup called Mokka, or Muck, Fiord.

below left Snow 15: In cold weather, even a dusting of new snow creates significant friction for a sled hauler.

below right Snow 24: Sastrugi parallel to the direction of travel allow for less bumpy sledding than if the waves were lying across one's path.

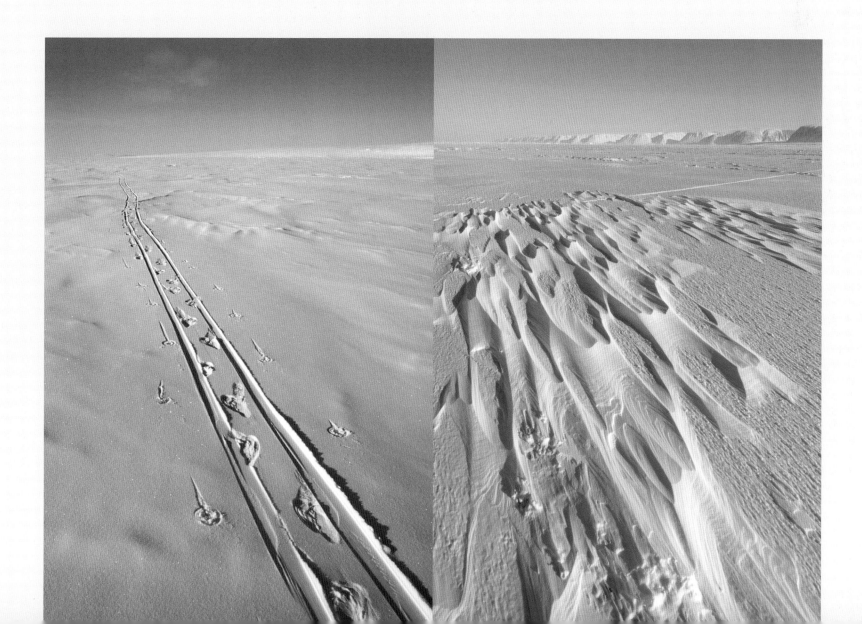

above Bob Cochran unwinds with a cigar at the end of a long sledding day.

right Manhauling is one of the only modes of wilderness travel that allows one to carry two months' worth of supplies.

NEAR THE SEA, Bob and I sledded past a site I'd visited once before. A hundred years ago, Otto Sverdrup dogsledded through an ice cave underneath a glacier. When I first passed this way in 1988, the cave was a third of a mile long and magnificently lit by skylights where the roof had collapsed. Since then, it had changed only slightly, and we spent several hours inside it, lost in wonder. "If I mention Sverdrup's Ice Cave to anyone in L.A.," said Bob, "they'll ask, 'What's that, a nightclub?' "

Early on this trip, I noticed that The Man Who Does Not Sit actually did sit down at the end of the day. Then he lit a trademark cigar. The twenty-four-hour sun baked the tent as we slept, so despite the outside temperature of –13°F, we hardly needed our superwarm Arctic bags. Our food was basic hard-work fare—lots of fat, lots of sweets. The key is *lots*. Unlike the members of the Greely expedition, no one went hungry. I ate a pound of chocolate a day; Bob, about two feet of dried sausage. A family-sized box of Harvest Crunch granola lasted us a breakfast and a half. Bob found these marathons meals "amiably taxing." To me, his comments sounded positive, although I'd been wrong before.

There was a time when I couldn't conceive of anyone not liking sledding. Thousands of people backpack, and to me pulling a sled was easier. Sure, –40°F might be challenging for some, but -4° or -13°F—typical spring weather—was fine with the right gear. Then one year, my novice partner experienced a kind of mental meltdown after just one day on the trail. He hated everything about sledding: the ox-in-the-yoke feeling, the cold,

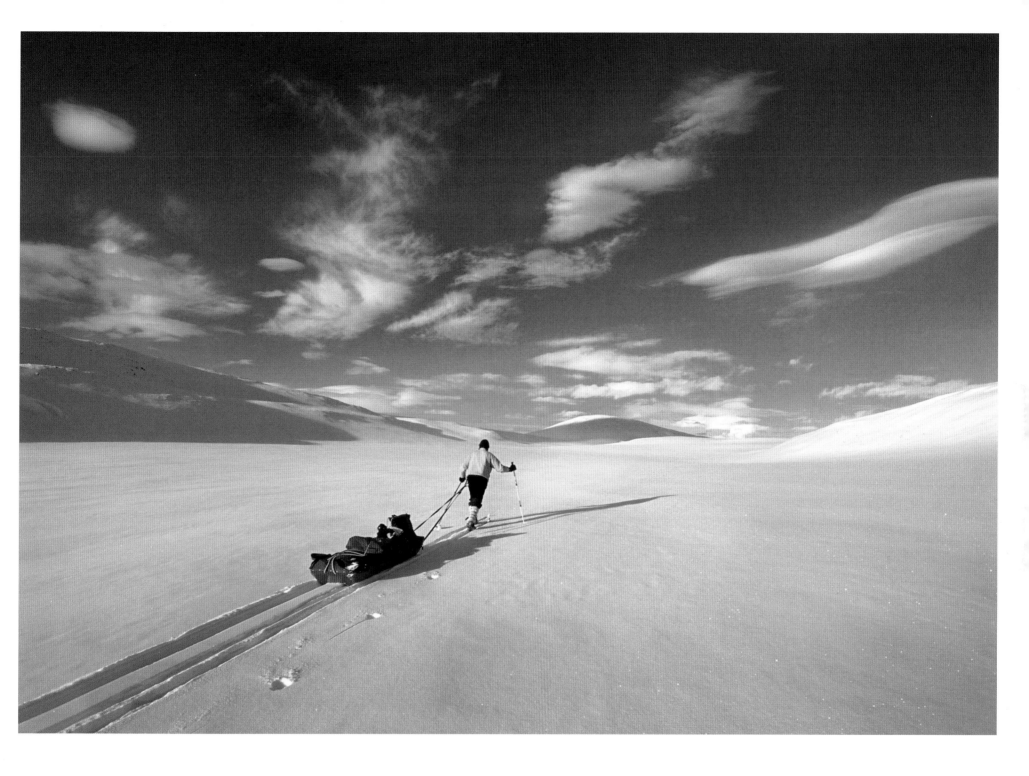

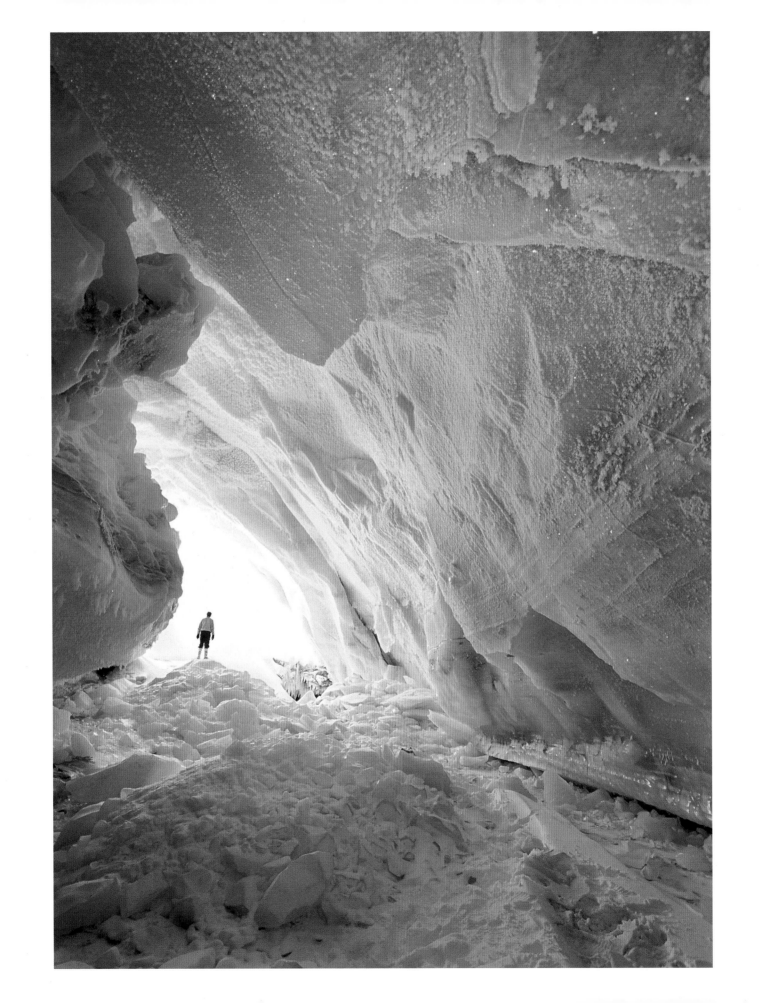

left "It was like fairyland, beautiful and fear-inspiring at the same time," wrote Otto Sverdrup upon discovering this ice tunnel in 1900.

below Tons of glacier above his head, Bob Cochran reemerges into the light after exploring the one hundred-year-old ice tunnel.

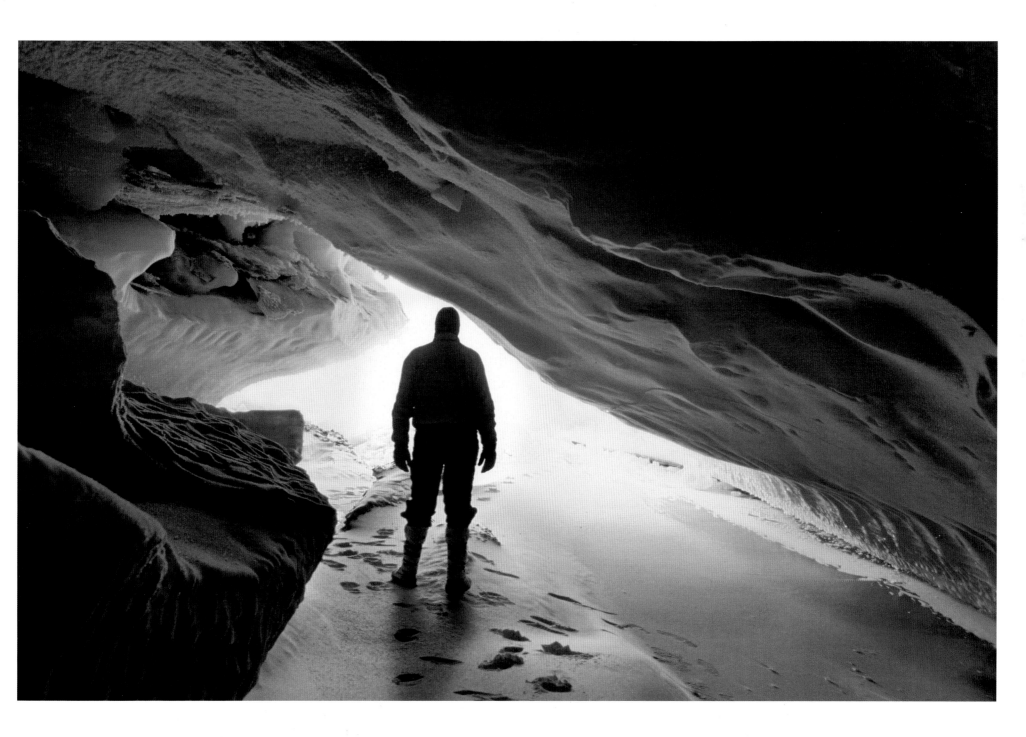

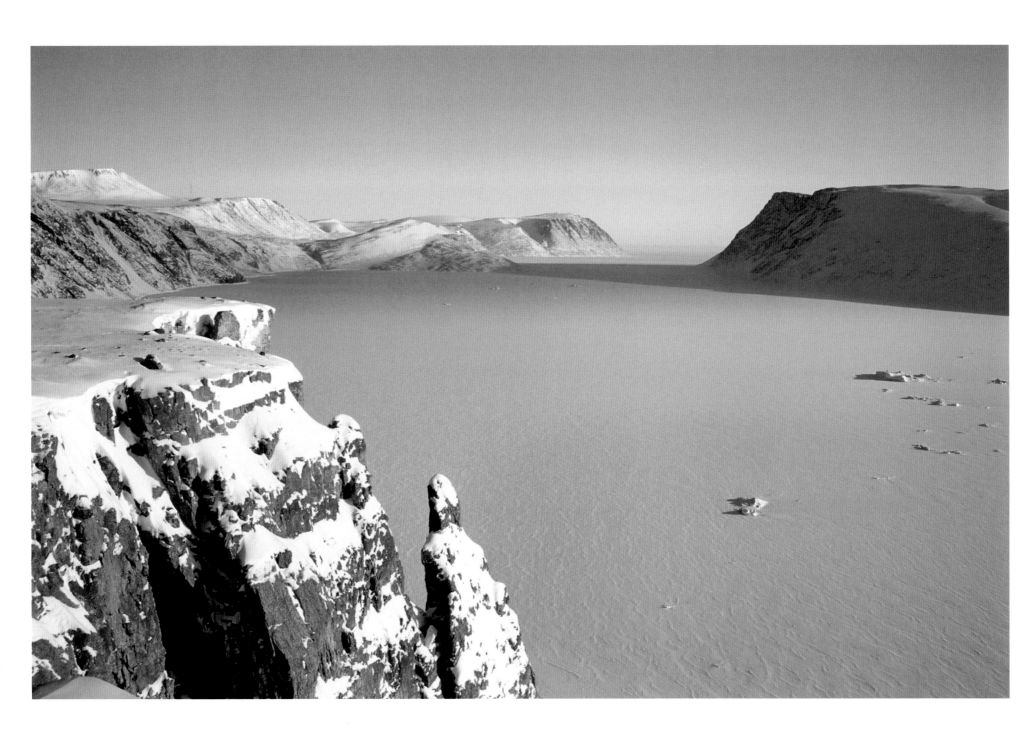

his sunglasses frosting up from sweat till he could barely see. Another partner new to manhauling was mentally tougher, but we just didn't get along. Finally, I had to admit that sledding was stressful and that finding the right partner was not easy.

During the sledding day, I have to go to a special place in my brain and live there. It is a place where monotony, fatigue, and discomfort don't exist. It always takes me an hour or so every morning to find it again, but at least I know it's there. It's a refuge, but it's also an escape from who I normally am and one of my reasons for doing these treks.

Somehow Bob tapped into it, too. He got the Otherness of it all. "We're using ourselves to carry us somewhere, which is kind of weird," he said one day. I came to believe that it was his past training in the Marines that gave him such ready access to this place.

"How does this compare to jungle warfare training in Panama?" I asked during one break.

He thought a little. "Jungle training felt like play. This is more like war. It's the real thing."

I'D DONE A dozen sled trips longer than this one, so I had some perspective on 250 miles. You just have to retreat to that special place in your brain every day for about three weeks, and you're there. One morning, after studying the map, I mentioned that if we put in a couple of longer marches, we should be able to time our arrival in Grise Fiord to catch the Wednesday flight out, six days from now. Bob didn't say anything but later admitted realizing for the first time, "Oh, I guess we're going to make it, then."

After two weeks, Bob had remained the same polite gentleman he was back home. He still apologized whenever he farted, even if he was twenty yards away. On such a journey, where rich diets turn everyone into backfiring jalopies, that was remarkable.

By day twenty, we both looked pretty ratty. Bob's mane of hair was gelled for the first time with natural grease rather than mousse. But our legs looked like they'd been chiseled by Praxiteles. On a sunny Wednesday morning, Bob skied into Grise Fiord, master of a destiny he did not choose himself.

left The frozen sea, like this inlet near Grise Fiord, has served as the traveler's highway for centuries.

A Good Climate for Loafing 75

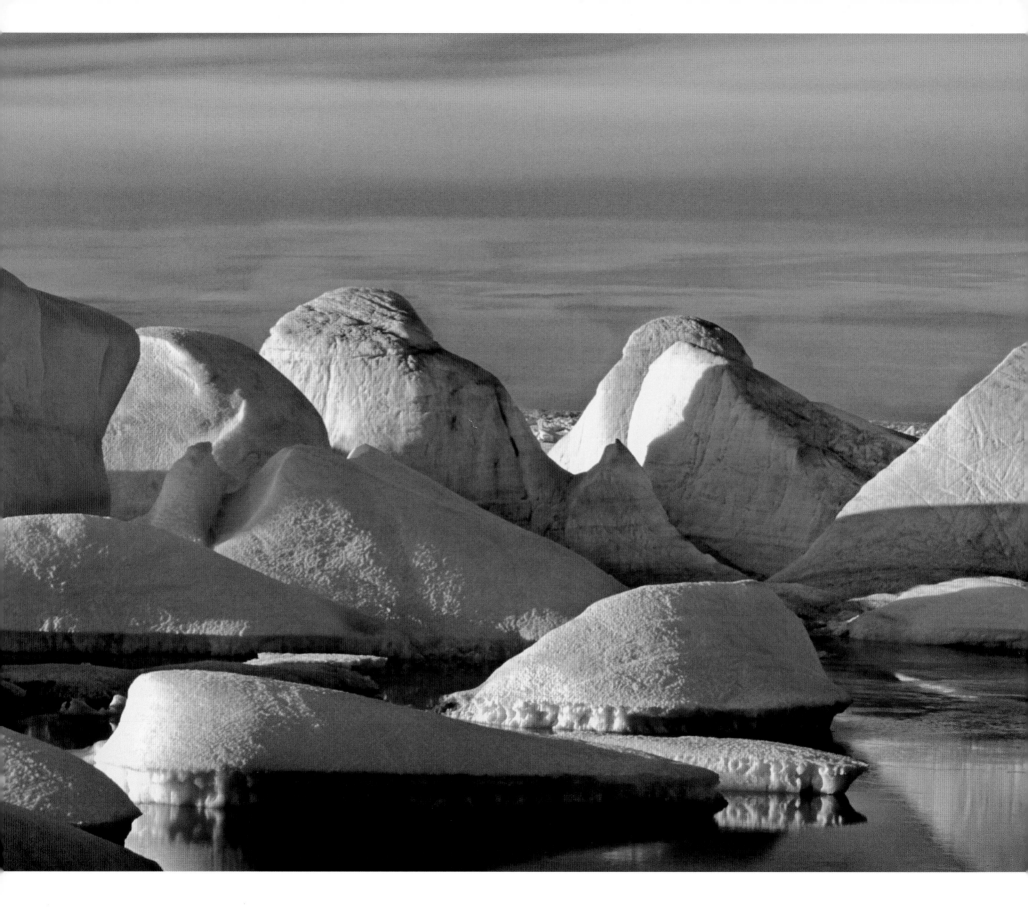

THE THICK multi-year ice, or floebergs, that stymied and sank explorers' vessels is now disappearing as the North warms.

"Oh, would you know how earth can be

A hell—go north of Eighty-three!"

ROBERT SERVICE, *Death in the Arctic*

4 | EDGE OF THE POLAR SEA

ALTHOUGH THE High Arctic often inspires comparisons to Mars, its north coast is
more like Neptune. An ice world. Mountains of frozen methane, seas of liquid
nitrogen. Space suit required. With all due respect to the poet laureate of the
Yukon, the Arctic appeals, in part, because of that alienness. Whether it transports us to
Mars or Neptune, it makes us feel like astronauts.

Only the northernmost land on earth—the rugged final capes of Ellesmere Island and
Greenland—attains the far-flung latitude of 83°. From here, an imperfectly frozen ocean
stretches to the North Pole and beyond to Russia.

At 83°06′, Ellesmere's Ward Hunt Island lies just shy of nearby Cape Aldrich, the
northernmost point of Canada. To safely pierce the thick layers of stratus that enveloped
the island, our pilot veered over the Arctic Ocean so that we couldn't fly into a hillside.
He lowered the plane until he spotted a hole in the fog, then dove for it. Once below the
ceiling, we skimmed so low over the ice that a standing polar bear could have swatted us

out of the sky. I have heard commercial pilots dismiss flying as driving a taxi in three
dimensions, but our masterful pilot squeezed a landing out of conditions that no jet crew
would have attempted. Dodging patches of ground fog, he touched down amid a spray
of gravel near some quonset-style huts that date back to the military use of Ward Hunt
Island in the 1950s. A lone white wolf, feeding on the canned rations that still littered
the site, slipped away like a ghost as we taxied.

I had joined the wardens of Quttinirpaaq National Park, who come here once a
summer as part of a cleanup and maintenance program. Because of its military history,
Ward Hunt Island does not yet officially belong to the park, but its wardens look after it.

We stayed for three days. I helped drag some of the old garbage into a pile to be
burned and watched the head warden paint the outhouse Day-Glo orange as a private
joke: "It'll give expeditions returning from the North Pole something to look forward to."

BECAUSE THICK ICE kept ships from coming within six hundred miles of the North Pole,
its very nature puzzled geographers for centuries. Was it on land? On water? Was there
a hole at the North Pole leading to the center of the earth? Did a navigable Open Polar
Sea lie beyond the barrier of ice? Academics and admirals made crisp assertions based
on pet theories, but no one had any real idea until the late nineteenth century. By then,
enough expeditions had chipped away at the mystery to make it reasonably clear that the
North Pole sat in the middle of a mostly frozen ocean. This realization did not diminish
the quest to reach the Top of the World. The North Pole had become iconic and reach-
ing it one of the unattained summits of human endeavor.

In 1909, Americans Frederick Cook and Robert Peary both independently
announced that they were the first to reach the North Pole. Their claims are now dis-
credited—Cook's within a few months, Peary's only in our time. The debate polarized
the world; whose side you took said a lot about who you were. The personable Dr. Cook
became the people's choice, while Peary, who aligned himself with politicians and
captains of industry, emerged as the establishment hero. Even today, a few people who

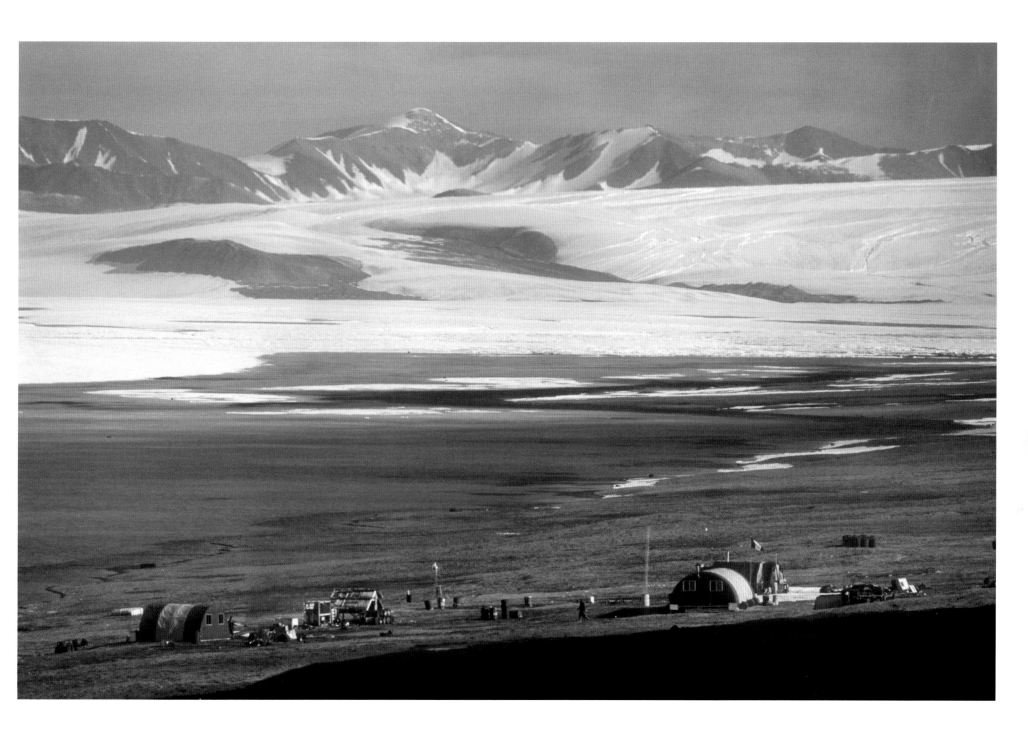

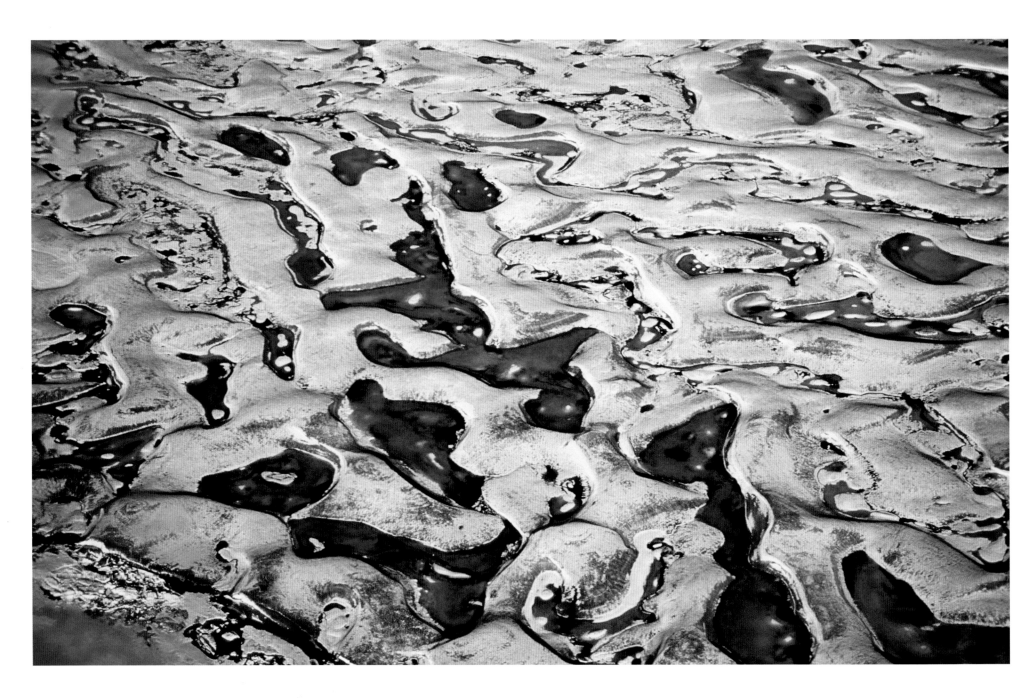

ARCTIC EDEN

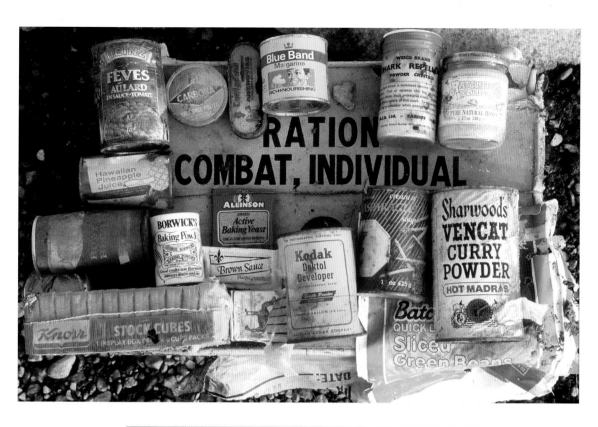

RATION COMBAT, INDIVIDUAL

far left Meltwater pools on the three-thousand-year-old Ward Hunt Ice Shelf can measure up to a quarter-mile wide.

left Quirky garbage left on Ward Hunt Island by modern North Pole expeditions includes shark repellent, shoe polish, and something simply called Brown Sauce.

below The world's northernmost outhouse.

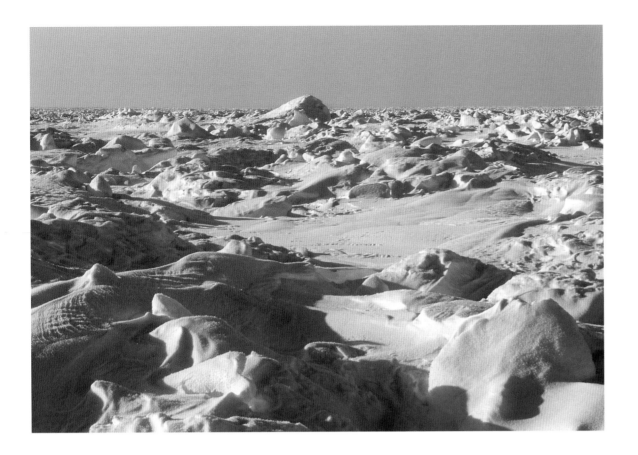

regard the Polar Controversy as a morality play pitting the individual against the system defend Dr. Cook, while Peary supporters have tended to be, like their icon, opportunists who want something for their allegiance, such as sponsorship or media attention. And there are earnest people on both sides who just don't read a lot.

When I began traveling the Arctic in the mid-1980s, the debate about Peary was alive, sort of. Or maybe I just hadn't read a lot yet. While most of Peary's early supporters, such as the *New York Times,* had embraced objectivity, the National Geographic Society continued to vigorously defend his claim. It was as much about loyalty to their own past as to Peary. In Peary's day, *National Geographic* had a brilliant idea: promote an up-and-coming hero, and when he or she achieves success, the magazine gains from its association with the famous figure. Peary was the first in this line of celebrities that continues to this day—Jane Goodall, Louis Leakey, Will Steger, and many others, in many disciplines, owed their support to a star-making policy that dates back to Peary.

Understandably, *National Geographic* has been reluctant to disavow the person who helped transform the small academic publication without photos into a powerhouse. If you were a polar traveler and you wanted the support of the world's most famous magazine, you had better toe the Peary line—and so many did. But in the last twenty years, in the face of more available documents and unbiased scholarship, the question marks

became too big to ignore, and most sources stopped repeating the old mantra that Peary discovered the North Pole.

Even *National Geographic* began to squirm, and in 1988 it printed an article by polar traveler Wally Herbert delicately suggesting that Peary had fallen a little short. The magazine later regretted that decision and commissioned a strange piece that played with numbers to conclude that Peary had hit the target after all. But doubts continued to creep into its mentions of Peary. It began to emphasize his iron will rather than his putative success. Finally, in 2009, for the hundredth anniversary of Peary's expedition, *National Geographic* did the unthinkable—nothing.

I never believed that Peary had reached the Pole or even come within a hundred miles of it. The most cursory glance revealed Peary as someone who couldn't be trusted. He liked to tyrannize other people—the Inuit, his own men, rival explorers. He was, down to his thick moustachios, a sort of Stalin of the Arctic. None of this bears any relation to his veracity or lack thereof, but it prompts a tougher scrutiny, since such people do not regard truth in the way that most of us do. If truth clashes with their place in history, they subvert truth to mean almost anything.

The strongest arguments against Peary have less to do with the details of his trek than with his character and overall track record. Yes, the speed with which he supposedly reached the Pole after he sent back everyone who could verify his progress was suspicious. Yes, the blank pages in his journal during his supposed time at the Pole are hard to fathom—his exuberant "The Pole at last!" was written on a loose-leaf page slipped in much later. He failed to take key navigational sightings. And would someone who had

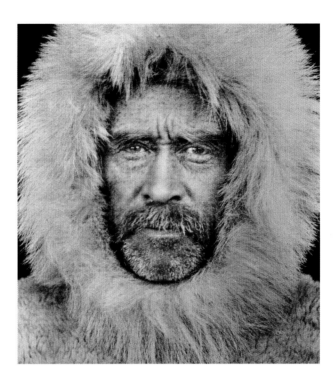

above and left A master self-promoter, Robert Peary, *above,* planned this publicity photo of himself with "face unshaven," to appear more rugged. As an explorer, he was less successful, and modern historians dismiss his claim to have reached the North Pole over the Arctic Ocean, *left,* in 1909.

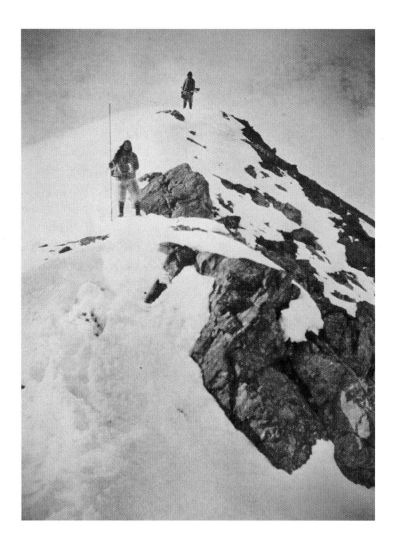

strived for a decade to reach a single goal shut himself up in his cabin for days after his return to the ship without a word about his success to anyone? It sounds more like the behavior of someone trying to swallow a bitter pill.

But most damning, Peary's previous expeditions reveal a lifelong pattern of deception. He publicly claimed that he had reached the northern tip of Greenland on an early trip, but a suppressed page of his journal confides disappointment that he'd only made it as far as a "puny" fiord, far from Greenland's terminus. In 1906, after another failed attempt to reach the Pole, he allegedly discovered Crocker Land, a nonexistent island off Cape Colgate, in northwestern Ellesmere.

Sympathetic sources later claimed he'd seen an Arctic mirage. But I've been to Cape Colgate, and I've even photographed a mirage of land there. Arctic mirages occur on every calm, sunny spring day and are easy to distinguish from the real thing. They are as evanescent as auroral curtains. No one of Peary's experience could mistake them for land. He invented Crocker Land to bring home a token of success and to ensure sponsorship for another attempt at the Pole. Peary cooked his books on other expeditions as well, just as we students used to do in high school chemistry class, when our lab experiments didn't give us the results we wanted.

To doubt Peary, you don't need to read a slew of books or sled six thousand miles. Mainly, you need a bullshit detector in good working order. Experience confirms that it's the story that smells rather than your own prejudices.

left and below Peary and two Inuit helpers built a cairn atop Cape Colgate, on Ellesmere's north coast, and left behind these bamboo wands.

ARCTIC EDEN

left and below Sledder Graeme Magor celebrates the view west from atop Cape Colgate. Peary claimed to have seen land to the north from this summit, but although remarkable mirages, *below,* often appear here, they wouldn't fool an experienced eye.

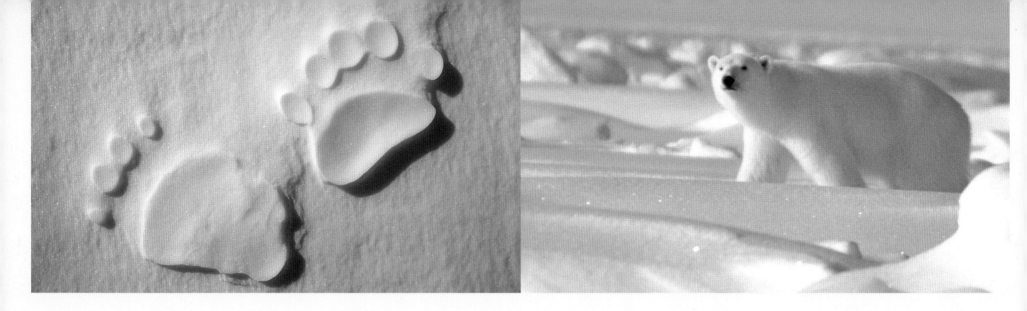

DEALING WITH POLAR BEARS

EVERY ARCTIC VISITOR wants to see a polar bear, just as tourists in East Africa are not content until they have seen a lion. Since the polar bear has become the poster child of global warming, its appeal has increased.

News stories focus on starving polar bears and dwindling populations. This is true in the Beaufort Sea and western Hudson Bay, but in the eastern Arctic, their numbers have increased, according to scientists and Inuit.

The Discovery Channel view of polar bears as "adorable" or "cute" ends the first time one drops by your camp. Arctic travelers—unlike BASE jumpers and Formula One drivers—are not risk junkies. The Arctic attracts us for its contemplative thrills. It's for those who like to walk

and think amid beauty. If a frightening incident occurs, it feels like a failure and a distraction.

Unless you spend a lot of time kayaking among walrus, polar bears are the Arctic's lone unpredictable danger. I live in grizzly country; grizzlies can kill you too, but they are not as dangerous. Grizzlies want to be left alone, and their disputes with people are mainly territorial. But polar bears look at you as food. As a result, you don't try to appease a polar bear as you do a grizzly. You stand up to it. It is a policy of aggressive defense: Churchill, not Chamberlain.

Everyone who travels the Arctic—Inuit, scientists, outfitters, adventurers—carries a firearm as a last line of protection. A responsible traveler, however, usually manages to scare the

bears away with nonlethal deterrents. It would be tragic to have to kill a polar bear.

The good thing about polar bear encounters, as opposed to grizzly attacks, is that they tend to unfold slowly. The polar bear ambles toward you rather than charges. It lowers its head, and its little stone eyes bore into yours. If you succeed in checking its approach, it may circle some twenty yards away while it makes up its mind whether to attack or retreat. This agonizing standoff can last half an hour if the bear does not frighten easily. It is a miserable experience, and I take no pleasure in it. It has taught me that polar bears are not blank slates on which to project one's idealism about nature.

At night, I position my sled so that a wandering bear happens on it first. Usually, the food in the sled distracts the bear before it reaches the tent. This gives me time to hear the disturbance. But the need to confront polar bears with flares or noise or rubber bullets before the situation escalates into a fatal encounter for one of us has meant that I have few good photos of them. When a bear approaches closely enough to photograph, I am too busy trying to intimidate it to take its picture.

far left A polar bear tamps down the snow, then the wind blows away the loose crystals around the tracks, leaving a trail of bas-relief prints.

left A curious polar bear approaches the author.

below A mother polar bear leads her two cubs away from unfamiliar human scent.

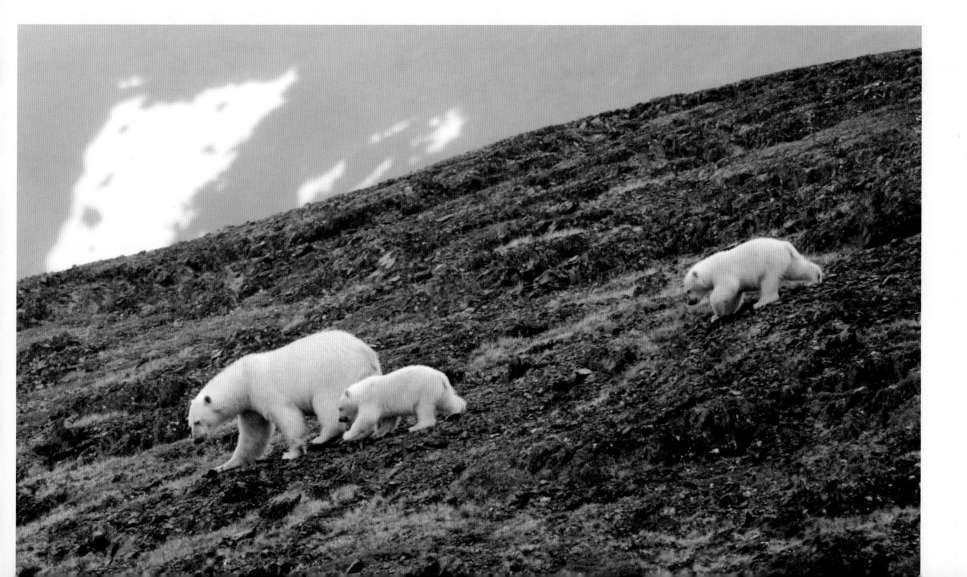

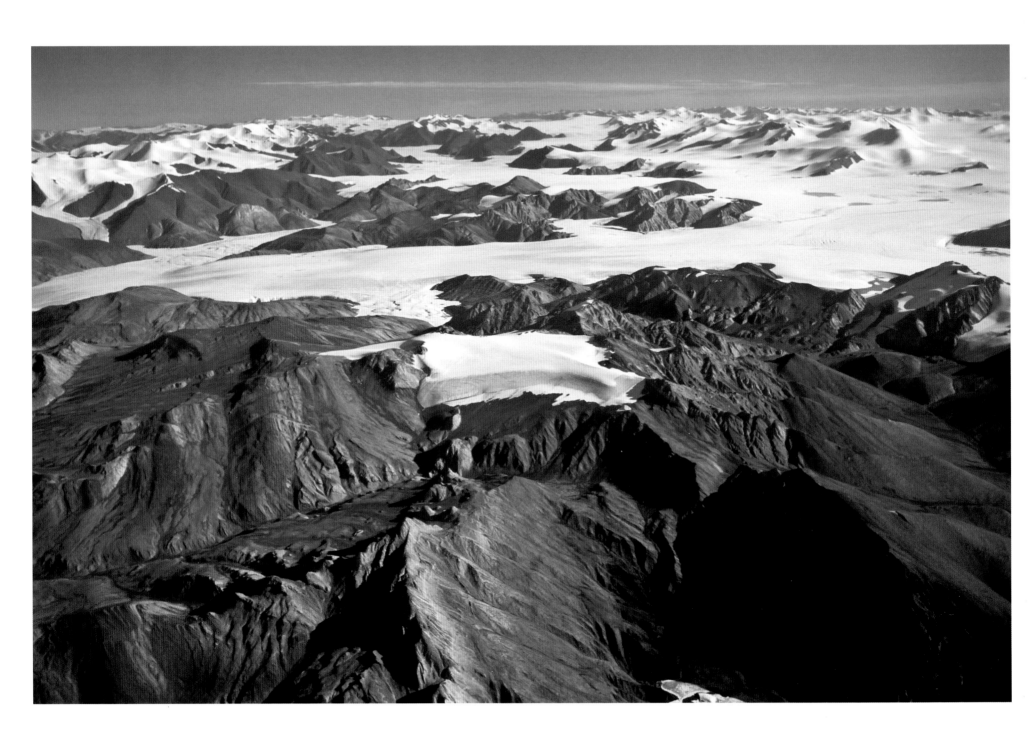

ARCTIC EDEN

But Peary pioneered one modern fashion. Despite his modest achievements, he became one of the most famous men in America. He was perhaps the first celebrity to become famous for being famous. In that sense, he has more in common with Paris Hilton than with Stalin.

PEARY LAUNCHED HIS controversial journey from Cape Columbia, but most modern expeditions leave from nearby Ward Hunt Island. They ski the 476 miles to the Pole in March and April, when bitter cold still stitches the broken ice together.

At first, I too wanted my crack at the Pole, but to afford the drop-off and pickup flights, you had to be wealthy or else be a dogged fundraiser, and I was neither. In time, a few strong, competent athletes accomplished most of the good North Pole goals—in particular, the first confirmed round trip—and I lost interest in the route even as I became more interested in arctic history.

I came to recognize that in a way, skiing to the North Pole was an entry-level challenge. That's not to say it's easy—it's not. But it appeals mainly to those who have little or no experience and who, like Peary, have professional motives—to become a celebrity or to launch a career as a motivational speaker or guide or, my own original reason, to advance a life of adventure, which I eventually realized through writing and photography.

Today, the North Pole has become a kind of circus, where ambitious clients pay guides to lead them, or solo trekkers strike off with twenty-one-gun hoopla, only to quit after a few days when the conditions prove too much. The North Pole makes the tick list of every fame seeker who wants to bag a high-profile but nontechnical series of challenges: North Pole, South Pole, Mount Everest—or North Pole, South Pole, Seven Summits. Some pretend or believe that the Peary-Cook controversy still lives and that their expedition proves something about it. Since the media don't scrutinize the claims of adventurers with the same care that they analyze important news, the dead debate revives briefly almost every spring, as expeditions sic their PR releases on unsuspecting reporters.

left Rarely seen and never climbed, the iron-stained mountains of Ellesmere's British Empire Range signal the end of the continent.

below A trail of wreckage marks the remains of a military aircraft known as Boxtop 22. The 1991 crash near Alert killed five but fortunately spared thirteen.

right Glaciers and barren peaks make much of Ellesmere's austere north coast uninhabitable.

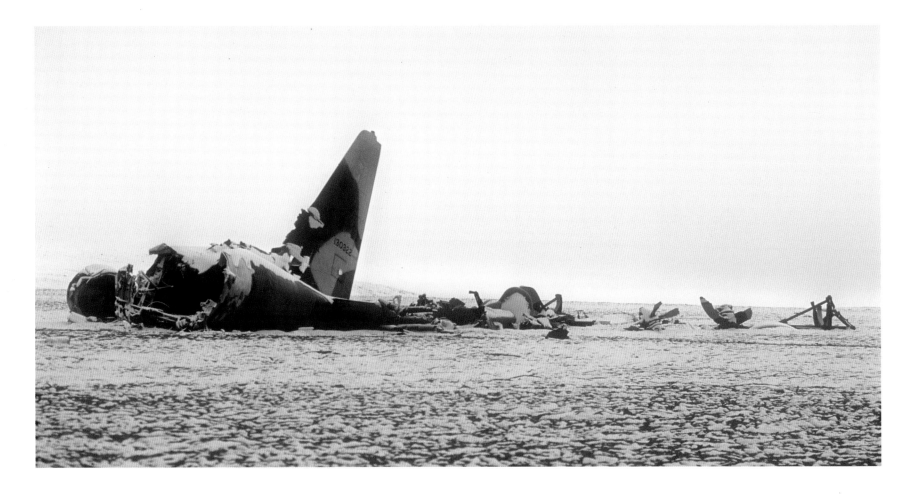

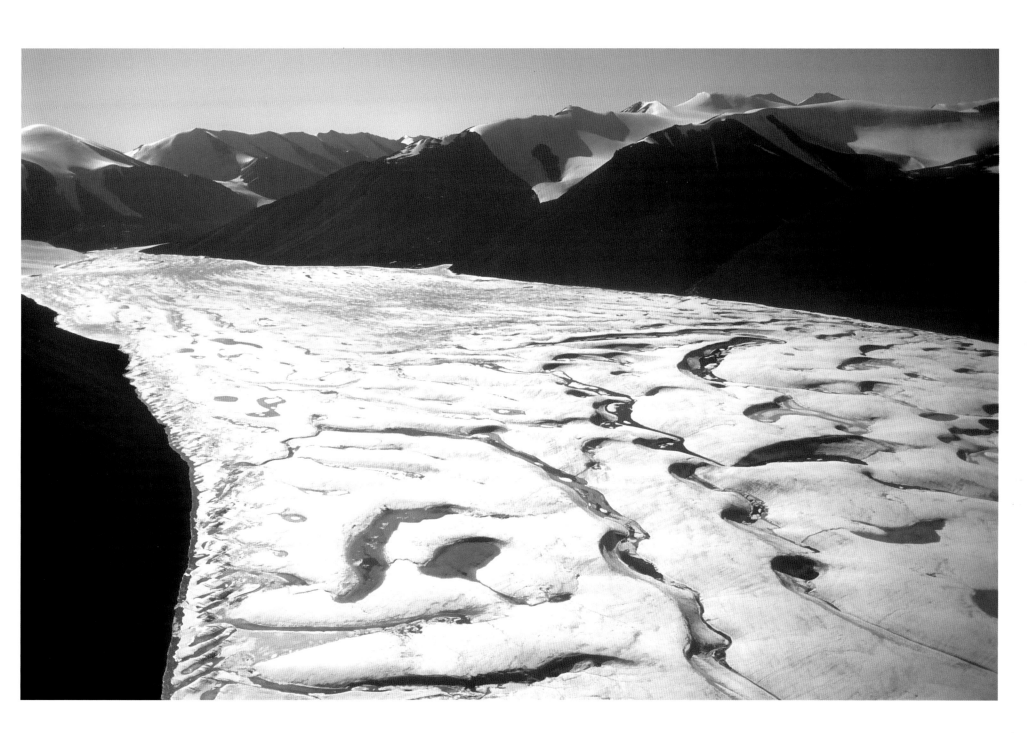

Edge of the Polar Sea 93

For several days on Ward Hunt Island, I took advantage of breaks in the fog to photograph. I climbed Walker Hill, named after a young geologist who fell ill here in 1959 with a fatal brain tumor. I had hoped for a good overview of this weird, wild clime, but Walker Hill gave the north wind its first obstacle in a thousand miles, and the summit trembled with the gale's violence. I went down without taking a frame.

The solitary wolf continued to haunt the outskirts of camp and seemed even more ethereal in the fog that half dissolved it. The weather finally cleared as we left, revealing the meltpools and corduroy furrows of the Ward Hunt Ice Shelf—a three-thousand-year-old amalgam of glacier and sea ice. Ward Hunt Island already enjoyed modest recognition for its part in the North Pole saga, but shortly after our visit, it came to symbolize a more contemporary story, as most of the ice shelf broke off and drifted away—a likely victim of warming temperatures.

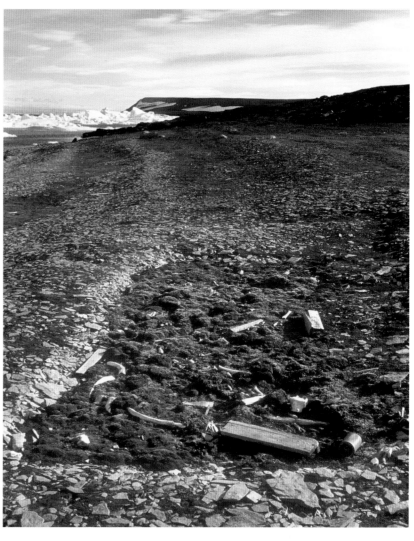

PEARY AND THE earlier British expedition under George Nares based themselves on Floeberg Beach, a raw and foggy corner of Ellesmere Island 155 miles east of Ward Hunt. *Floeberg,* a term used by Nares, refers to pressed-up pieces of old sea ice common in this narrow channel. Even today, Floeberg Beach is as far north as most ships can go. A few years ago, a tourist vessel became stuck nearby and had to be rescued by a nuclear icebreaker, the only type of ship that can muscle through even the thickest ice.

The scene of a dozen exploration dramas, Floeberg Beach lies in the most distant corner of the archipelago. A charter airplane can't land, because Floeberg Beach falls within the airspace of Alert, a restricted military base that listens for submarines and who knows what else. But, in one of those breaks that teaches a traveler that if you don't ask you won't get, Alexandra and I received permission to fly to Alert with the military, and Floeberg Beach was just ten miles away.

Our trek had the obscure distinction of being the northernmost backpack trip ever done. Unfortunately, souvenir hunters from the base had long ago carted off most of the Nares and Peary artifacts. Until the 1970s, even scientists routinely pocketed historic trinkets as souvenirs. Duncan Grant, one of the great early bush pilots, refused to reveal any of the sites he'd discovered, after a politician plundered a find that Grant had showed him.

"But all that knowledge will die with you," a scientist protested.

"That's the way I want it," replied Grant.

The thefts that appalled Grant happen less often today, although scholarly papers still waffle about the exact locations of archaeological sites because of the potential for treasure hunting. I sometimes wonder what some of the hundreds of items I've left in

ARCTIC EDEN

far left The Cold War military base of Alert still gathers what it calls "signals intelligence." In this photo, the eavesdropping antennas have been digitally removed.

left and below Graffiti past and present: One of Nares's men etched the name of his ship in a rock, *left,* near the modern base. *Below,* a collection of contemporary signs listing hometowns and their distances from Alert.

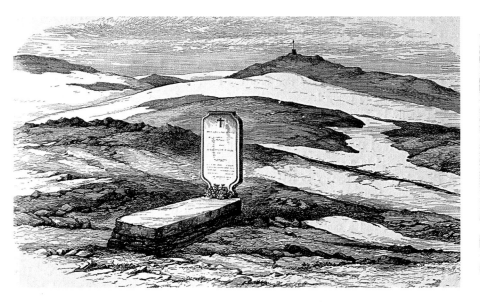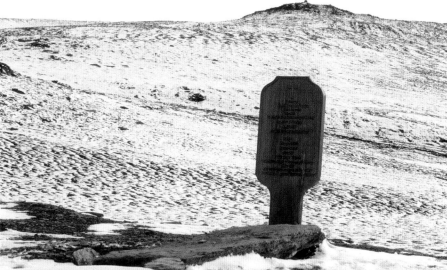

above left and right A scurvy victim's resting place at Floeberg Beach has changed little since 1876. Even Nares's cairn on a nearby hill remains intact.

far right Memorial to Ross Marvin, one of Peary's young assistants, who died under mysterious circumstances during the 1909 North Pole expedition.

place over the years would fetch among collectors of Arctic memorabilia—a pearl button from one of Peary's shirts, a hat from one of the starving men of the Greely expedition, a penknife from one of Otto Sverdrup's camps, a Thule pendant made from a polar bear canine. Whatever the amount, it would not equal the *in situ* value of these items to conjure up the spirits of these past travelers.

Mainly generic garbage remains at Floeberg Beach today—rusty cans, fragments of wood or rope—along with several cairns, which are difficult to abscond with. When we were there, two pieces of flagpole still protruded from the top of Nares's big slate cairn. One day in 1875, they had had to correct the broadside orientation of their ship with what Nares called "much labor and no trifling expense in broken hawsers" to keep the pack ice from crushing it. Those fragments of hawser remain, as if the struggle happened last week. One mile north lay the clear outline of Peary's tent, where he lived before setting off toward the North Pole. Grass grew thickly in the tent area, since Peary's garbage had enriched the nitrogen-poor soil.

Photos of historic sites aren't impressive to the eye like good landscape or wildlife images, but I still love them for the stories they tell. On Floeberg Beach, I photographed the same scenes that Nares's surgeon, Edward Moss, had painted. Little had changed in a century. The grave of Niels Petersen, one of Nares's men who died of scurvy, looked exactly the same except that the heavy slab—which had taken a dozen men to lift into place—had settled slightly into the earth. The dotted letters on the grave marker were as clear as the day a crewman had painstakingly tapped each one into the copper leaf with the point of a nail. Amid the cries of seabirds, an odd line from a Victorian travel book on Iceland chorused in my head: "a turbary haunted by whimbrels . . . a turbary haunted by whimbrels . . ."

A cross made from steel-shod sled runners topped Peary's own cairn. Farthest north of all stood the cross and plaque commemorating the death of Ross Marvin. One of Peary's Inuit had murdered Marvin for reasons that remain unclear.

FOR TWO WEEKS, Alexandra and I combed every inch of coast around Floeberg Beach, from Cape Union in the south to Cape Sheridan in the north. Turnstones and sanderlings probed the water's edge. Ivory gulls bleated. Floebergs pressed up on the sad shore. Thick, wet fog licked us like a dog's tongue and made the land indescribably bleak. Good weather to suffer scurvy by. In winter at this latitude, the sun is below the horizon for 142 days hand running.

Eventually we shlepped inland, under towering backpacks filled with the usual mixture of camping and camera gear. The sort of burden that over the years has helped compress me from six foot two to my current six foot one. After eight hours, we camped, exhausted.

Although our distance in the two weeks was modest, this trip was about people, not miles. Peary hated the Arctic—hated living in igloos, hated trekking. "Another hell begotten day," was a typical trail comment of his. He would have agreed with Robert Service. Aboard ship, Peary rarely emerged from his stateroom, with its Positively No Admittance sign by the door. Alone inside, he scribbled in his journal with naked vanity about his plans to exploit fame, including designing his own mausoleum worthy of a pharaoh and setting up a publicity portrait of himself in furs, posing heroically—with "face unshaven," he advises parenthetically. Modern marketing: another Peary talent. As for the more humane Dr. Cook, you could never figure out from his writings where he was, because he was lost somewhere in his own head and never noticed the world around him. Funny people to be Arctic explorers, but the burden of their ambition was the true hell north of Eighty-Three.

left An ermine investigates Jerry and Alexandra's camp at Floeberg Beach.

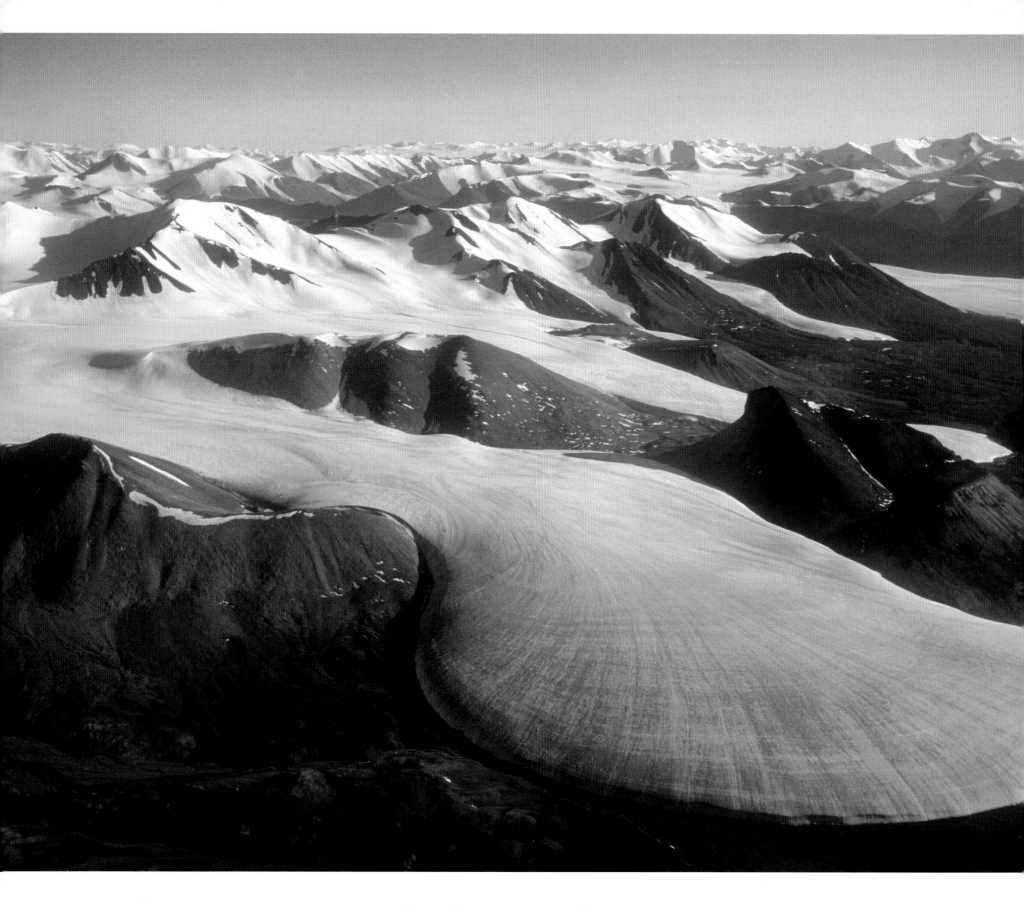

THE SECOND-LARGEST park in Canada, Quttinirpaaq National Park covers the northern one-third of Ellesmere Island.

"We sat in the open in front of our tent and, without moving, we could see a polar bear walking across the fiord, two wolves sleeping on the ice and a herd of some 20 muskoxen. What could be more wonderful than this...!"

DAVID HAIG-THOMAS, *Tracks in the Snow*

5 | NATIONAL PARK BLUES

A FEW CRUISE ships skim the High Arctic every summer, but the tourists with the best chance to experience Haig-Thomas's wonder camp in one of three Arctic oases: Lake Hazen, Alexandra Fiord (both on Ellesmere), or Truelove Lowland on Devon Island.

An Arctic oasis is not a scientific term. It informally describes a local area with good weather, fresh water, and lots of wildlife. The mean July temperature hovers around 45°F, but on any given day the temperature may climb to 65°F or higher. Meteorologists at the Eureka weather station, another summer hot spot, stage barbecues on the back deck and wear ball caps proclaiming, "Garden Spot of the Arctic."

The High Arctic has three attractions: scenery, wildlife, and history. Most areas feature one or two of these. Finding all three together is rare. In Quttinirpaaq National Park, Tanquary Fiord has the scenery, Lake Hazen has the wildlife, and Fort Conger has the history.

right A hiker almost vanishes in the spacious landscape above the MacDonald River.

Less than twenty visitors a year hike Quttinirpaaq, the second-largest park in Canada, after Wood Buffalo. The park's isolation adds a serious edge to the relatively easy terrain. One summer at Lake Hazen, a hiker had a medical emergency. Her pacemaker malfunctioned, perhaps from the pressure of her pack straps. Every few hours, she lapsed into convulsions. The rest of the time, she felt okay and was reluctant to be evacuated. Eventually, they decided to fly her out. The plane took several hours to arrive and several more hours to return to Resolute. Before she reached the nearest hospital, still twelve hundred miles away in Iqaluit, she died. I later described her symptoms to a cardiologist friend, who said that even he could not have saved her at Lake Hazen. She needed a new pacemaker.

Given incidents like this, it's reasonable to ask an Arctic voyager: What if you get hurt? What if you get sick? What if you get appendicitis? What if…?

Most outdoor injuries happen at speed. Downhill skiers blow a knee. Whitewater kayakers dislocate their shoulder if they high brace at the wrong time. But Arctic travelers walk or shuffle slowly on skis, paddle calm waters, or backpack. All low risk. Training minimizes the main physical threat, repetitive stress injury.

As for illness, you don't catch a bug in the Arctic; you bring it with you. So before an expedition, I keep washing my hands and meticulously avoid touching my face. No finger food at parties. If I see someone coughing, I flee. After a week on the trail, if you're not sick, you're not going to get sick.

I always leave a map of my route with my family, the charter airline, and the local RCMP. If I don't show up on a certain day, a Twin Otter flies the route at my expense, looking for me. If I couldn't travel because of injury, I'd camp in one spot and wait. I may die of boredom, but I'd have plenty of food until the plane shows up; one day of travel food supports three days of lying around.

As for the other what ifs, I get a dental checkup before every expedition. I carry antibiotics and behave conservatively on the land. But I can't live my life on the off-chance that appendicitis or some other serious ailment may strike. That's like never leaving your house for fear of drive-by shootings.

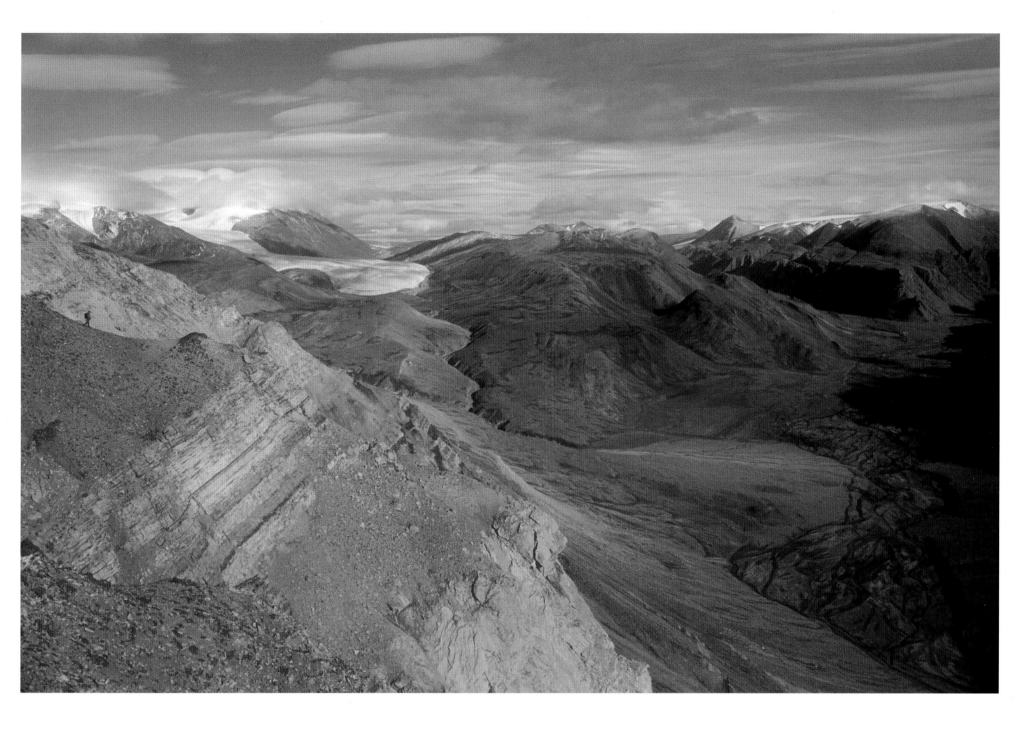

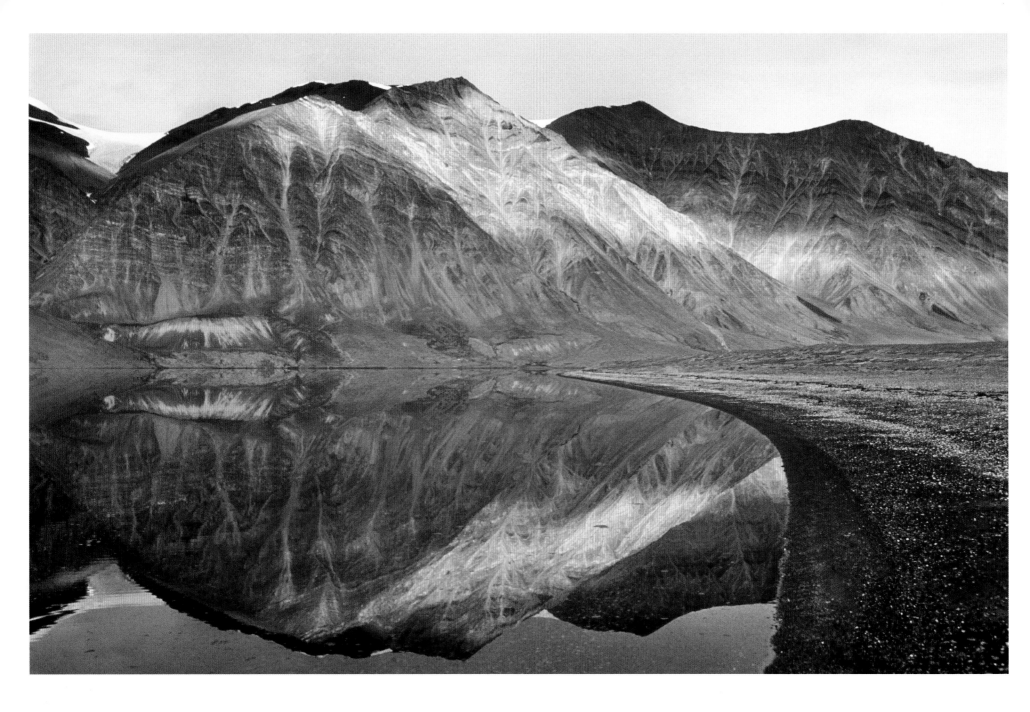

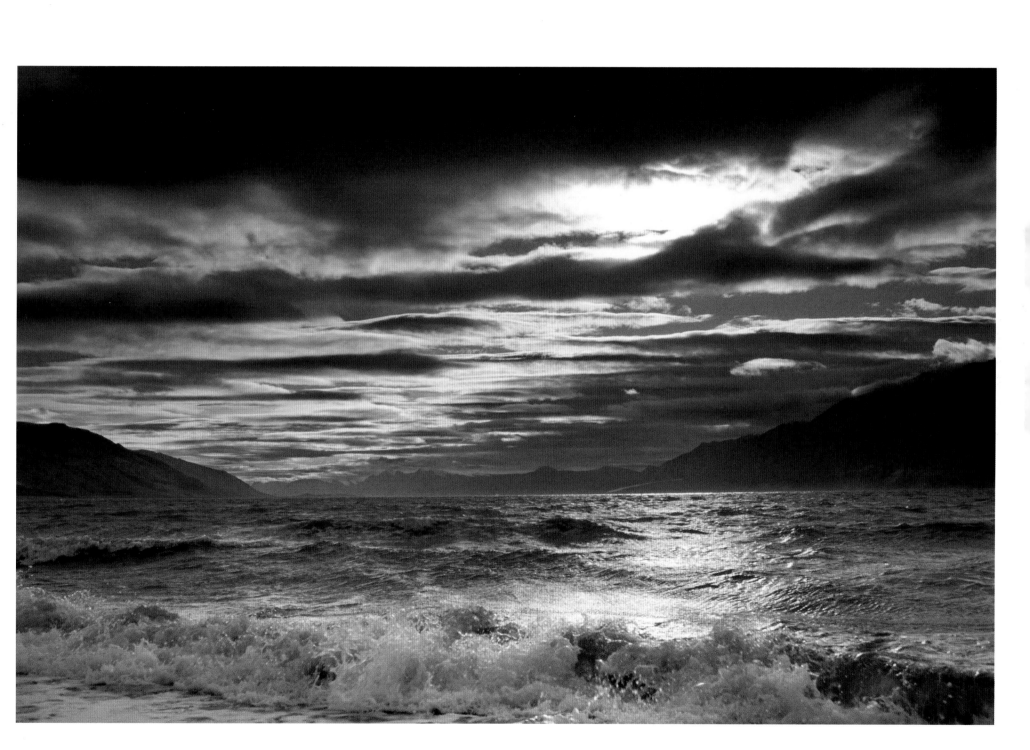

left and below Two faces of a fiord:
Depending on the hour, Tanquary Fiord
can be either millpond-calm or terrifying.

below "A Grand Canyon with ice floes," Tanquary Fiord reaches inland for fifty rugged miles.

right Wardens spend summers in the park, but in winter, local muskoxen reclaim the buildings as windbreaks.

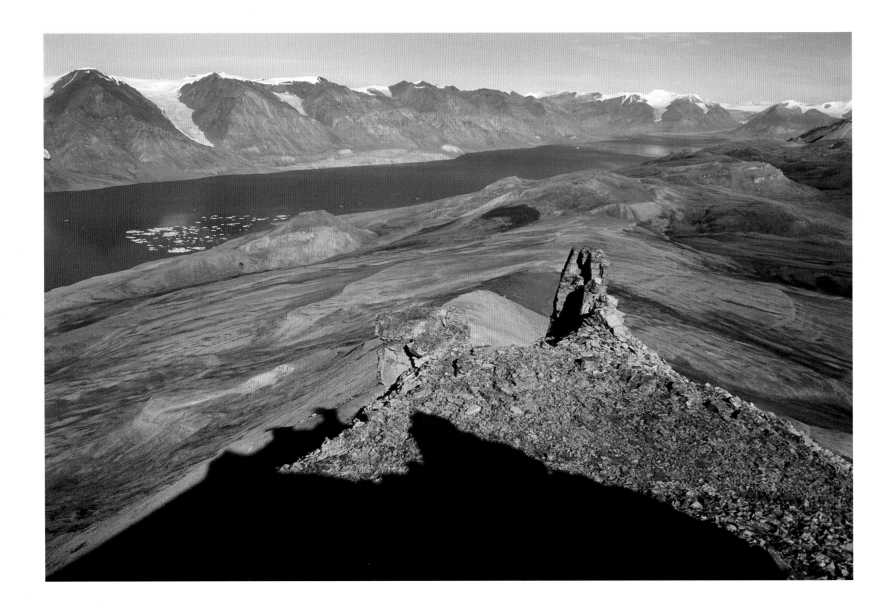

above and right Robert Peary built the three small huts at Fort Conger from Greely's single large building, which was harder to heat.

I FLEW TO Fort Conger with two wardens from Quttinirpaaq. Renee was the current head warden; Barry, his understudy, would take over that job the following year.

Barry's first visit to Fort Conger with Renee the previous summer had been worthy of this legendary site. The pilot landed the wardens near the buildings rather than at the usual gravel strip one mile away. The landing went fine, but he didn't have enough room to take off again. He pointed the plane downhill and gunned it. As it lifted off, one of its skis clipped Greely's brick observatory. The plane lurched; the broken ski dangled by wires. They had to make an emergency landing on the sea ice on one ski. Barry emerged white-faced from the plane. "You big baby," said Renee with a straight face. "We do that all the time."

When I began to take pictures seriously, a wildlife photographer friend warned me, "A national park is a garden of Eden with lots of forbidden fruit." He began his career in the Rocky Mountains. Wardens don't like wildlife photographers, and the feeling is generally mutual. Photographers notice animals by the roadside. They pull over and start photographing. Tourists notice the photographers. Traffic jams start. Although the pros know what they're doing—wildlife shooters need to understand animals as much as light and composition—park officials balk at how close photographers allow the animals to approach.

Even landscape shooters run into problems. A vaguely worded regulation states that any professional who photographs in a park must obtain a permit, which costs several hundred dollars a day. This law was reasonably created for big advertising productions, but a few wardens challenge anyone with serious camera gear. No self-employed nature

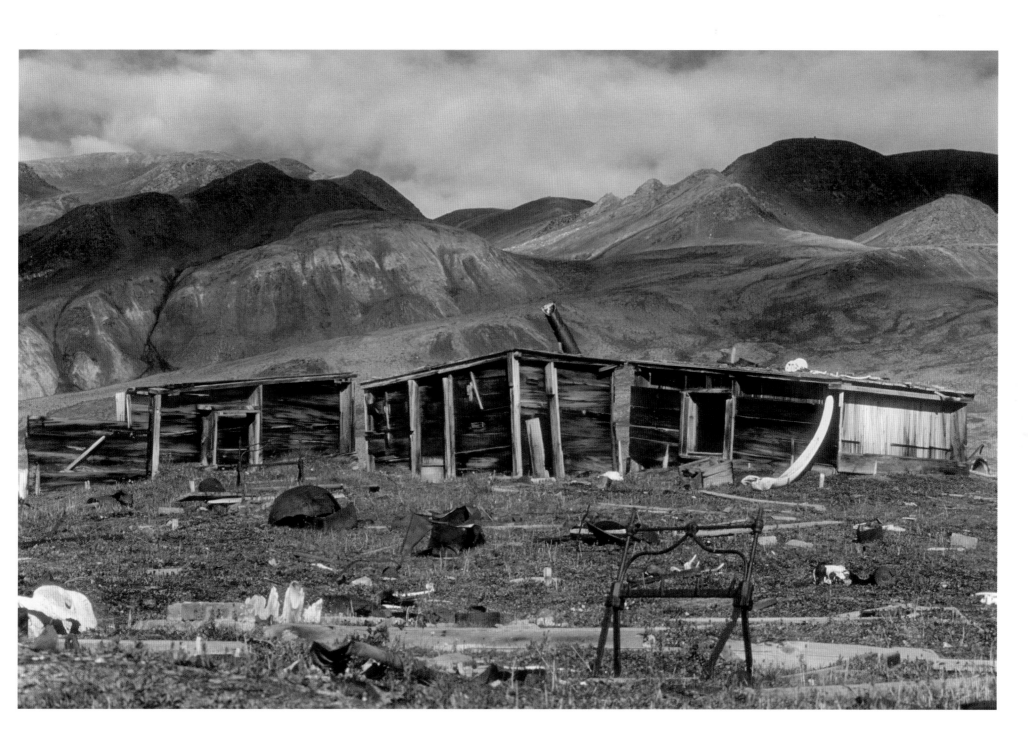

photographer can afford the fee, and no one buys the permit. So every souvenir photo of a national park, whether on a postcard or calendar or in a book, has been taken illegally, including the ones in park gift shops.

Most of the wardens with whom I traveled on magazine assignments, good people who shared their food and expertise with me, had a them-and-us outlook. Yet for Renee, this divide didn't exist. He followed what he called the "spirit and intent" of a law. He was a shit disturber who once caught an important politician stealing an artifact at Fort Conger and forced him to put it back. On one of our hikes together, Renee killed time by carving a crude muskox out of stone and hiding it beneath a rock "to baffle future archaeologists." It was the sort of prank an adventurer might pull.

In his job, he'd spoken to so many researchers that he'd acquired a grand overview of Arctic science and history. He'd even had his adventure phase; years earlier, he had declined an invitation to join a famous American expedition to the North Pole in favor of organizing his own journey in the footsteps of the Inuit shaman Qitdlarssuaq. I envied Renee, who seemed able to play the game from the inside, with an outsider's perspective. You can accomplish a lot of good that way, if you're clever. Now, after years in the North, Renee, like many white people, was moving south as his kids reached school age.

FEW ADVENTURERS HAVE kids while they are adventuring. There are exceptions: adventurers with money; adventurers with a spouse who does most of the parenting (still common in some cultures); adventurers from past generations, when everyone had kids; adventurers with messy personal lives.

I never wanted kids, but not because I was irresponsible or didn't like them. Some of us only take up what we think we can do a proper job on. I never earned enough money or had enough time. It was do this—writing, photography, expeditions—or have kids, not both. The Law of Maximum Takeable Risks was also in play: there is a limited number of risks any one of us can take, and we can only take certain risks by avoiding others.

Some adventurers have kids without intending to give up The Life. Defiantly, they try to involve their firstborn in a big adventure. This is difficult, and there are drawbacks. For one thing, they must choose the adventure carefully—not too dangerous, not too hard. For another, the kid inevitably becomes the story, and from a professional point of view, that works once but not every time. The expedition *en famille* is usually a swan song.

Alexandra never wanted kids either. In most parts of the country, we'd be considered strange. But where we live, in the Rockies, many couples choose to forgo kids. Not everyone does expeditions; some are writers, photographers, or filmmakers, or just want the freedom to go skiing for a weekend without babysitter woes. At a recent evening with friends, only one of four couples had kids, and they were both in their seventies. Different era.

left "It won't be the same the first time a telephone rings at Lake Hazen," said former Ellesmere warden Renee Wissink, a year before satellite phones became standard parks issue.

COOL SCIENCE

ALTHOUGH FRANKLIN SEARCHERS and North Pole seekers all but ignored science in their pursuit of glory, most other historic expeditions included a research program. Nares's weather observations served as reference for that area until recently. Modern papers still cite the meticulous inventories of Otto Sverdrup's geologist and zoologist. Adolphus Greely's 1881–84 expedition began as one of a dozen projects for the first International Polar Year before morphing into a melodrama of tragedy and perseverance.

From the late 1940s until the 1970s, scientists and military personnel had the run of the High Arctic. When I began traveling in the late 1980s, I felt a slight hostility from researchers. What was I, a frivolous adventurer, doing in

their beautiful private laboratory? That tension ended as Arctic travel became more common and as I came to know, in my own way, as much about the place as they did.

Not every student takes to the Arctic. "They either hate it and can't wait to leave or love it and can't wait to return," says Miles Ecclestone of Trent University in Ontario, who has studied the glaciers of Axel Heiberg Island for over twenty years. I once overheard a shaken graduate student on Ellesmere Island beg over the radio to be evacuated. He had fallen into a stream two days earlier and claimed to be still suffering from hypothermia. His tone told a different story. The Arctic terrified him, and the dunking had little to do with it.

Some classic High Arctic science:

> In 1985, a helicopter pilot noted stumps sticking out of the ground on eastern Axel Heiberg Island. He had accidentally discovered a 45-million-year-old fossil forest. It's not the only such forest—neighboring Ellesmere Island has at least six—but Axel Heiberg's is by far the best. Some of the dawn redwood and cypress trees grew 150 feet high, in a place where now—so goes the joke—anything higher than six inches is an animal.

> John Smol and Marianne Douglas analyzed the algae layers at the bottom of ponds at Cape Herschel, on Ellesmere Island. They discovered that since the Industrial Revolution, the dominant organism has changed from a more cold-resistant species to one that prefers warmer water. It was a strong and easy-to-grasp sign of climate change early in the global warming discussion.

far left The Thule winter house belongs to a rich trove of seven-hundred-year-old sites whose artifacts included chain mail—the first sign that the Vikings may have come this far north.

left Coast guard icebreakers do double duty as research vessels.

below Archaeologist Patricia Sutherland inspects old house sites near Tanquary Fiord.

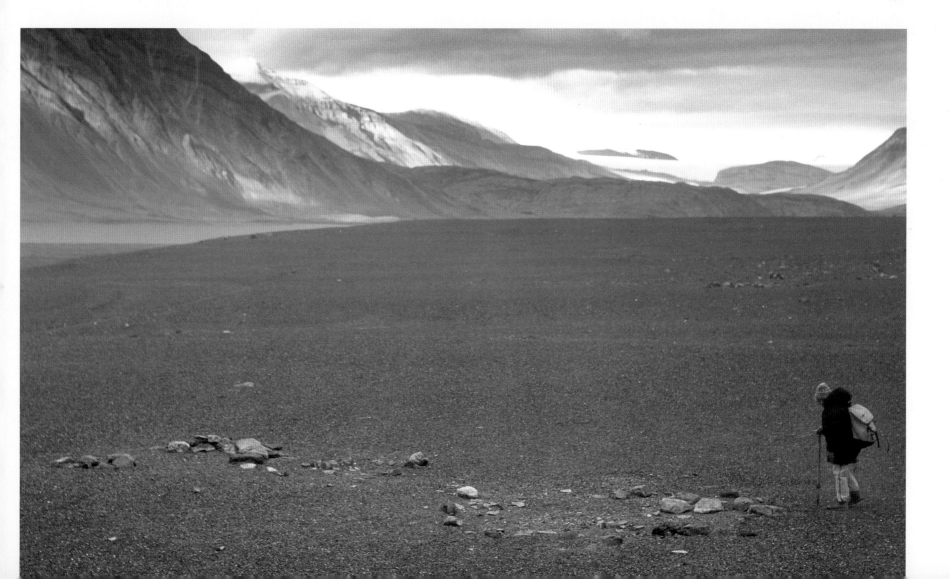

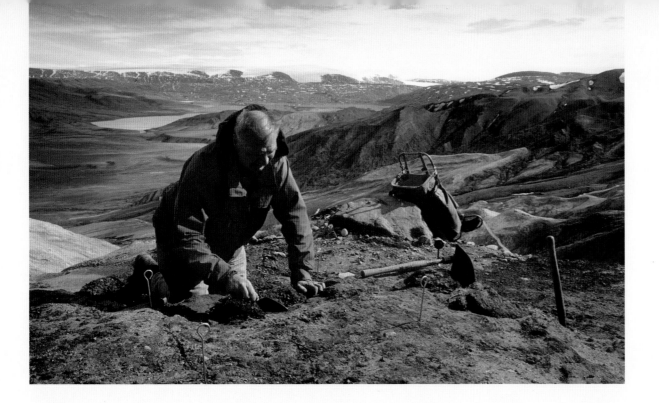

> Drawn by an explorer's description, archaeologist Peter Schledermann discovered fifty items of Norse origin, including wool and chain mail, in seven-hundred-year-old Inuit sites on Skraeling Island in Alexandra Fiord. It remains unclear whether the Vikings visited this far north (the theory is strengthened by a pair of mysterious cairns that used to exist atop a nearby island) or whether the Inuit conveyed these trade items from farther south.

> Ever since the great Inuit traveler Nukapinguaq saw a dinosaur skeleton near Ellesmere's Trold Fiord in 1927, the hunt has been on for unusual High Arctic fossils. The first verified dinosaur in this region was an eight-foot champsosaur on Axel Heiberg Island. Other discoveries included a four-million-year-old beaver from Strathcona Fiord, complete with gnawed fossil birch twigs, and a "fishapod" called Tiktaalik from Bird Fiord, also on Ellesmere, that had begun to develop limbs for moving on land and from which the first amphibians may have evolved.

> For twenty years, the tolerant white wolves near Ellesmere's Eureka weather station have given Minnesota researcher David Mech an intimate look at the world's most charismatic canine. These white wolves have been as important photographically as scientifically. Images by photographer Jim Brandenburg riveted the world when they were first published, in 1988. Previously, most photos of this shy predator came from rent-a-wolf services on game farms.

Although viewers like to imagine that photographers stumble across their best shots—and we do occasionally—it's more common to ask a partner, "Can you sled past that ice cave again?" Frank Hurley and Herbert Ponting staged many of their best Antarctic images. Likewise, an Arctic wolf doesn't just happen to be standing on a gorgeous iceberg. A wily photographer puts the bacon where he wants the wolf to be.

> In Robert Peary's day, a single continuous ice shelf extended across the entire north coast of Ellesmere Island. Large chunks of that original shelf have calved into ice islands since then. In 1961–62, the Ward Hunt Ice Shelf lost half its area. Recently, the breakup has accelerated. In 2005, the Ayles Shelf sloughed off entirely, accompanied by tremors that registered on earthquake detectors. While each new shattered piece makes international headlines, the writing has been on the wall for some time: The remaining five shelves are doomed remnants.

left Paleobiologist Richard Harington unearths a four-million-year-old beaver den at Strathcona Fiord, on Ellesmere Island.

below left and right Researchers gather plankton samples from the North Water polynya, *left*. Twice a day, a meteorologist at Eureka releases a weather balloon, *right*.

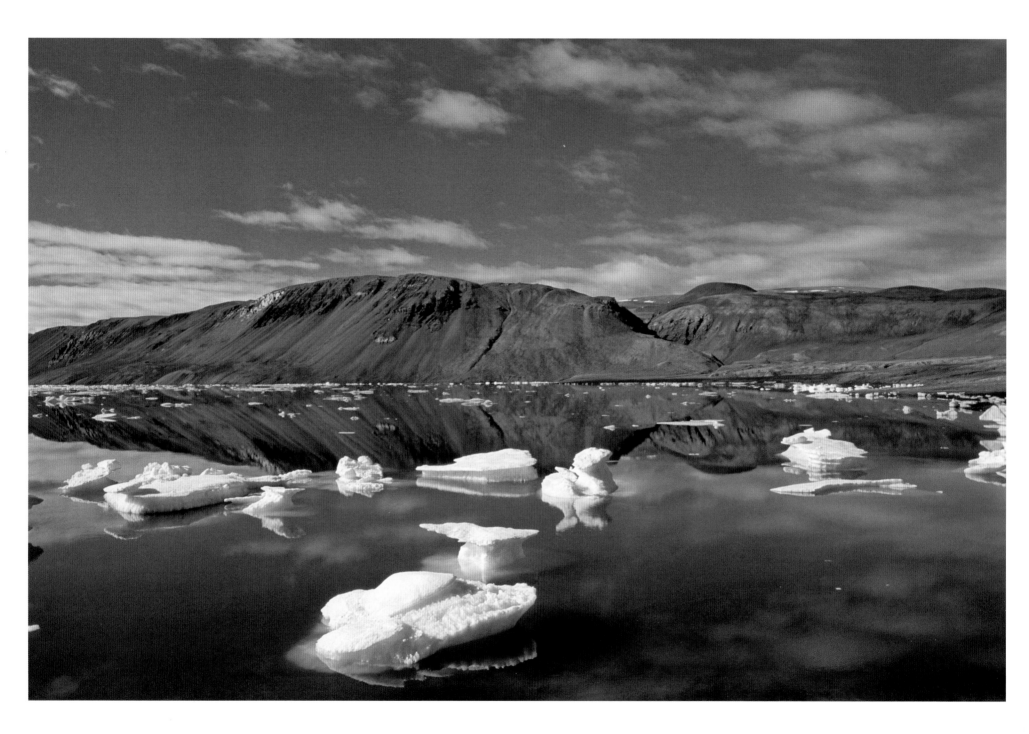

Some friends say they no longer want to travel because they don't want to miss their kids growing up. This is a red flag to the committed traveler. Having kids is like puberty; it turns you into a different person. But unlike puberty, you can choose not to change, by not having kids in the first place.

The myths of the Marquesas Islands in Polynesia follow a man until he has his first child. Then they follow the child. On some level, adventurers believe that life is mythic, and we want to continue to write our story, in miles and degrees of wonder.

FORT CONGER CONSISTS of three small huts in states of disrepair from the roofless to the almost liveable. Robert Peary built them out of what he disparagingly called Greely's "great barn of a structure," which now exists only in outline, as a low mound of raised earth. The huts look onto the ice floes and limpid waters of Lady Franklin Bay. Greenland looms from any hilltop. You can almost see the small Greenland bay in which the arsenic-ravaged body of explorer Charles Francis Hall still rests.

But more than the huts, the garbage on the ground defines Fort Conger. To a studious eye, each of those cans and bones and outlines tells a tale: the circle of barrel hoops in which Greely's men tried unsuccessfully to plant a garden, the remains of the Post Office cairn from the Nares expedition—"a monument to devoured beef," one explorer described it. An estimated fifteen hundred food cans filled with dirt once towered like a fortress of cards. The cans now lie on the ground. Subtler items reward a more determined search. I turned over a slatted door and found some 1880s graffiti poking fun at Nicholas Salor, "Frog Eater"—a reference to one of the French immigrants on Greely's expedition.

As I looked within the perimeter of Greely's former house, I consulted a diagram that showed where each man had his bunk. I tried to visualize their lives. Lieutenant Greely, a stickler who believed in the letter rather than the spirit and intent of army regulations, had forbidden his men to lie down during the day. During the winter, they fidgeted uncomfortably on benches, reading, arguing, smoking, and playing cards. On a

left What Peary once called "the Cimmerian chaos of broken ice" in Lady Franklin Bay is today, more typically, a few isolated floes.

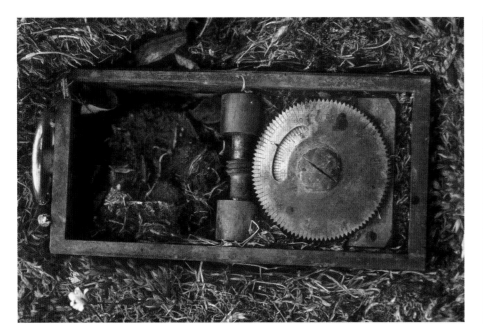

nearby hilltop stood a barrel filled with small rocks that they had carried there for something to do. When I fondled the decaying barrel in awe, it gave me splinters. Greely's Army Range No. 1 stove was in perfect condition, although the grisly collection of Paleo-Eskimo skulls that they had stored inside it had disappeared. Only a single human mandible, embedded in the nearby turf, remained.

Two muskoxen grazed on the hills behind the camp. Sunlight sparkled on the ocean. Plants grew on soil fertilized by the garbage of at least eight historic expeditions. It is not surprising that after two years in this almost pastoral setting, Greely did not realize how inhospitable the High Arctic could be. When a ship failed to pick them up by August 1883, they retreated south 190 miles to Pim Island, a piece of rock spat out from hell and allowed to cool. On its barren shores, most of them died of starvation.

A FEW SUMMERS later I visited Lake Hazen again. Renee and Barry had moved on; their seasonal replacement thought Ellesmere was nothing special, and he had no interest in history ("I studied biology"). I tried to engage him about the cryobiology that has been done at Lake Hazen—studies of natural antifreeze in the caterpillars and fish may improve cold-water detergents—but he had no interest in that, either. I wondered why he had come at all. Probably, like Nares, as a career move.

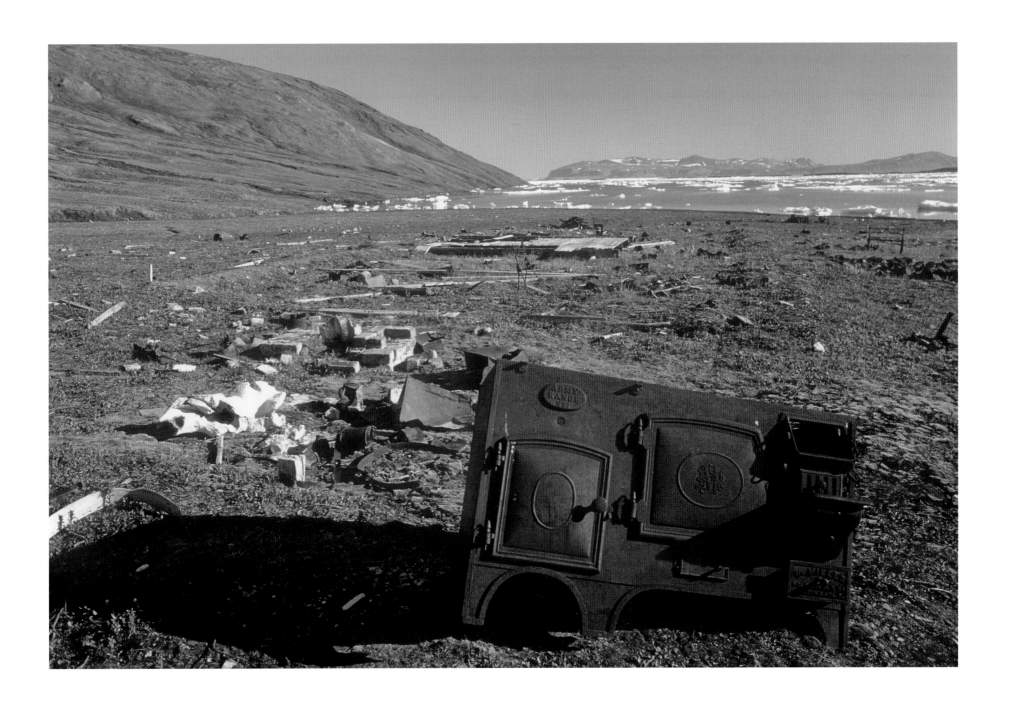

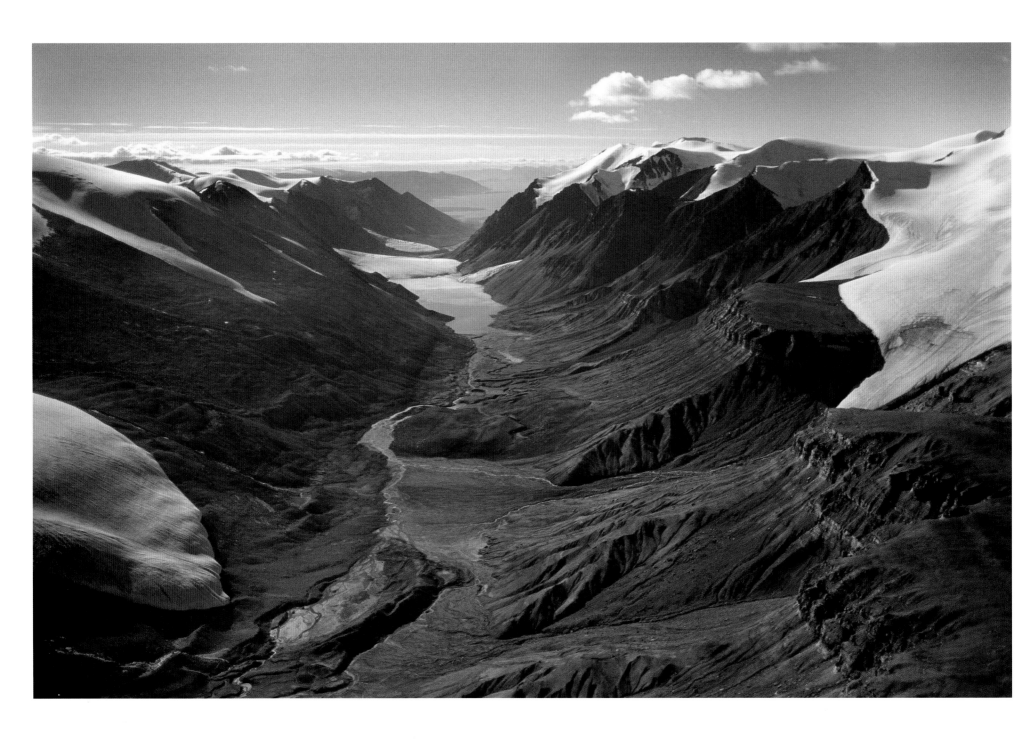

left When the hillsides thaw in Rollrock Valley every summer, loose boulders cannonade down.

below A sedge meadow, a muskox's favorite summer hangout.

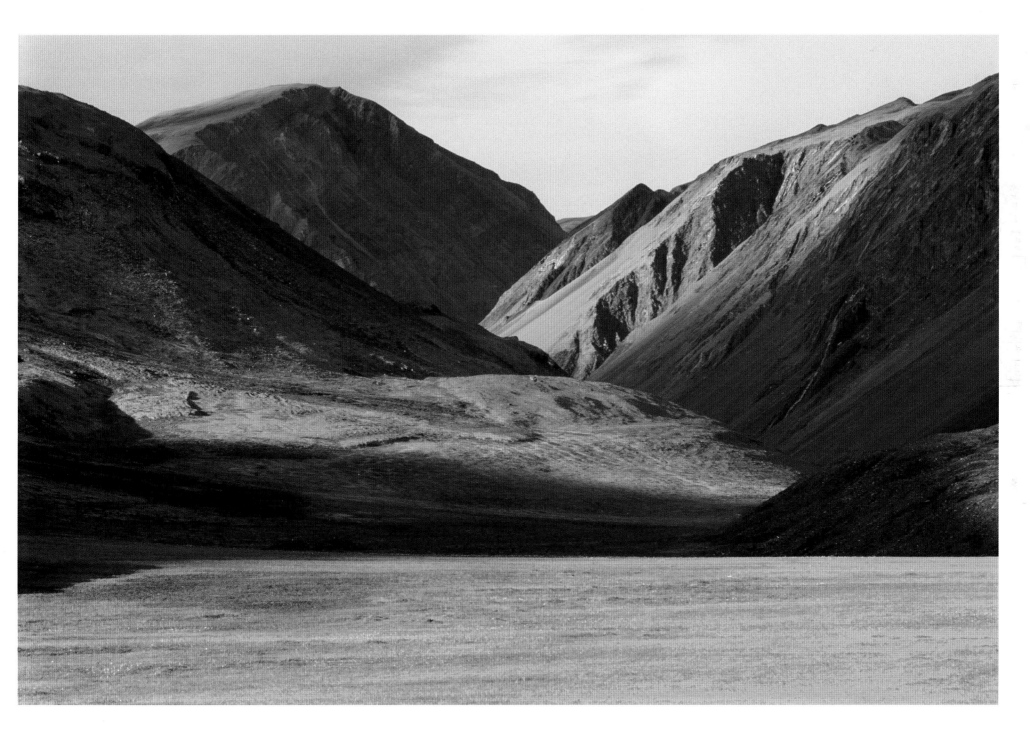

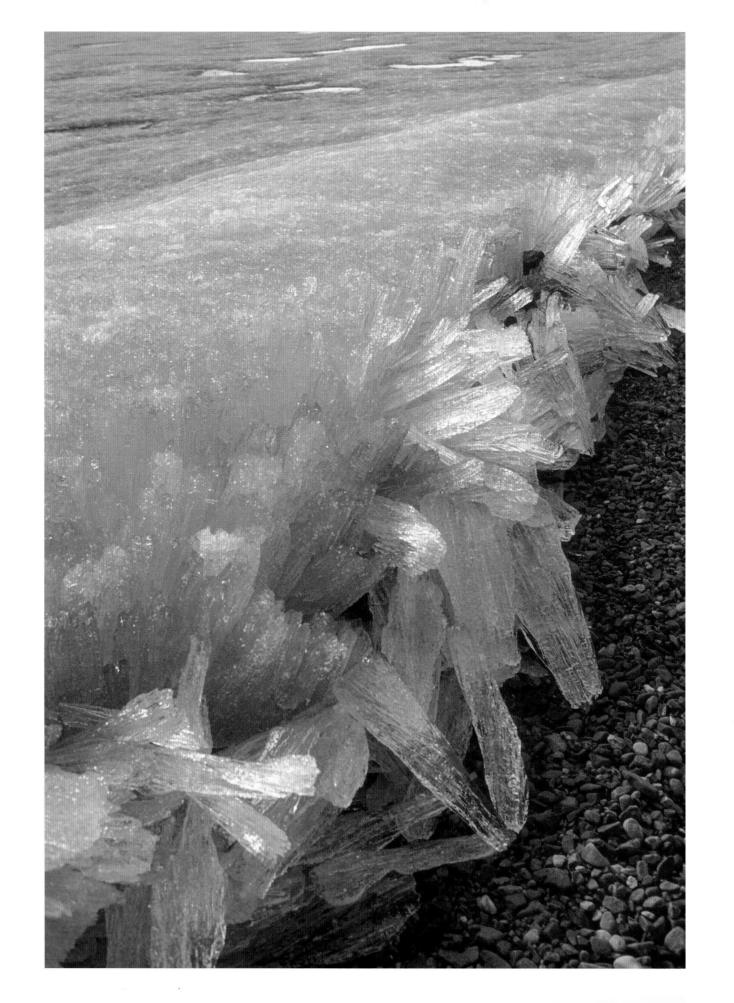

After Renee and Barry's enlightened stewardship, meeting a bureaucrat at 81° north disturbed me. I packed hurriedly to leave for Fort Conger that evening.

The combination of camera gear, research papers, food, and camping equipment means that my pack is rarely under ninety pounds. With big telephoto lenses for wildlife, it is even heavier. On this trip, I had to double my food, because I might have to hike back to Lake Hazen.

The seventy-mile trek from Lake Hazen to Fort Conger takes "four ball-busting days—but that's not the point," Renee once told me. In other words, a reasonable six days. The route winds through such flat terrain that Greely and his men dragged their gear on a small wagon until it broke down. (Following Greely's über-precise journal, I once hunted for this wagon, but it had disappeared—another minor mystery.)

I tramped the shore under the midnight sun, as Lake Hazen's candle ice tinkled in the breeze. A tern went ballistic above my head, swooping in ever-lowering parabolas, like the deadly blade in Edgar Allan Poe's "The Pit and the Pendulum," trying to harass me from her nest area.

The midnight start proved a blessing at the Snow Goose River. Rivers flow less in the cool evening, and I forded the cataract easily. A few days later, two hikers lost their footing in this spot and went for an icy flume ride, from which they emerged bruised but alive.

I soon reached a wolf denning site that I knew about. Arctic wolves had used it intermittently for centuries. The explorer, Sverdrup, believed that Arctic wolves lived on hare. In fact, they mainly hunt muskoxen, and their den lay conveniently beside a muskox travel route.

This year, the wolf pack had denned elsewhere, so I denned for the night, amid old muskox skulls. I loved the overview, and the overlapping boulders in which the wolves had their pups and whose flat tops served me as camp tables.

At the northeast end of the lake, Peary's Inuit helpers had built a *qammaq* roofed with sod and furs. Its tunnel entrance remained intact. Nearby was the old camp of

left Candle ice scours the shallows and makes Lake Hazen one of the most sterile lakes in the world.

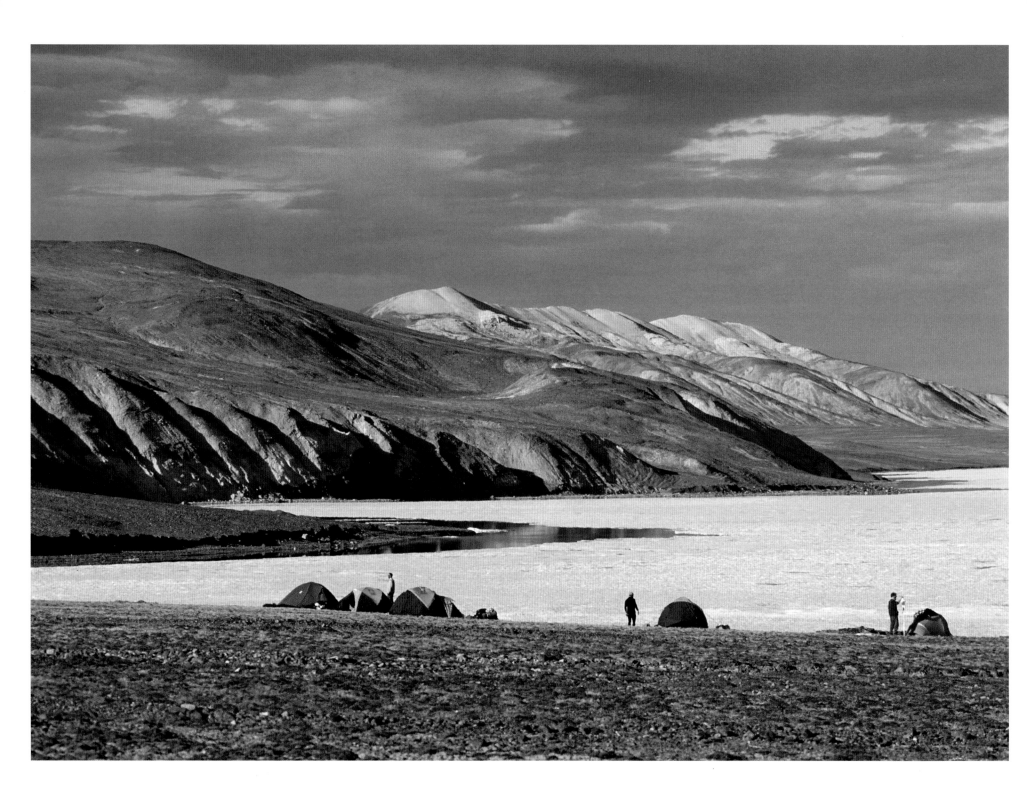

ARCTIC EDEN

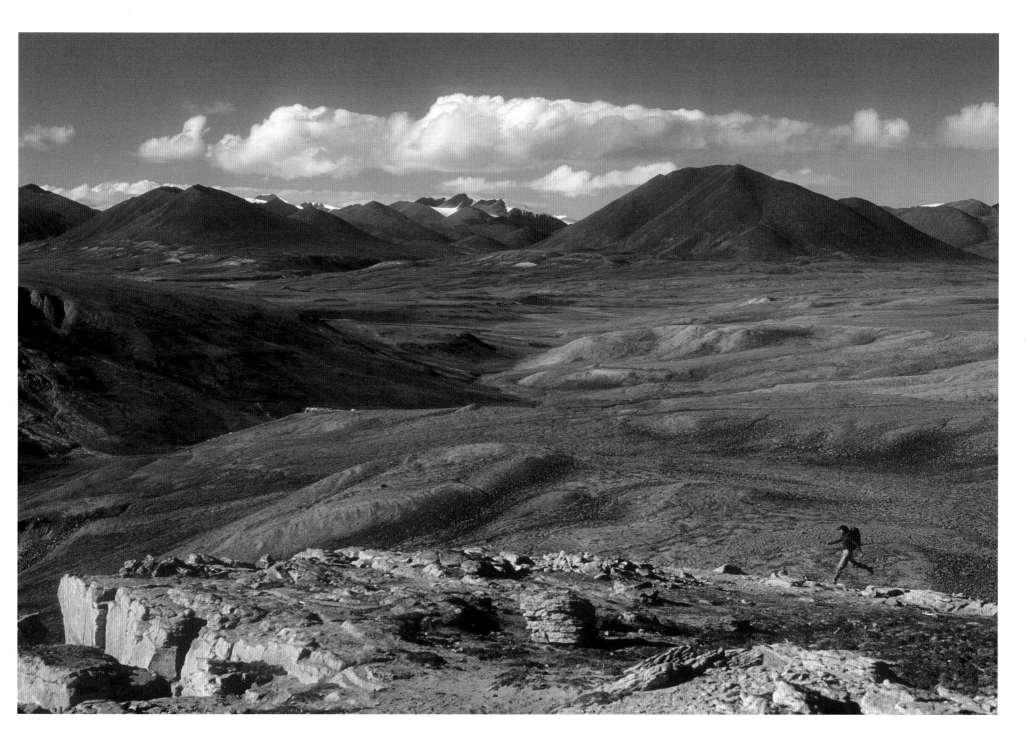

left A dream destination requiring a five-hour charter flight, Quttinirpaaq National Park sees a handful of hikers a year.

below No trails, but no need: In the gentle, treeless High Arctic, hikers can go wherever they want.

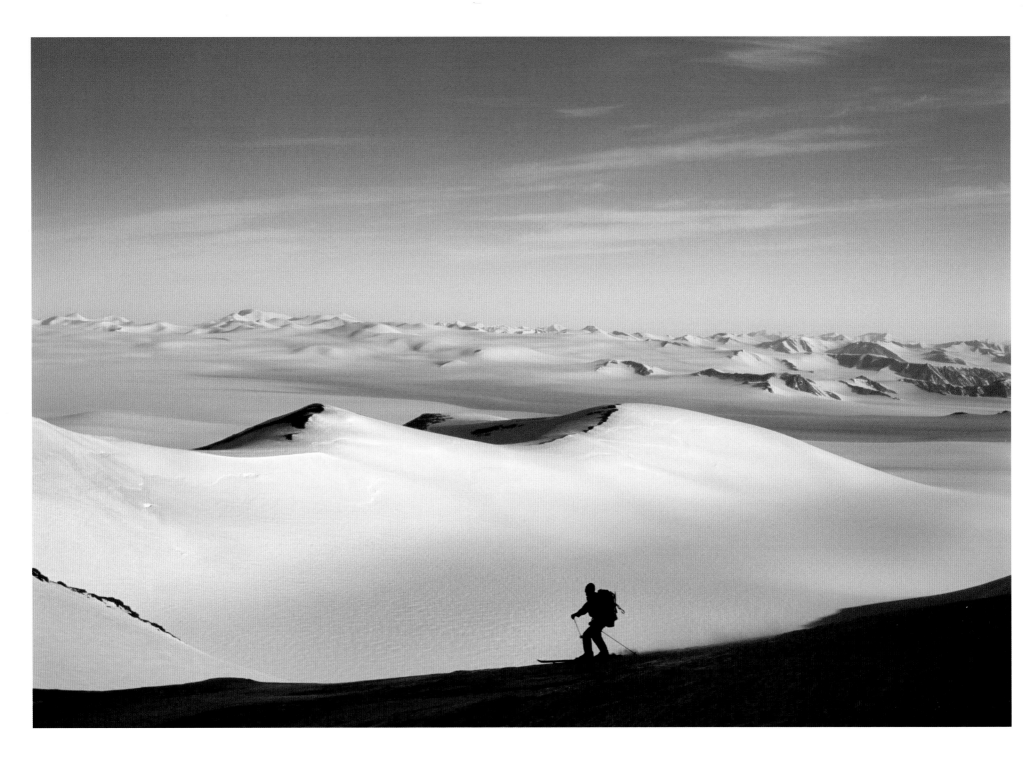

Geoffrey Hattersley-Smith, a glaciologist in the 1950s and 1960s who also excelled as a climber, traveler, and historian. I once visited Geoffrey at his family manor in Kent, England. I slept in the same bed in which mountaineering legend Bill Tilman once snored. Geoffrey had recently spent an evening chatting with the now-late Sir Wilfred Thesiger about Lawrence of Arabia. To me, a poor kid from Montreal, such monumental discussions were my teenage vision of what life could be. Years later, Geoffrey's ancient home, built in Shakespeare's day, still pops up in my dreams, invested with wonder.

left and above A skier glides down from the summit of 8,583-foot Barbeau Peak, the highest mountain east of the Rockies.

I had begun my travels relishing ball-busting days, and though I still enjoyed those, my trips became more about connecting with historic figures and people like Geoffrey than about a walk that any fit person can accomplish. A few years later, I climbed Barbeau Peak, at 8,583 feet the highest mountain in Canada and the United States east of the Rockies. Geoffrey had made its first ascent in 1967. Most memorable about my climb was not the fact that ours was only the sixth trek ever up this remote peak; it was calling Geoffrey, then eighty, by satellite phone from the summit. It was like speaking to Edward Whymper from the top of the Matterhorn.

A lone muskox methodically trimmed the meadows near one creek. "Part sheep, part cow, part frayed bathmat," the muskox rubbed its foreleg with the scent gland on its snout to warn me off as I passed. In the hard noon sunshine, I didn't bother taking out my camera. I followed the creek along dried-mud polygons solid as pavement. A rusty can from one of Greely's campsites served as a planter for avens.

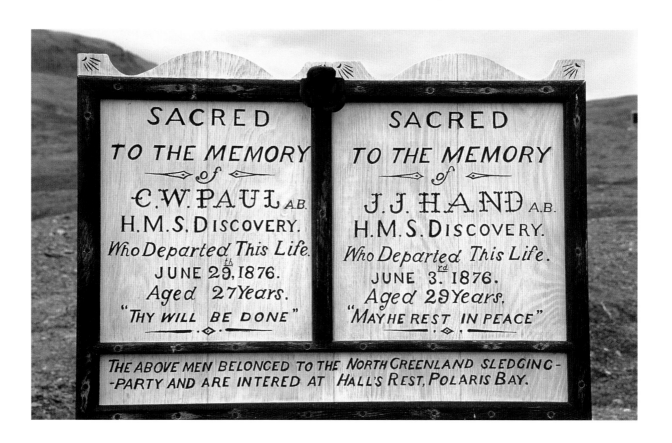

SACRED
TO THE MEMORY
of
C.W. PAUL A.B.
H.M.S. DISCOVERY.
Who Departed This Life.
JUNE 29th, 1876.
Aged 27 Years.
"THY WILL BE DONE"

SACRED
TO THE MEMORY
of
J.J. HAND A.B.
H.M.S. DISCOVERY.
Who Departed This Life.
JUNE 3rd, 1876.
Aged 29 Years.
"MAY HE REST IN PEACE"

THE ABOVE MEN BELONGED TO THE NORTH GREENLAND SLEDGING--PARTY AND ARE INTERED AT HALL'S REST, POLARIS BAY.

Usually mosquitoes only registered when one or two reminded me how sweet the insect-free High Arctic summer was. But they flourished around warmish Lake Hazen. At times, my entourage numbered a thousand. I'd never needed insect repellent on Ellesmere before, and when I discovered a half-empty bottle from a recent Ontario trip at the bottom of my pack, I was ecstatic. Above, a glaucous gull—what Greely called a burgomaster gull—seemed to laugh at my discomfort: "Ha ha ha!" it called.

"Burgomaster gull!" I mocked back.

"Ha ha ha!"

"Burgomaster gull!"

"Ha ha ha!"

"Burgomaster gull!"

This went on for some time, the bird tiring of the game before I did. Birds have lost the reptilian stubbornness that Arctic travelers tap into.

Greely had tried to cross the river flowing into Heintzelman Lake but found it "too deep for safe fording." Today, crossing this feeble trickle didn't even wet the boot soles. Not so the Bellows, a major river near Fort Conger. The prospect of wading across a wide river of unknown depth, alone, made me ill with anxiety. I was also not sleeping well, because the heavy pack had rubbed the small of my back raw. I could neither lie on my back nor turn over without waking up. I had not even managed to take many pictures. Still, not every trip needs to be good for the relationship with a place you love to continue.

High cutbanks usually indicate deep pools, so I trekked upriver to a wide section with low banks. I stripped to my briefs and waded in. I couldn't gauge depth in the muddy water, but I made it across the waist-deep river. Hillsides sloughed dirt as the permafrost thawed. As my boots churned up a sandy slope, another earworm popped into my head: "Erosion: Watch it happen. Make it happen." This phrase repeated itself maddeningly for the next two days.

Rain poured with a steadiness that would have shocked anyone who had read that the High Arctic is as dry as the Sahara. Precipitation wasn't unusual near Fort Conger: Greely recorded twenty days of snow or rain in July. The rain made the loose rocks along one lakeshore slippery. Even huge boulders shifted under my weight.

Suddenly, a noise behind me: part of the sodden hillside above had given way. Tons of boulders avalanched down to where I had stood ten minutes earlier. No wonder all these rocks are so loose, I thought, in between refrains of "Erosion: Watch it happen. Make it happen."

When I reached Fort Conger after six days, I pressed my forehead to the wooden memorial to scurvy victims Charles Paul and James Hand from Nares's expedition. Even if you don't believe in the divinity of those you're following, trips are pilgrimages, and some of them involve hair shirts. Sore and alone, I was happy to worship the end of this trail.

left Two able-bodied seamen from the Nares expedition perished from scurvy on Greenland's shores, just opposite Fort Conger.

DOTTED WITH ponds and blessed with mild summer weather, Truelove Lowland on Devon Island also has mosquitoes—rare in the High Arctic.

"*Where things that own not man's dominion*
dwell, And mortal foot hath ne'er or rarely seen."

LORD BYRON, *"Childe Harold's Pilgrimage"*

6 | TRAVELS ON A LEGLESS DONKEY

TAKING YOUR new girlfriend to a place called Truelove might be a brilliant move,
cementing your reputation as a romantic. Or it might be a disaster. Bouquets of tiny
flowers on the tundra are Truelove Lowland's only nod to conventional romance.
Even in July, you need a hat and parka. A backpack weighs so much that you must sit
down to put it on, then struggle to your feet like a weightlifter doing a clean and jerk. Polar
bears may pass at any time, and when Alexandra test-fired our shotgun for the first time,
the noise and recoil were so frightening that she burst into tears. To most sensible people,
Truelove Lowland might seem more like a Valentine's Day horror movie than a Valentine's
Day treat.

This was our sixth date. Alexandra and I had met when I rented a house on Saltspring
Island in British Columbia to work on a book. She managed a professional photo lab in
nearby Vancouver. I brought my film to her lab for processing, and a friend introduced us.
Alexandra had recently left a long relationship. It hadn't been bad; she just wanted more,

or different. When photographers came to her lab and described their latest exotic shoot, she felt as if life were passing her by.

My own former wife had often assured me that no woman except her would be interested in me. This was a reasonable assumption, given my quixotic leanings, which showed no sign of mellowing with age. But after we split up, I discovered that I seemed to appeal to women searching for personal freedom. There was no shortage of those, but the problem with being a catalyst is that after the chemical reaction occurs, the catalyst is no longer needed.

In early July, Alexandra and I arrived at Truelove Lowland on Devon Island for three weeks. Alexandra spent her childhood summers car-camping with her family, but she had no backpacking experience. Before the trip, she practiced by carrying a backpack full of water jugs around the neighborhood. Drivers pulled over to ask if they could give her a lift somewhere.

Truelove Lowland was not named for lovers but after a nineteenth-century whaling ship. In the 1960s and 1970s, up to sixty scientists at a time came to study its ponds, its muskoxen, hares, and foxes, and its five hundred species of plants.

Although one visitor described Truelove as "a 43-square-kilometer Eden," the mean annual temperature is 9°F. Permafrost runs 2,000 feet deep. Anything can happen. Once, a researcher paddled his canoe out on one of the ponds to fish for char. On this idyllic evening, red-throated loons called and snowbirds flitted among the shoreline rocks. The other scientists were asleep in the camp buildings. Suddenly a wind came up, and the pond heaved with whitecaps. The canoe flipped. The researcher was at most a quarter of a mile from shore, but the water was too cold. A couple of his colleagues thought they heard someone shouting over the wind, but then the sound stopped. In the morning, they discovered his paddle and overturned canoe. Police divers flew in, but his body had disappeared into the deep silt at the bottom of the pond. Years later, his skull washed up on shore. The High Arctic is Edenic only as long as you remain on guard.

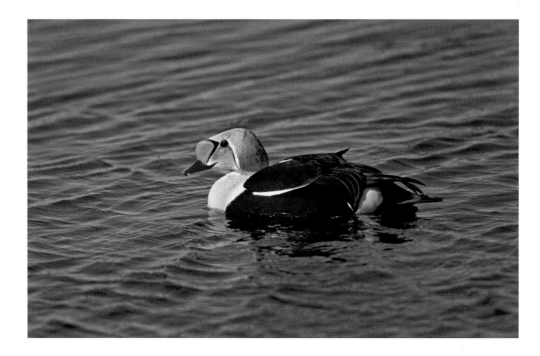

left Botanists flocked to Truelove Lowland in the 1960s to study the five hundred plant species in this polar oasis.

above A king eider brightens one of Truelove's ponds.

GROWING PAINS

IT ISN'T THE cold that keeps most plants from growing in the Arctic; it's the lack of warmth. This apparent tautology contains a subtle truth. Plants can endure long, frigid winters—lichens can even survive the absolute zero of outer space—but need a decent July average of at least 39°F in which to grow. The Barren Wedge, north and west of Resolute, falls below that temperature, so the number of species tops out around thirty-five, and plants cover less than 5 percent of the ground. Meanwhile, 127 species manage to grow on comparatively pleasant Axel Heiberg Island.

High Arctic plants face other challenges besides cold. The soil lacks nutrients. Little rain falls. Ice caps cover about a third of the land. Another third is bare rock, freshly liberated from permanent ice. In most of the remainder, only a few ground-hugging pioneers have staked a claim. Oases like Alexandra Fiord and Truelove Lowland cover a mere 1 percent of the High Arctic.

Occasionally, an old bone leaches nitrogen into the soil and supports a wheel of vegetation around it. Bright orange jewel lichen grows on rocks where birds perch. Some popular nesting cliffs turn almost entirely orange.

In other places, drifted snow accumulates around boulders, and the life-giving puddles persist into summer, even as the dark rocks create their own mini-climate by radiating warmth. Concentric circles of different ecosystems become more spartan the farther away they grow from the rock's influence.

Flowers have evolved elegant strategies for maximizing warmth. Some grow in tight, dark clusters that are 60 to 77°F warmer than the surrounding air. Cup-shaped petals focus solar radiation on the plant's ovaries. The center of a poppy is 43 to 50°F warmer than the ambient temperature. Mountain avens follow the sun.

Many flowers come from the alpine regions—purple saxifrage, heather, avens, poppies. Their seeds blew north or hitched with birds centuries ago. Great stories surround the lowly purple saxifrage, perhaps the most resilient High Arctic flower. Clumps of it endure on dank Ward Hunt Island. The starving members of the Greely expedition ate purple saxifrage and flavored their tea with it. Vitamin C in the flower may have minimized their scurvy. And although Peary caribou favor poppies when they can find them, purple saxifrage may be their most important year-round food. In early summer, their muzzles turn purple from saxifrage feasts.

In recent years, botanists have managed to grow hardy southern plants like radishes during the brief but intense summer at Alexandra Fiord. The Greely expedition had less success with radishes at Fort Conger, despite the imaginative efforts of one man, who doused their garden with boiling water in an attempt to give the seedlings a little extra warmth.

left Cottongrass, *far left*, favors wetlands while the arctic willow, *left*, grows almost everywhere and turns bright colors in August.

below left and right The hardy purple saxifrage, *left*, is a favorite food of wildlife. High Arctic soil lacks nutrients, but even this old bone, *right*, leaches enough nitrogen to support a wheel of vegetation.

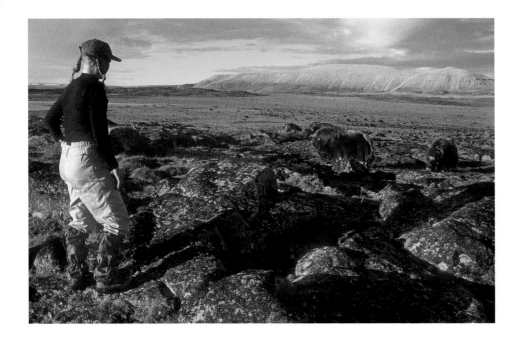

In early summer, frozen Jones Sound glints in the hard sunshine, throwing up mirages of floating ice. Pyramidal icebergs kiss their mirror images in the air above them. Distant capes perform levitation tricks. Meanwhile, the land convulses with life. Flowers explode open. Grass grows so thick and green that it resembles a lawn—unprecedented richness this far north. A cacophony of exotic birds, from phalaropes to turnstones, frantically nest. Snow geese continue to fly north, as if Devon Island is not north enough for them.

The twenty-four-hour sun creates a flexibility undreamed of in a world sharply divided into day and night. One morning it rained; we lounged in the tent for five hours till it stopped and then began our normal day. It didn't matter if we ate breakfast at 10 AM or 10 PM. The constant daylight, wondrously jarring at first, becomes so normal that culture shock sets in when you fly home and night falls for the first time. The darkness is unsettling, alien.

Along with Ellesmere's Fosheim Peninsula, Truelove Lowland has the most musk-oxen in this part of the North. That means only a few dozen, but their larger-than-life presence makes the place feel like a Serengeti of wildebeest. After the willow leaves turn bitter at the end of June, muskoxen graze on the sedge meadows near Truelove's ponds. "Muskoxen are not very good subjects for motion pictures," wrote one traveler in the 1930s, "as they usually stand perfectly still." But muskoxen were now entering their breeding season, and two restless and horny males butted heads with a sound like a rifle shot. A nearby female, the object of their competition, rammed a boulder in sympathy.

Near the abandoned science camp, three arctic fox pups had just emerged from their den. Shy at first, they soon got used to us. They practiced pouncing for lemmings. One bold pup came up to Alexandra, grabbed her shoelace, and gave it a death shake. They sniffed arctic poppies and slept in furry clatches in the sunshine. Every day or two, their

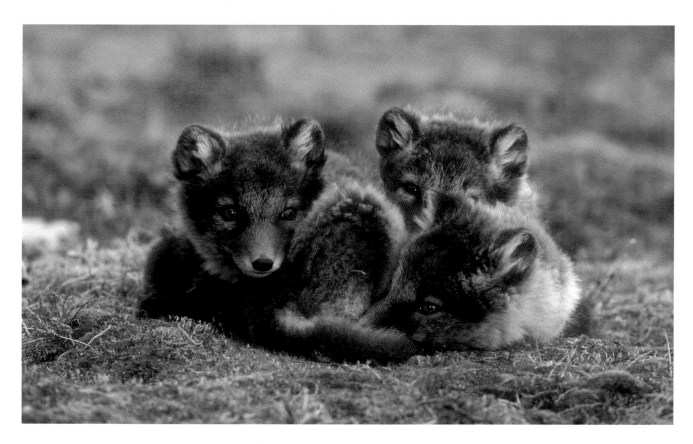

far left Alexandra gets up close and personal with two phlegmatic muskoxen.

left and below A sweet introduction to what will be a hard life, arctic fox pups enjoy their first summer relaxing, playing together, and practicing pouncing for lemmings.

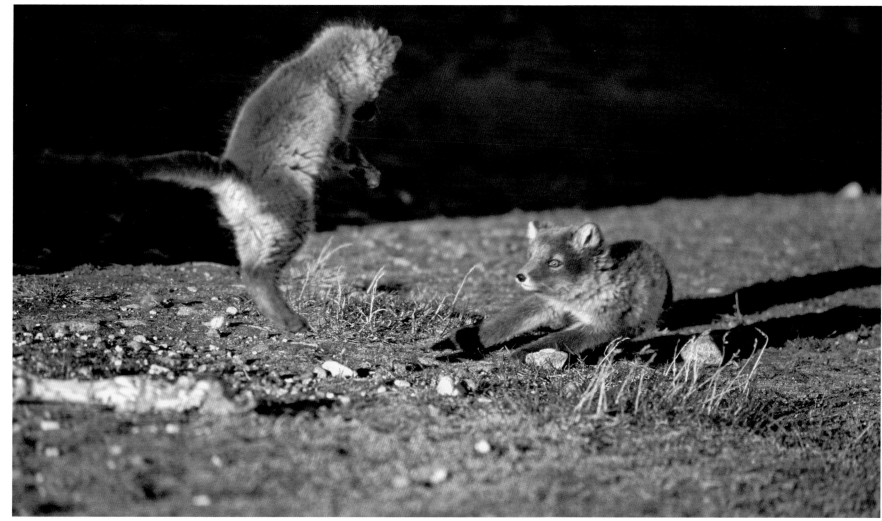

mother showed up to regurgitate something she had caught for them. She was more skittish than the pups, and we stayed away when she came around.

TWICE THE SIZE of Massachusetts, Devon Island "may be likened in shape to a legless donkey with its head thrown up to bray," according to *Arctic Canada from the Air,* an old book of inspiring aerial photographs. Truelove Lowland lies near the donkey's rump. The name Devon came from the home county of one of explorer William Parry's officers. The Inuit call it Tattoos of the Chin, because its ravine-slashed southern coast resembles the lampblack tattoos that used to decorate women's faces.

Although Devon is more accessible than Ellesmere or Axel Heiberg Islands, I've traveled it sparingly. Its ice cap reaches a respectable 6,300 feet, but its mountains are less fanglike than its neighbors', and its western flank, which I sledded one spring, has some of the off-putting flatness of neighboring Cornwallis Island, on which sits dreary Resolute.

Meanwhile, danger waits on the more alluring south and east coasts. The swift current of Lancaster Sound unpredictably tears the sea ice from shore. And the east coast is for those who don't mind lots of polar bears. Picture tramping around Churchill, Manitoba, without a tundra buggy. One modern party avoided the worst of it by staying high on the ice cap, but despite their *haute route,* they met at least one polar bear a day for a month.

Yet those forbidding coasts of Devon Island have been called one of the great ornithological wonders of the world. A pilot told me of bays near the east coast that "twinkled with kittiwakes... You could almost see the old Eskimos dancing on the beach at so much life," he recalled fondly.

I could picture those ancient Inuit too, because the bays he spoke of lay near where Qitdlarssuaq and his band took a six-year break from its epic migration from Baffin Island to Greenland. In 1858, the great shaman met the explorer Francis Leopold McClintock on eastern Devon and learned of the existence of the Polar Inuit of

left In some places, the grass at Truelove displays an almost lawn-like luxuriance.

below A canoeist once drowned
on this deceptively tranquil pond.

right The snowy peaks of Bylot
Island loom in the distance from
the abandoned RCMP post at
Dundas Harbour, on southern
Devon Island.

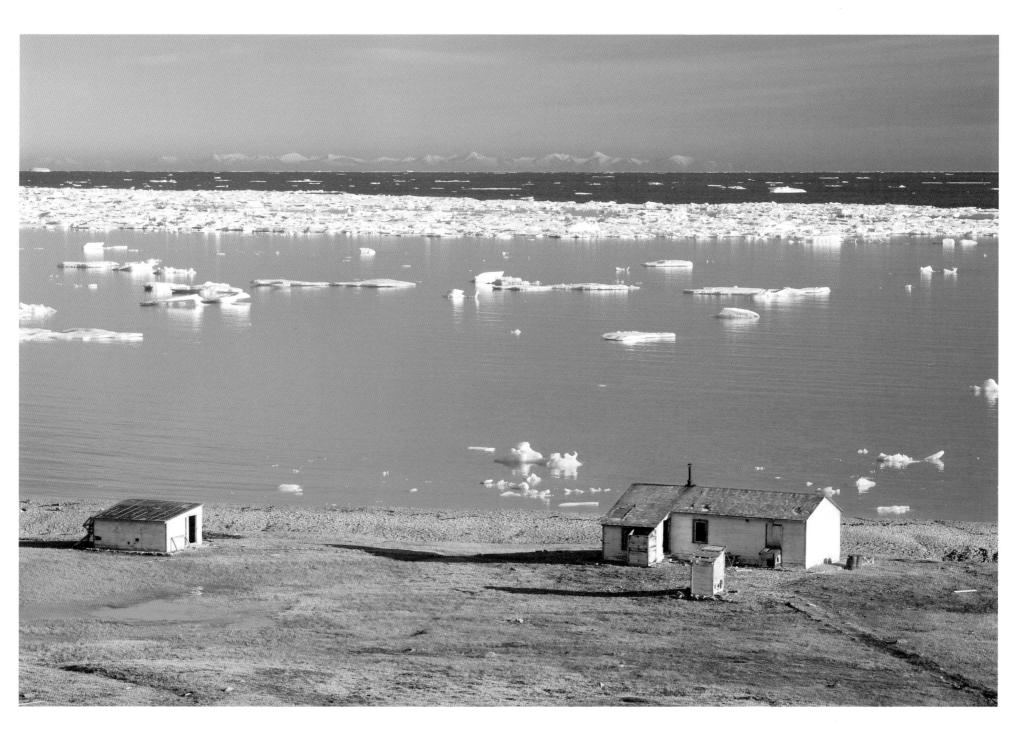

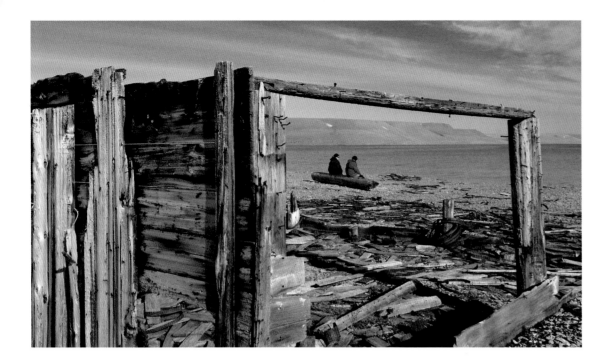

northwest Greenland for the first time. One day, Qitdlarssuaq was hunting in his kayak when a walrus attacked him. His wife witnessed the battle from shore and was convinced that her husband had perished. When he showed up in camp later and asked casually, "Isn't everyone glad to see me?" his appearance seemed to confirm the charismatic leader's magical powers.

Not everyone flourished on Devon Island. One RCMP officer was so lonely and depressed that he committed suicide. Another died alone in a hunting accident. Their graves overlook the abandoned station at Dundas Harbour, today a popular stop for cruise ships.

And on Beechey Island, linked at low tide to the southwest corner of Devon Island, stand three graves from the doomed expedition of Sir John Franklin in 1845. These seamen died the first winter, perhaps poisoned by the lead solder in their food cans. The following year, Franklin and his remaining crew headed deeper into the barren islands to the west and perished to a man, their precise fate still a mystery. An archaeologist who briefly exhumed the bodies on Beechey Island in the 1980s found that the cold had preserved them as mummies, with skin and eyes and clothing still stretched over withered frames. Photos of one of the bodies, half-encased in ice, made world headlines. "Human Popsicle Speaks to Historians," a supermarket tabloid declared.

When I first visited Beechey Island, the bare shingle beach and crappy weather enhanced the bleak Franklin saga, but the replica grave markers disappointed me. Maybe I was too used to seeing the real item. But well-meaning officials often despoil a site under the guise of saving it, and I admired the Haida of British Columbia, who have decided to let their two-hundred-year-old totems rot in dignity rather than embalm them in the name of preservation.

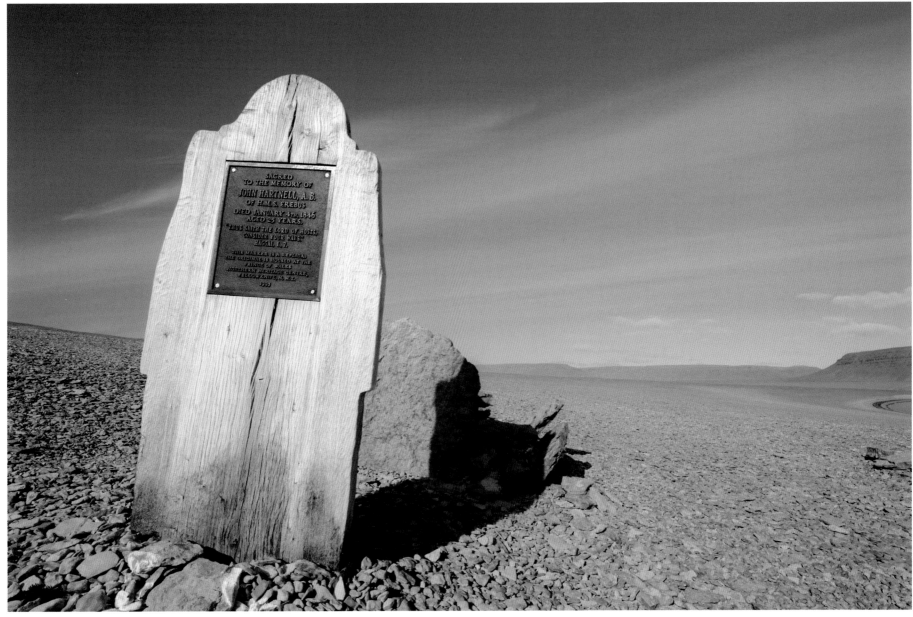

SACRED
TO THE MEMORY OF
JOHN HARTNELL, A. B.
OF H.M.S. EREBUS
DIED JANUARY 4th, 1846
AGED 25 YEARS.

"THUS SAITH THE LORD OF HOSTS,
CONSIDER YOUR WAYS"
HAGGAI, I, 7.

THIS MARKER IS A REPLICA.
THE ORIGINAL IS HOUSED AT THE
PRINCE OF WALES
NORTHERN HERITAGE CENTRE,
YELLOWKNIFE, N.W.T.
1993

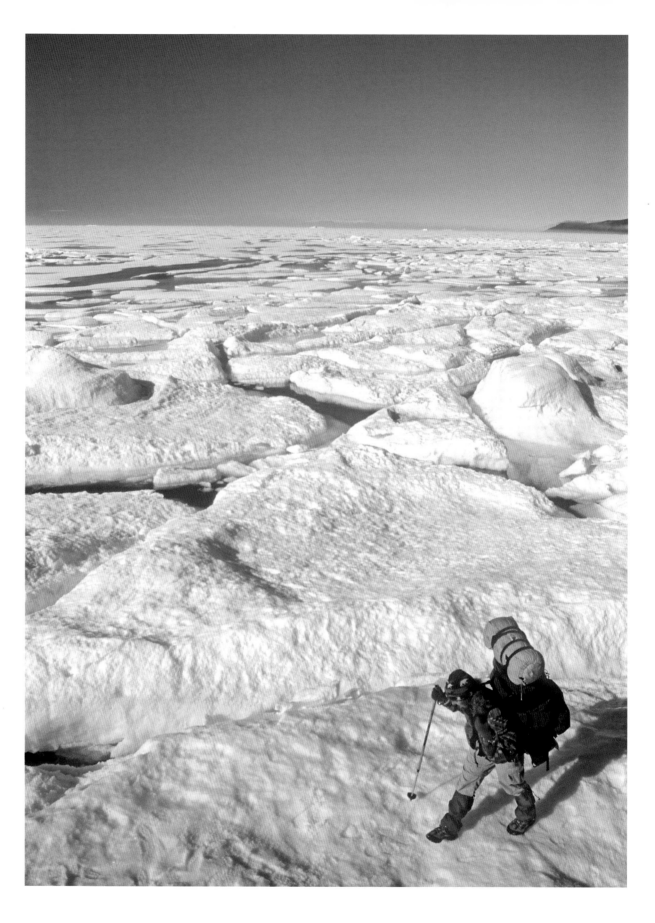

right In early summer, the frozen sea still makes the best hiking path, despite cracks.

far right Polar mirages, like this striking one over frozen Jones Sound, occur when distant icebergs are distorted through air that is cold near the surface and warmer above.

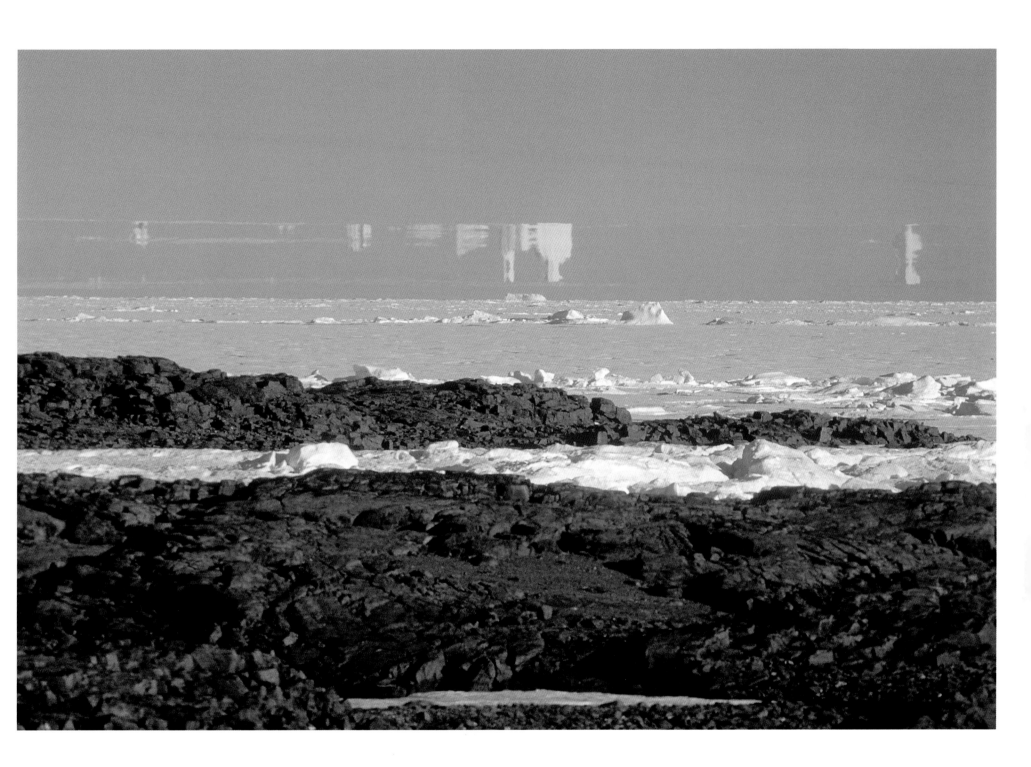

AFTER SEVERAL DAYS at Truelove, Alexandra and I hiked toward Cape Hardy, thirty miles east. Here, explorer Frederick Cook and his two companions spent the winter of 1908–9. They picked one of the best spots in the High Arctic to amass food for the dark season. As many muskoxen hung out at Cape Hardy as at Truelove. Without much effort, Cook laid in hundreds of pounds of meat. Then the three men hibernated until the sun came back in February, when they walked 450 miles back to Greenland.

The first day of toting a pack that weighs half what you do reveals a great deal. Do you want to go home? Do you grimly think, "I'll do this once but never again"? Or have you already begun to surprise yourself?

I did what I could to make the trip easier for Alexandra, but in the end, you either accept some difficulty and discomfort as part of the experience or you don't. Now and then she wept from frustration, when the effort was too much. "Don't worry, I'll die quietly," she assured me at the end of one long day. More often, though, she discovered strength and resilience—in flowers that inspired her with their toughness, in a ptarmigan that led her through a maze of boulders when I'd wandered too far ahead. She always found an extra gear when she most needed it. "I'm not sure where this inner strength comes from," she said.

Alexandra approached her first arctic experience without expectations. "You go to Hawaii and expect white sand, and if it's not white, you're disappointed," she said. "I didn't imagine what the landscape would be, so I accepted the landscape. I didn't know what the weather would be, so I didn't expect anything different."

Alexandra had never met an animal she didn't like, except spiders, and our intimate time with the muskoxen and fox pups became her transformative experience, as that first kayaking tour had been mine. Back at Truelove, as we waited for the plane, we decided to get married.

Our relatives pegged her participation as one of those things that you do when you're crazy in love and that stops once the relationship matures. A dozen expeditions and ten years of marriage later, that maturity continues to elude us. She admits that she likes the simplicity and clarity of wilderness life. Like any good traveler, she remembers the good parts and forgets about the weight of the pack and the icy stream crossings that rip like piranhas at her cold-sensitive skin.

She's slept on the Great Wall of China, fallen off a galloping horse in Tuva (twice in one day), and flown in a helicopter every year. When she visited the ruins of Xanadu, the guardian of the site gave her a fragment of tile from the fabled pleasure palace, which she now wears in a pendant. She was new to skiing when we met, and she now skis better than I do. She even deters polar bears with utter sangfroid.

Yet sometimes I wonder if she gets anything out of these journeys for herself. She says she does, but is she just sharing the passion of a driven partner? Both adventure and photography couples wrestle with this question. It's not easy to answer. When one member is the engine, does the train itself enjoy the ride? It would not go to those places without the engine, but is the engine dragging the train where it doesn't want to go? Where would it go otherwise? Or would it still be in the station feeling that life is passing it by?

left Unlike arctic hares, this rock ptarmigan turns brown in the summer.

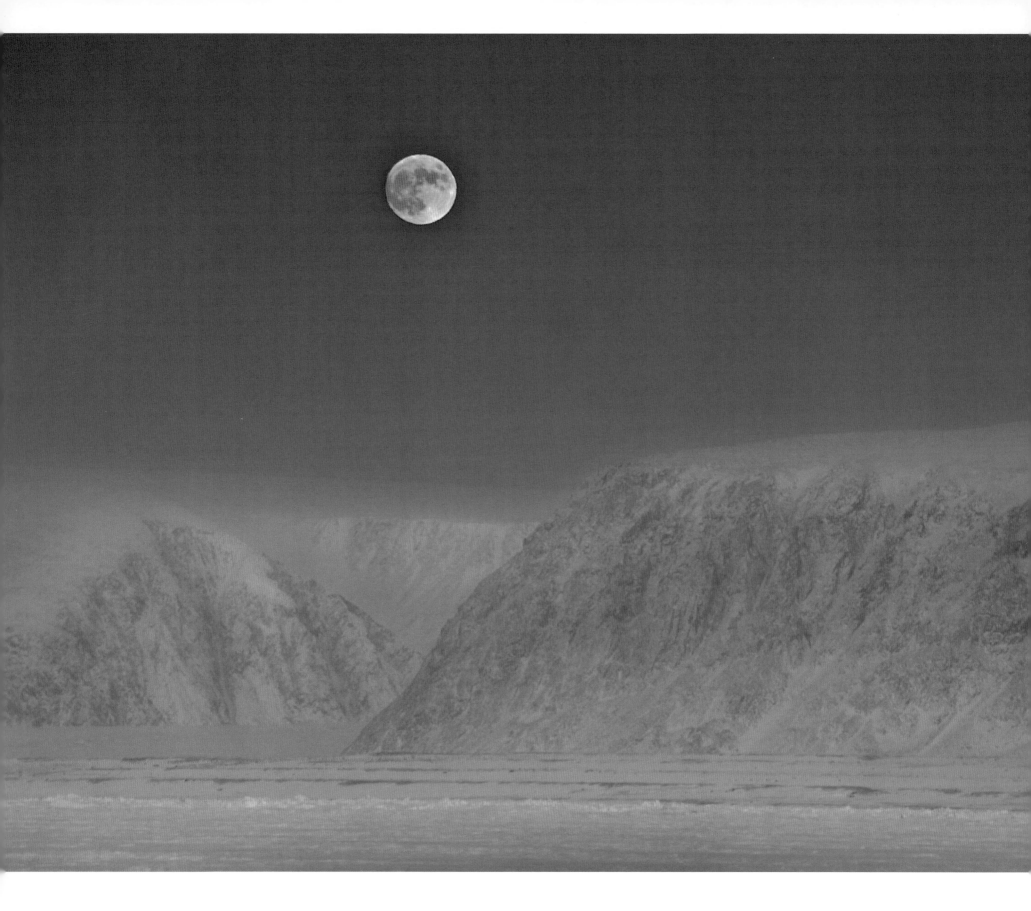

"BRAVING THE cold, Fairy Frost and Lady Moon parade their rival charms" on a March night on Devon Island.

"It is a sledging life which is the hardest test."

APSLEY CHERRY-GARRARD, *The Worst Journey in the World*

7 | THE HARDEST TEST

WITHOUT A doubt, trekking 450 miles from Devon Island to Greenland in the footsteps of the disgraced explorer Frederick Cook was a wild goose chase. No one believes anymore that Cook attained the North Pole in 1908, so we weren't trying to prove anything. It wasn't even likely that we'd reach Greenland. By the time we left in early spring, the thirty-mile-wide ice bridge between Ellesmere Island and Greenland had not formed as it usually does by then. This season, for the first time, open water reached the northern tip of both islands.

But as one writer put it, a wild goose chase is an exercise in experiential empathy. You didn't have to believe that Frederick Cook reached the Pole to admire his endurance and that of his two Inuit companions, Ahwelah and Etookashoo. After the aborted North Pole trek, they struggled south six hundred miles to Devon Island, no easy feat. Here, they survived four months of darkness in an old *qammaq* they rebuilt. When the sun returned, they saved themselves by walking back to Greenland—a magnificent, and incontrovertible, journey.

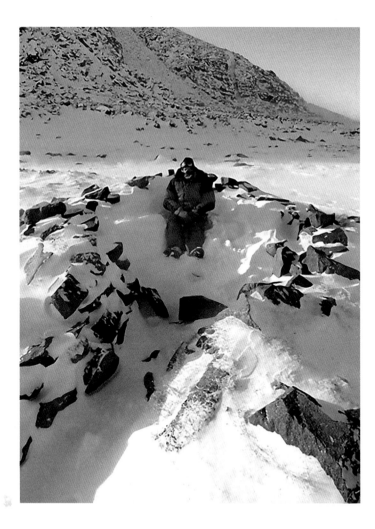

above and right Frederick Cook's den in winter and summer.

Bob Cochran, from Los Angeles, joined me again for this adventure. Bob had loved our 250-mile ski trek on southwestern Ellesmere two years earlier and he was keen to take his passion for the Arctic one step further.

Although it's hard to grasp this until you've done it, skiing 250 miles in May is pretty easy. The light sleds pull effortlessly over the mild snow. By contrast, this trek would test our limits. Apart from the greater distance, our sleds for this seven-week marathon weighed over 250 pounds. Because our route grazed the North Water polynya at several points, we had to begin as early as possible, before open water ate away our sea ice. This meant setting out in the minus thirties of late March.

Two young Inuit guys from Grise Fiord agreed to snow-mobile us the seventy miles from their village to Cook's wintering site on Devon Island. The direct route across Jones Sound is half that distance, but open water forced a long westerly detour. During the four-hour journey, we passed five polar bears, which fled from the noisy, confident machines. Another snow-mobiler had passed twenty-three bears on Jones Sound a day earlier. Frederick Cook and his friends had many close calls with bears that lurked outside their shelter. For the first time, I brought a tripwire alarm fence, which would sound if a polar bear approached our tent while we slept.

Cape Hardy was named for a "chum and mess-mate" of Captain Inglefield, who discovered Ellesmere Island in 1851. The cape is one of twin buttes attached to main-land Devon Island by low causeways. While Bob and I set up the tent, our snowmobil-ers brewed some tea and then turned for home. By late March, it no longer gets dark at night, but a blue twilight drenches the land. On this night, a round red moon added

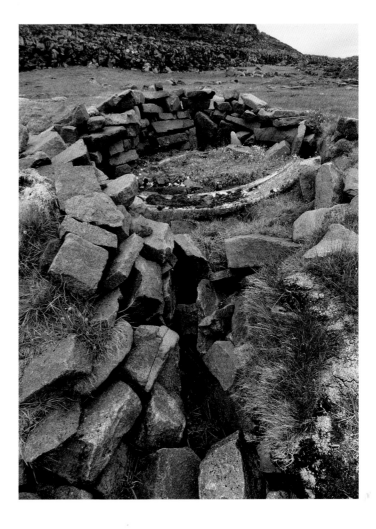

to the Plutonian weirdness. "Most beautiful sight I've ever seen," said Bob.

The next morning, we found Cook's den, the best-preserved of three or four *qammaqs* on a low bench about seventy-five feet from the sea. The whalebone ribs that supported the roof had long collapsed into the interior. In his book *Return from the Pole,* Cook claimed that they were all but out of bullets and had to spear muskoxen for food. All winter, they huddled beside a feeble blubber lamp. Their sleeping platform seemed barely wide enough for one. "My life," Cook wrote, "was that of a man in the Stone Age."

In bitter cold, we skied back across Jones Sound. Life in the deep freeze. The worst moment of the day is going to the toilet in a knifing wind, when there is no shelter. It takes ten minutes to recover from the ghastly experience.

After two days, Ellesmere Island emerged from the mists like a vision, blue with white glacier ribbons. Its fluted cliffs, topped by ice caps, gradually sharpened into view. The absence of wind and the ideal snow put me in a great mood. I listened to my iPod, settling on Bonnie Tyler's "It's a Heartbreak," not because its words spoke to me, but because its lively beat drove the cadence of my legs. My feet flew, as I listened to the same song all afternoon. I felt one with the sea ice. I sensed its moods, its surfaces, I made snap judgments about the best snow to step on that usually turned out right. It was one of those rare afternoons of pure joy. I stripped to my undershirt to cool off during the fast tempo. I walked with my arms outstretched to further ventilate and to celebrate being alive. And when the first flush of perfection faded, I put on my parka and lay down on the ice and gazed at the blue sky overhead. It had a purity usually found only in dreams.

BEYOND GRISE FIORD, new powder slowed our progress, but eventually we arrived at Craig Harbour, our last whiff of civilization before the White Emptiness to the north. Craig Harbour was an abandoned Royal Canadian Mounted Police post, founded in 1922, during one of Canada's intermittent but intense frettings about Arctic ownership. Because it lay near the floe edge, where seals and whales and polar bears liked to congregate, snowmobilers from Grise Fiord often used the sole remaining shack as a hunting cabin. A logbook inside outlined some of their adventures. One young guy was so affected by shooting his first bearded seal, a passage to manhood, that he wrote of crying himself to sleep.

In the cabin, Bob enjoyed one of his precious cigars and then relaxed by grooming his thick hair. When I teased him about it, Bob drew on his classical reading to remind me how the ancient Spartans considered primping their hair before battle an acceptable indulgence.

Open water nudged King Edward Point, the ever-windy southern tip of Ellesmere, so we decided to avoid it by mounting the ice cap behind Craig Harbour. This meant portaging our gear in four loads up the first five hundred feet of glacier. Herbert Patrick Lee, one of the original RCMP officers at Craig Harbour, wrote of cutting steps with an ax up the steepest section. In early spring, snow covered the burnished glacier ice, so we managed without hacking footholds. After twelve hours of brute effort, we reached a height where the slope lessened. We still had a long climb ahead, but we were now able to drag everything in one go on the sleds. For safety, we kept high enough to avoid the heavily crevassed Wilcox Glacier.

The views from ice caps make up for the wind and austerity of the high country. The serrated mountains of distant islands beckoned like castles in the pink spring light. Icebergs far below resembled ice cubes. Steam billowed into the frosty air from the open ocean to the south.

As we continued to haul up toward a height of twenty-five hundred feet, a puff of wind turned into a vicious ground blizzard that sent loose snow in smoky S-curves past

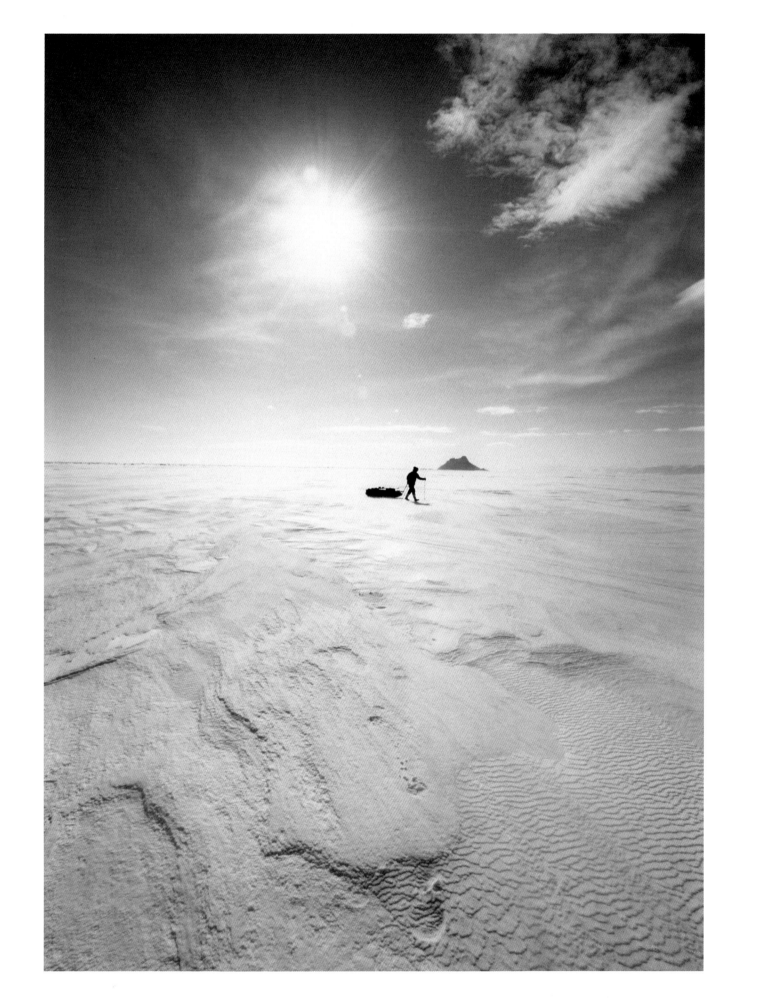

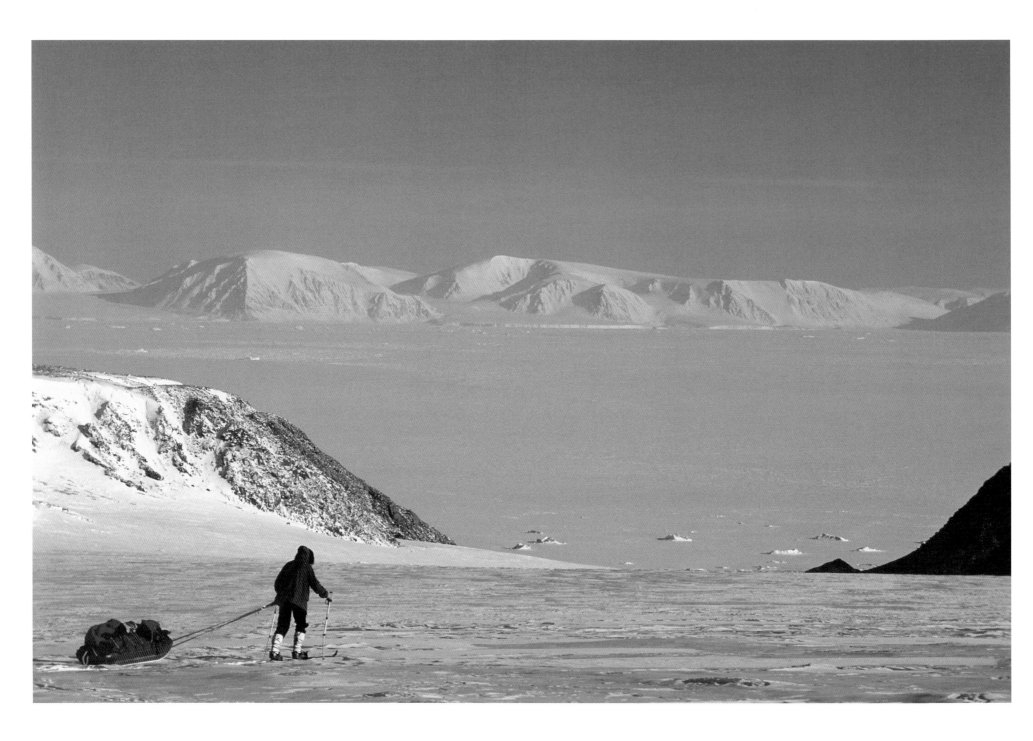

our feet. Bob performed every task with great deliberation, but these extreme conditions challenged his methodical style. You have to act quickly, to constantly fine-tune your face mask, zippers, and layers of clothing. In the Arctic, you dance a fine line between sweating and hypothermia, and in a gale the dance is a jig, not a waltz. If you stop longer than a minute or two, you get cold, and if you keep stopping, you can't warm up.

We had to camp to escape the wind. While I got the tent out, Bob began to shovel a flat platform in the wind-packed snow. But he proceeded at such a dignified pace that I impatiently volunteered to take over the task. Digging like a fiend, I promptly broke our only shovel on a piece of hard snow.

Bob graciously did not bring up this incident in the weeks that followed, even when the missing shovel made life difficult for us.

WE DESCENDED TO the sea ice the next day, but glaciers remained a continual presence. The nearby polynya made this part of Ellesmere much snowier than most of the island. It has spawned the largest tidewater glaciers in Canada. Once, it took us days to pass a single glacier front. To navigate, I often took a compass bearing off one of the monster icebergs calved from these glaciers. In good visibility, we could walk toward that distant iceberg for hours without another bearing.

When Frederick Cook passed this way in 1909, he discovered two little islands, which he named after his companions, Ahwelah and Etookashoo. After Cook's North Pole claim was rejected, his legitimate discoveries were also, somewhat unfairly, taken away from him. So these two dots of land are now called the Stewart Islands. They were our only point of contact with Cook for hundreds of miles, and we visited the northern one, giving us the minor distinction of being, in all likelihood, the only living persons to set foot on them.

Open ocean lay just a few miles to the east. Once, it edged close enough for us to spot a heap of walrus drifting past on an ice floe. Unlike freshwater ice, sea ice tends to be safe right to the water's edge. With waves lapping at your boots, you can peer over

left Bob Cochran skis down an unnamed glacier to the sea, as the white line of Coburg Island dominates the horizon.

NORTHWEST GREENLAND

GREENLAND COMES AS close as twelve miles to Ellesmere Island, and they share a common history. But the Canadian island is a little colder, supports less sea life, and has never had permanent settlements, as Greenland has. Ellesmere served as a meat locker for the Polar Inuit of Northwest Greenland, who called it Muskox Land. Nowadays, Ellesmere also has most of the polar bears.

Explorers wintered mainly in Greenland, amid the Inuit who sewed their clothing and guided them. In the spring, they dogsledded over the frozen sea to Ellesmere and began their explorations. Only the most northerly expeditions did the reverse, probing northern Greenland from Ellesmere Island bases at Floeberg Beach and Fort Conger.

This world's largest island often dominates eastern Ellesmere's horizon, its ice sheet glinting through coastal rock fortresses. Our biggest icebergs come from Greenland. We rejoice when Greenland's clear weather moves in our direction.

Many exploration sagas that climaxed in what is now North America began in Greenland, in places like Etah and Annoatok, the bases of expeditions both famous and obscure; on Littleton Island, where Donald MacMillan's men gathered six thousand eider duck eggs in a few hours and Adolphus Greely reported fifty explorers' cairns; and by the rocky finger of Cape Alexander, named by William Baffin in 1616, its winter waters full of walrus. Other Greenland sites have modern mystique: Siorapaluk, the

world's northernmost Inuit village, and Thule Air Base, where a hydrogen bomb from a 1968 plane crash still rests on the dark bottom of the ocean.

Best of all, Northwest Greenland has the Polar Inuit, a great people cut off for centuries from the rest of Greenland by the nearly impassable ice stew of Melville Bay. When John Ross first discovered them in 1818, only about two hundred lived along the coast, in small family groups. After centuries of isolation, they had lost the ability to build a kayak and so were very interested in the one that Ross's interpreter from southern Greenland had brought. "Are you from the Sun or the Moon?" they famously asked one explorer.

For centuries, the Polar Inuit dogsledded to what is now Canada to hunt. I often find the stone circles that weighed down their skin tents.

far left Most of the ten thousand to fifteen thousand icebergs that float down Canada's Iceberg Alley every year come from Greenland.

left Despite their modern Danish-style homes, people in Qaanaaq still travel with dog teams rather than snowmobiles.

below Thule Air Base, perhaps the hardest spot in the Arctic for a civilian to visit.

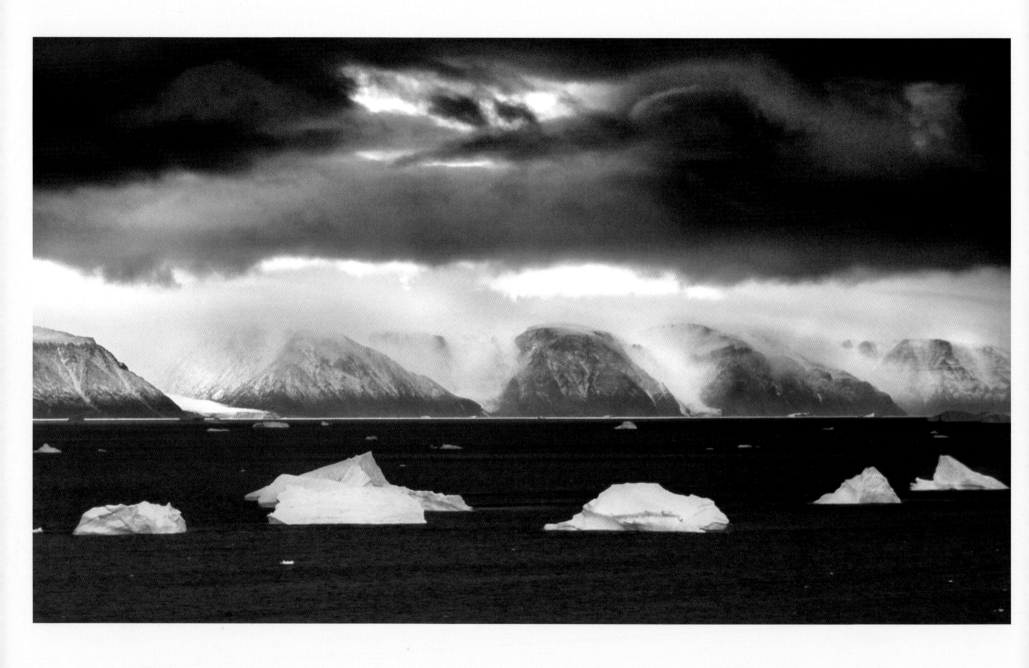

As guides, they aided nearly every expedition from the 1850s until the 1930s. Even the Royal Canadian Mounted Police hired the Polar Inuit in the 1920s to help guard Canadian sovereignty, so "the poachers became the gamekeepers." Some expeditions suffered because they brought guides from more southern Greenland, thinking that all Inuit had equal skills. It would have been like Great Plains dwellers guiding a jungle trek. In recent years, national borders have barred these nomads from hunting their ancient routes on Ellesmere.

It is ineffably thrilling to walk amid the brightly colored Danish-style houses of Qaa-naaq and realize that most of the people living in them descend directly from either the two hundred souls in John Ross's time or from Qitd-larssuaq's ragtag band of migrants. They remain the ultimate High Arctic travelers, and even sizeable Qaanaaq, with a population of about six hundred, has more sled dogs than people.

The great Quebec sea captain Joseph-Elzéar Bernier once tried to convince Canada to buy Greenland for three million dollars. "Surely a bargain," he wrote prophetically, "that will never come our way again."

left Icebergs and mountains briefly line up on a stormy fall afternoon near Qaanaaq.

below Canada and Greenland come within twelve miles of each other, and for centuries, Inuit hunters crossed freely back and forth. Greenland from near Ellesmere's Fort Conger is shown here.

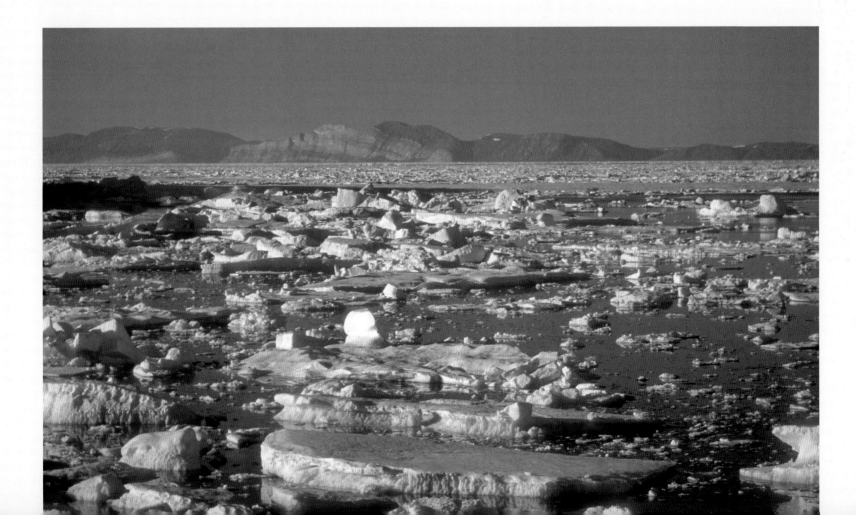

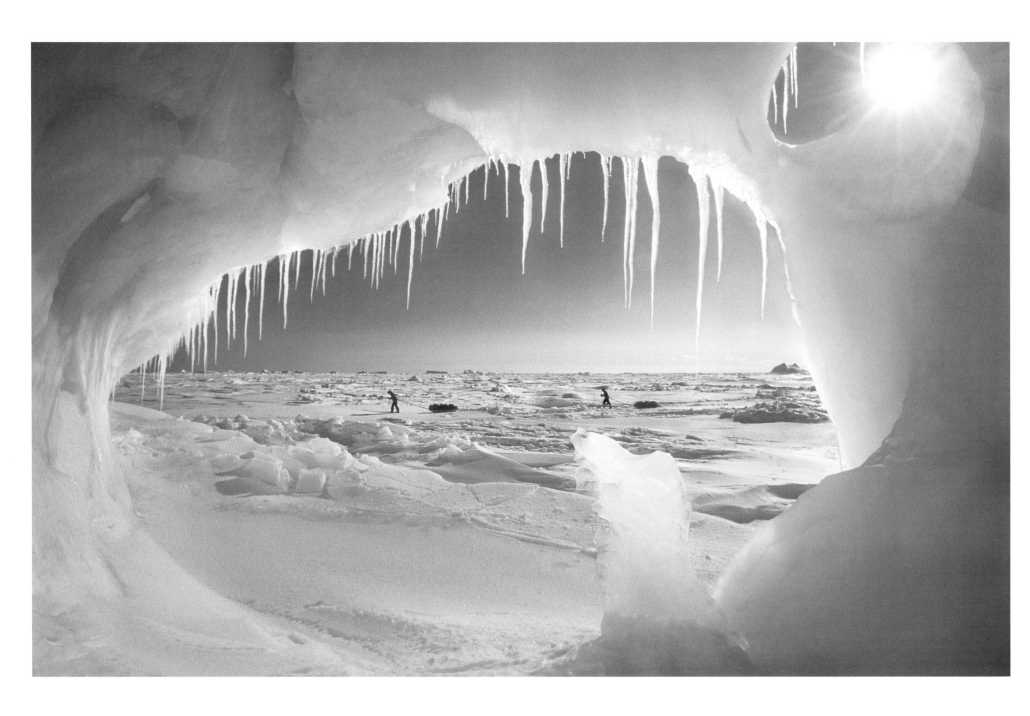

and see several feet of solid ice beneath your feet. So the nearness of the North Water did not concern us until Cape Norton Shaw. Here, open water pressed right against the cliff. This happens at jutting headlands, where fast currents tear away the ice that tries to form. The ice usually resumes on the other side of the cape. We camped nearby so that we could scout ahead the next day. If necessary, we could paddle around the cape in the small inflatable raft that we carried for this sort of thing, floating the sleds on a tether behind us.

That night, the shrill, boiling-kettle whistle of our bear alarm fence woke us up. Shotgun and flares in hand, I unzipped the tent door. Polar bears don't understand tents, and even the curious ones are tentative around them at first. It wasn't likely that a bear stood outside the door, poised to clock me with a paw strike, as they do at seal holes. Still, I peered out with caution, jabbing my head out quickly and then withdrawing it, the way movie cops look around corners in gunman-infested buildings.

Nothing. Everything was in place. We stepped into the shady evening. The wind had blown our fence's two lead wires together, triggering the alarm. Bob separated the leads so that they would not touch again, then we went back to sleep.

An hour later, the bell rang again. "Probably another false alarm," I groaned. But peeking outside, I saw that my sled had moved six feet. Only one thing does that. About forty yards away, two young adult polar bears were dashing off. One of them had something in its mouth. Bob yelled to scare them, but they turned and started running at us. I fired a flare at them, and they hit the brakes and sped away for good.

I inspected the sled and found a small tear in the cover, next to the zipper. This precise tear might have been the work of a seam ripper. Only the stitches were torn, not the material. Bears can be astonishingly delicate.

I also marveled at the laser accuracy of their noses: the foot-long rip in the seven-foot sled lay right above my sealskin *kamiks*. One of the bears had reached inside and carried a skin boot off in its mouth, like a spaniel running away with a slipper. Happily, it had dropped its prize while fleeing, and we retrieved it. Despite the young bears'

coltish behavior, the situation could have turned dangerous quickly, and Bob and I cracked jokes to diffuse the tension.

"That was probably like getting harassed in a dark alley in L.A." I suggested.

"There are similarities," he replied thoughtfully. "All predators look for a combination of desirability and weakness."

Cape Norton Shaw proved easy to get around. A shelf of ice adhered to the side of the cliff, ten feet above the open ocean. In places, this catwalk stretched barely two feet wide, but by nursing the sleds over it one at a time, we soon reached frozen ocean again.

We soon began the seventy-five-mile line from Clarence Head to Cape Faraday—Ellesmere's Empty Quarter. For most of it, we sledded several miles out to sea. Our universe became even more ascetic than usual. The distant land was one white, unbroken glacier wall. "I wouldn't want to have to hunt along this route, like Cook did," said Bob. Indeed, by the time they reached Pim Island, near the crossing to Greenland, they were starving. "We had seen no living thing for a month," Cook reported. They survived thanks to a cache of old meat left there for them by the father of Etookashoo.

We had all the food we needed, but it's hard to eat enough during the day. Large amounts of frozen snacks just don't appeal. Bob, in particular, was losing weight. He never complained, but he often slipped and fell, like you do when you're at your limit. One by one, his legs, shoulders, and elbows acquired battle injuries. In the tent, he often dozed while waiting for supper.

Toughest for Bob, I was a little faster than he was. Sledding speed has less to do with fitness than it does with natural walking pace. My cadence on good snow ranges from 112 to 120 steps per minute, which is brisk even on a sidewalk, without a heavy sled. I have always had to rein myself in when walking with others, but I knew the slowpoke's discomfort from aerobic hikes up mountains with marathon runners. The fast one can rest, eat, drink, pee, dress perfectly, take pictures, and enjoy the view while the trailer scrambles to keep up, always feeling somewhat like a burden. On journeys like this one, it doesn't work to follow someone else's pace, so I would scoot ahead a little and then

right At Cape Norton Shaw, the North Water polynya approaches and then butts right against the cliff, forcing a tricky passage over the ice foot.

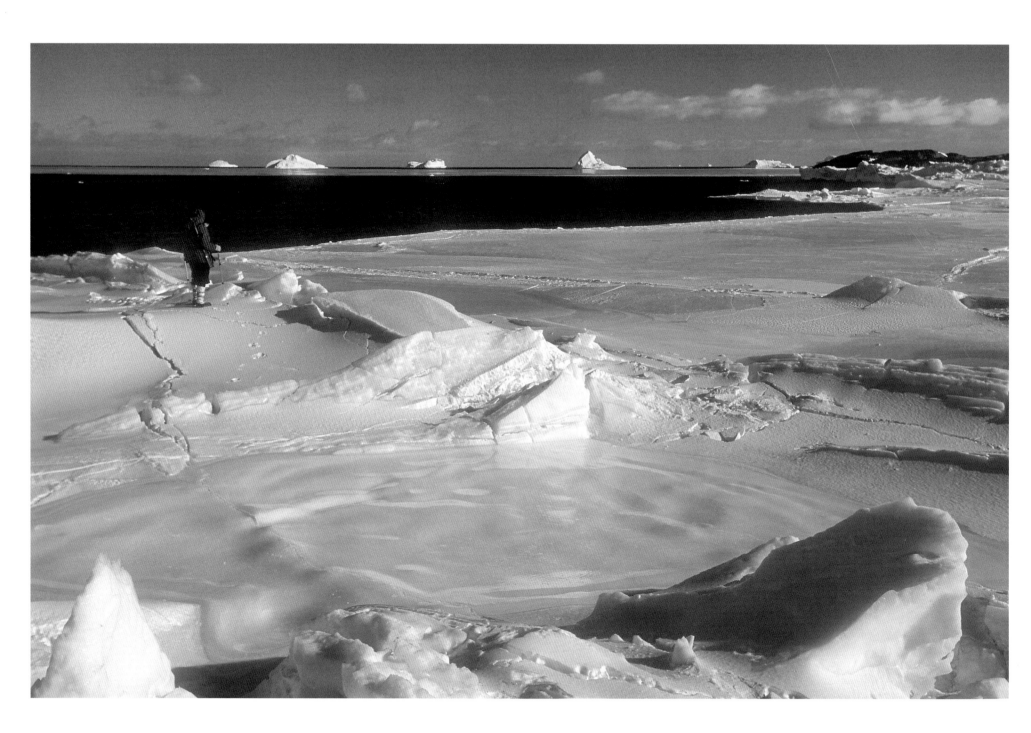

wait for Bob. On the longest days, Bob trudged into camp, utterly spent, and with a mixture of pride and perversity, he would ask why we had stopped and suggest that we go even farther. Then, with resilience and good humor, he would do it all again the next morning. Mentally, Bob was steel, but sometimes I wondered how long he could keep going before his body failed altogether.

ZONES OF ICE blocks slowed us down for part of every day, but then we reached a smooth ice pan that extended north for hours. "Good ice is like finding a hundred-dollar bill on the ground," said Bob. As our sleds became lighter and spring advanced, our mileage improved over the warmer, more slippery snow.

One placid night, we camped on some sugary snow. These coarse granules don't hold a tent stake securely, but I was too lazy to shovel away the snow with a saucepan to hammer in the nails that we used on bare ice. So only a few half-assed anchors held the tent.

Sometime after midnight, I woke up to pandemonium. The tent had collapsed on our heads. Half-asleep, I wondered if a polar bear had jumped on us. Gradually, the crazy flapping of the tent registered in my consciousness. A gale had blown our shelter down.

By now we were 250 miles from the nearest people, in Grise Fiord. We needed to get the tent back up fast, before it ripped or the poles snapped. Bob held down the wildly heaving tent, while I moored its guylines to the heavy sleds. Madly sweeping the snow away with my arm, I screwed our four ice screws into the key windward anchor points of the tent and then buttressed the lee side with nails. I had to hammer each one several times before I found an angle where the brittle first-year sea ice didn't shatter. Bob grimly held the tent until everything was secure. He wore only his thin liner gloves with the huge holes that he persisted in using as a kind of grunge fashion statement. His half-bare fingers must have been frigid, but he would die before letting go of the tent prematurely. Those with a military background like Bob might understand this behavior, but in the civilian universe, such commitment is astonishing to witness.

The fifty-mile-an-hour wind pinned us down for the next two days. The drifting snow buried everything: skis, poles, sleds, guy lines. Tons of it built up against the

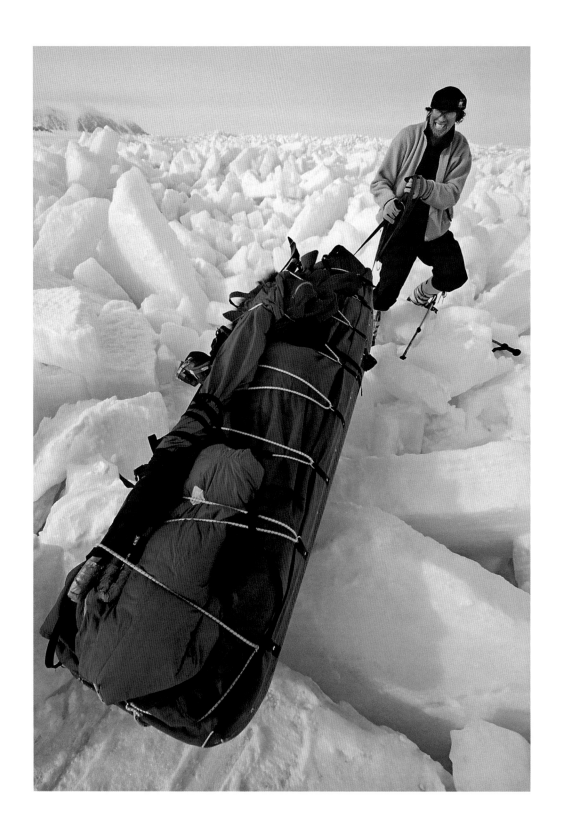

windward wall of the tent and threatened to engulf us. Every three hours, we had to spend an hour shoveling away the encroaching snow with our little cooking pots. I wondered if we would ever see our skis and sleds again.

By the third day, the wind at Camp Buried Alive had lessened enough for us to try to excavate our gear. Besides, we needed more fuel from the sleds, which lay hidden somewhere beneath tons of concrete-hard snow.

For the next fourteen hours, we worked nonstop with our cooking-pot shovels. Our labors were so involving that we didn't think to eat or drink. Bob had trouble finding his skis; each test hole required an hour's work.

left Zones of rough ice turn sled hauling into an ankle-breaking obstacle course.

above By the third day, the wind at Camp Buried Alive has lessened enough to begin digging out the tent and sleds.

I spent most of my time unburying the tent's many guylines. We needed them, and the nails and ice screws attached to them, against future storms. Eventually, a dozen tunnels ran in every direction through the snow. Finally, we salvaged everything. The hollowed-out shell of our camp looked like a bomb crater.

Despite the delay at Camp Buried Alive, we were closing in on Cape Faraday, the end of the Empty Quarter. We now faced a nerve-wracking new challenge. Cape Faraday was Grand Central for polar bears. A bush pilot once told me of seeing the snow in a nearby inlet entirely pounded down with bear tracks. Years ago, some scientists at the cape had to abandon their project because too many polar bears invaded their camp.

When Bob and I reached Orne Island, near Cape Faraday, it marked our first land camp since Cook's den site at Cape Hardy, almost four hundred miles ago. Cook had

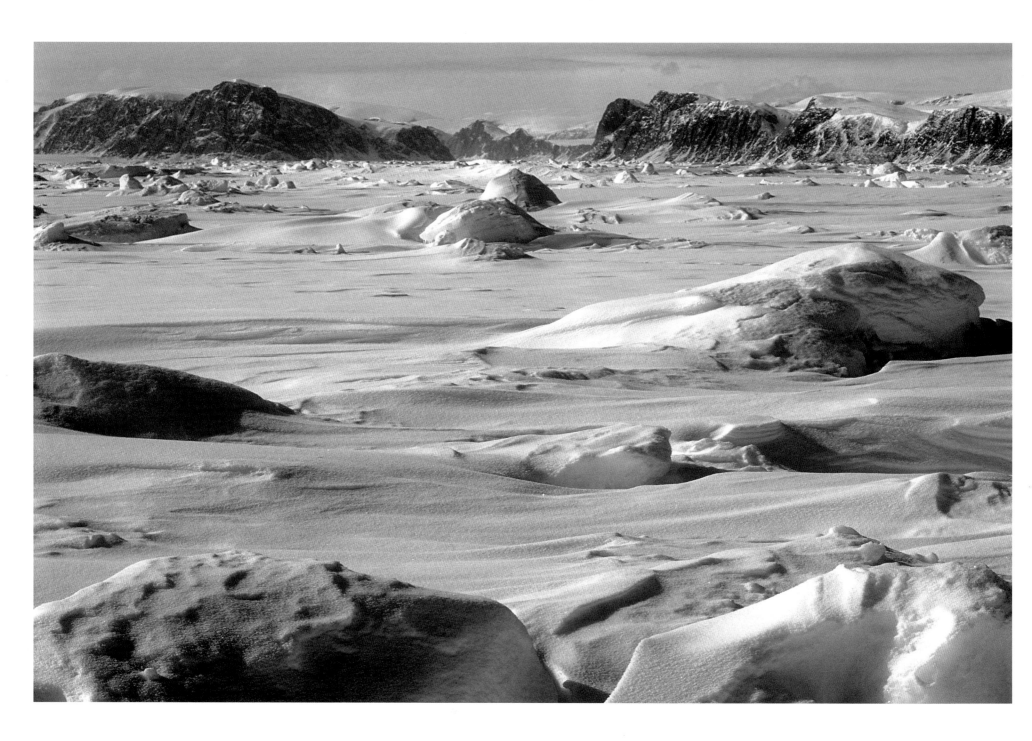

left The sea ice of Baird Inlet looks rough, but ample space between the blocks allows travelers easy passage.

below From their last camp, the white cliffs of Greenland look tantalizingly close, but thirty miles of open water and fast-moving ice separate it from Pim Island.

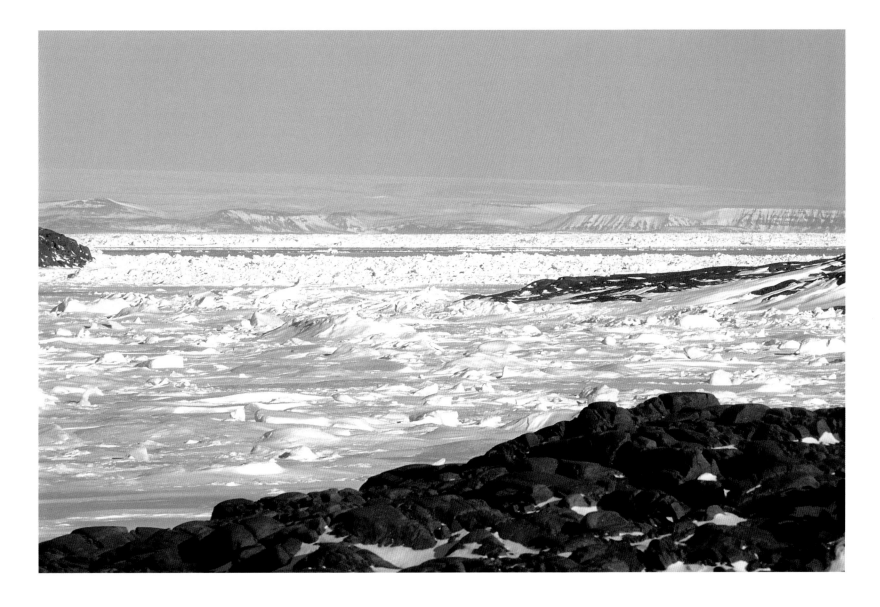

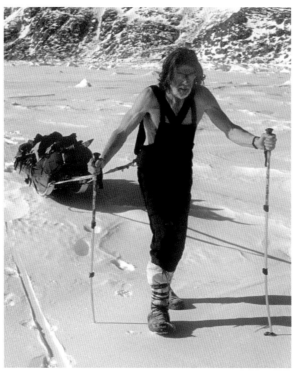

taken thirty-five days to walk this far. We had done it in about the same, thirty-four days.

In the 1850s, the great Inuit shaman Qitdlarssuaq led a group of migrants on a kind of vision quest from Baffin Island to Greenland. By the time they reached Orne Island, they had splintered into two groups that barely spoke to each another, one led by Qitdlarssuaq, the other by a rival. Seals flourished in the nearby polynya, so the migrants fattened up for several seasons. The remains of their encampment still stand on a gravel spit on Orne Island: four *qammaqs* in one cluster, three or four in the other. Only a stone's throw separates the two camps, but even this polite distance hints at the chilliness between the groups.

Two more polar bears bothered us in the next few days. One tried to drag my sled away while we slept, but by now my ears pricked at unusual noises, and I woke to the scraping of runners on ice. Two flares in front of its paws, and the bear ran away. A second polar bear stalked us upwind in long, lazy zigzags while we trekked, but when it came within hailing distance, we scared it off with loud shouts of "Boo!"

As a devotee of the Greely expedition, Bob was looking forward to Wade Point, the explorers' first landfall before they moved to Pim Island, where eighteen of the twenty-

five men perished. We reached Wade Point on a mild evening. Three stone squares—smaller versions of the larger foundation they later built on Pim Island—jutted out of the snow cover, which was thinning in the May sunshine. Bob lit up the Cuban Romeo y Julieta cigar I had brought as a treat for him, and he wandered the site, puffing contentedly.

Meanwhile, I explored the bare areas on my hands and knees looking for historical tidbits. To my delight, I found a small piece of the *Beaumont,* a whaleboat that originally belonged to the Nares expedition. Greely's men had commandeered it from Fort Conger during their retreat. Tar waterproofing still coated one side of the wooden fragment, which was about the size of a dessert plate.

After forty-six days, we pulled into Payer Harbour on Pim Island. Greenland, a mere thirty miles away, taunted us. We had covered over four hundred miles and still had a week of food left. I called Alexandra on the satellite phone. NASA photos showed no ice bridge to Greenland, she reported. Open water stretched all the way to Alert, at the northeastern tip of Ellesmere. Payer Harbour would have to be our end point.

Coincidentally, Frederick's Cook's rival, Robert Peary, had spent a winter at Payer Harbour, in the wheelhouse that Bob had inquired about years earlier. Peary, ever generous, ever sharing, destroyed his stove at the end of his stay so that no one else could use it. Rusted stove fragments lay everywhere.

We camped on the ice foot, which was slick and snowless. As I sat in the tent making notes, Bob stood outside, preparing to light his final cigar. Suddenly I heard a thud and then a loud groan. He'd slipped on the ice.

"Are you okay, Bob?"

He grunted an acknowledgment. Bob had lost twenty-five pounds and didn't have much padding left. He now looked like Mick Jagger. In previous falls, he had hurt both knees, his left shin, both hips, and his right elbow and left shoulder, but this sounded like the worst yet.

I unzipped the tent door. There was Bob, lying where he had fallen, lighting his cigar.

left Sledding as weight-loss program: Bob Cochran before the expedition and on the last day.

IN FALL, freezing rain may coat the ground with an impenetrable armor, decimating muskox and caribou populations.

EPILOGUE

SOME SAY, "You're living my dream!" A similar number, perhaps, believe that life is too serious for such escapades. They are the No Tomfoolerys, and they force us to question why we do what we do.

When I was a kid growing up during the Cold War, I often fantasized about surviving a nuclear holocaust. The prospect of war terrified me, but the postwar life of day-to-day struggle that I imagined seemed, well, fun. Later, I read how every population has a small number of individuals who function best under stress. They are the ones who help a society survive plague, famine, and other disasters. When things are good, they're not necessarily very relevant. They're just biding their time until the sky falls. It's a comforting thought: adventurers have a social purpose.

Maybe adventure is also what ethologists call a vacuum activity—like the well-fed captive bird that pecks at imaginary flies. The adventurer tilts at windmills thinking they are dragons because real dragons are in short supply, and battling dragons is necessary to stay healthy.

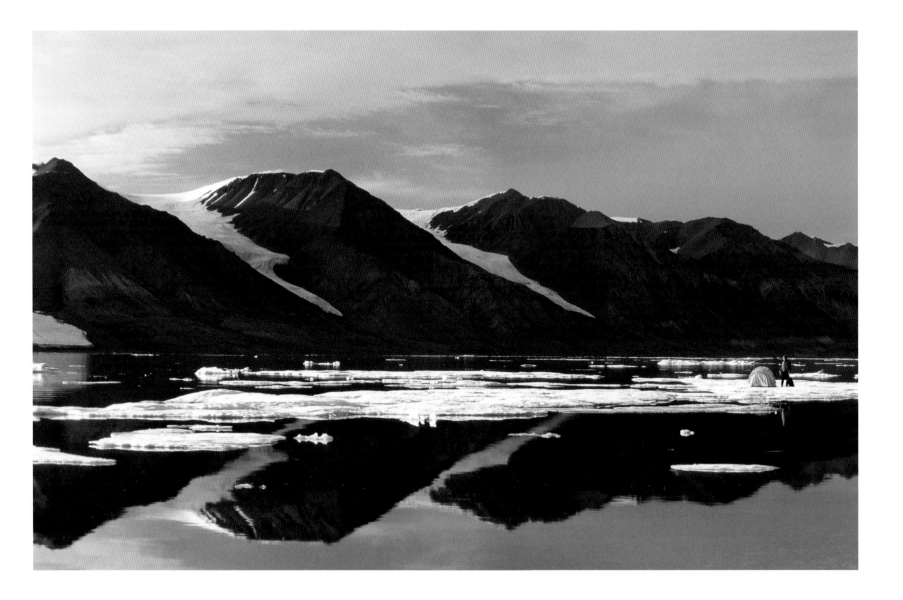

In the meantime, I try to live as a philosopher, but it's hard when you're just a happy lark that likes to sing in beautiful fields. For the same reason, I've never been much of an environmentalist; I prefer to celebrate what is, rather than dwell on losing what was.

I also find it hard to write about the warming Arctic because I'm a traveler, not a scientist. I've seen warm springs and hot summers up North, but I've also had cold springs and cool summers. The only consistent change I've noticed is that the abrupt transition every April from cold to cool happens about ten days earlier than it used to.

Still, when I imagine the future, I see a different High Arctic. One in which Elles-mere Island has North America's last downhill ski resort. Whose milder winters have more snow, and warmer summers more mosquitoes. Where spruce forests have caught hold. Where the nineteenth-century explorer's myth of the Open Polar Sea has become a seasonal reality. Where polar bears survive, while their southern populations have either perished or interbred with grizzlies.

Inuit no longer live in igloos and *qammaqs*; that traditional life vanished decades ago. In a warmer Arctic, they'll spend less time on snowmobiles and more time in boats, like their confrères in southern Greenland. They'd welcome milder, shorter winters, like everyone else would, with only a hint of nostalgia.

If the High Arctic continues to warm and becomes the subarctic, well, the subarctic is an impressive place, too. I'll still love it, just as I'd still love it if it ever became colder. The North has never been static. It's not a diamond that can only lose its shine; it can also become some other jewel. Ninety million years ago, turtles lived here; forty-five mil-lion years ago, cypress trees; four million years ago, beavers. Maybe beavers will move back in the near future. Only one thing is clear: if change continues, the High Arctic will not become something new, it will revert to something old.

This future High Arctic may still be an Eden, and the occasional misfit will still come and derive pleasure from whatever inclement conditions remain. And that quest will still lead to misunderstandings that are part of the delight of being a square peg on a round planet.

At an Ottawa diner on our way home, Bob and I spoke with a server who seemed fascinated by our journey. We told her where we had gone and how white and pure it was and how sledding was hard but we enjoyed it. After nearly two months on our own, it was nice to connect with a sympathetic soul.

In the kitchen, she must have told others about us, because a second server approached our table, all excited. "Is it true," she asked breathlessly, "that you've just climbed Mount Kilimanjaro?"

left Camp on an ice floe: Henry David Thoreau sometimes slept in the bottom of his canoe as it floated on Walden Pond because he liked not knowing where he'd wake up.

GLOSSARY

CAIRN Pile of rocks left by explorers to mark their passage and as a place to leave messages about their travel plans or for posterity. It is different from an *inukshuk,* a human-shaped pile of stones formerly built by Inuit as a navigational beacon in flat country or to herd caribou to a killing corral. In the mountainous High Arctic, where animals are few and navigation easy, the Inuit did not build inukshuks.

FLOEBERG Little-used term coined by George Nares but useful for describing a pressed-up, eroded piece of old sea ice.

ICEBERG Usually much bigger than a floeberg and made of freshwater ice. Icebergs come from glaciers that reach the sea. We picture icebergs drifting in open water, like the one that sank the *Titanic,* but for most of the year they're frozen in.

ICE CAP Expanse of permanent ice from which glaciers issue. On Ellesmere, the ice caps begin near sea level on the north coast and around polynyas and at about 2,500 feet elsewhere. They have endured up to 100,000 years.

ICE FLOE Flat piece of floating sea ice.

ICE FOOT Shelf of sea ice that clings to shore at the high tide line. Often a good road to travel.

ICE SHELF Kind of a super-ice foot, it is a blend of glacier and sea ice attached to the north coast of Ellesmere in several places. Ice shelves periodically break away to form ice islands, miles in diameter.

KAMIKS Sealskin boots with uppers of ring seal and soles of tougher bearded seal. Still the best footwear for walking in the Arctic spring.

KOMATIK Inuit sled, formerly of driftwood and bone, now wood shoed with hard plastic runners. May be pulled by either dogs or snowmobiles. High Arctic komatiks are about twelve feet long.

LEAD Open crack in sea ice caused by pressure.

MANHAULING Travel by dragging a sled full of gear and supplies over snow or ice. Different from dogsledding, in which dogs pull the sled and travelers either ride or ski beside it.

NUNATAK Meaning "piece of land" in Inuktitut, it is the part of a mountain that sticks above an ice cap.

POLAR OASIS Area of local warmth. The High Arctic's four oases are usually considered to be Alexandra Fiord and Lake Hazen on Ellesmere Island, Truelove Lowland on Devon Island, and Polar Bear Pass on Bathurst Island—but Tanquary Fiord and Eureka on Ellesmere might also qualify. These hot spots enjoy a few 70°F days a year, but a more typical July day is 45°F.

POLYNYA Region where the sea stays open much of the year. Ellesmere has three or four small polynyas and one, the North Water, that is the size of Switzerland.

QAMMAQ Half-igloo of rocks and sometimes bowhead whale vertebrae, roofed with sod and furs supported by whalebone or driftwood. A long-term residence, compared with more temporary summer tents.

SASTRUGI Hard, wind-sculpted snow resembling frozen whitecaps. Usually just a few inches high.

TIDAL ICE Disturbed ice along the edge of shore. Varies from a slight buckling around small tides to an impenetrable barrier of giant ice blocks.

A BOULDER wears a snow "beard" following a summer squall.

ON ARCTIC PHOTOGRAPHY

WHEN THE museum librarian rolled out William Bradford's *The Arctic Regions* on the book cart, I was glad I was the only reader at the table. The book, published in 1873, is enormous: over two feet high and twenty inches wide. Opened, it took up most of the desk. The intaglio cover alone weighs five pounds. Appraised at $175,000, it was the most expensive book—or indeed, object—I'd ever touched.

Apart from its statistical heft, *The Arctic Regions* has the distinction of being the world's first Arctic photo book. Bradford was a well-known American painter who had the bright idea of bringing two Boston photographers with him to take reference shots on his 1869 art cruise to Northwest Greenland. At the time, photography was relatively new— the daguerrotype had been invented just thirty years earlier—and the photos became more celebrated than the paintings they inspired.

As I flipped carefully through the book—a little surprised that the librarian had not given me the standard white gloves with which to handle the pages—I was struck both by how things have changed in Arctic photography and how they've remained the same.

The process that uses a series of tiny dots to render photos on the printed page hadn't been invented yet, so a patient Victorian man with a pot of glue had carefully stuck each photo in place, for all three hundred books in the press run. Some images depicted a time irrevocably gone, a time almost before photography, especially those of the ship with its ancient rigging and the long, soft trail of black vapor from the smokestack created during the required long exposure.

And yet, of the book's 140 photos, almost half were snapshots of icebergs. Even today, the overwhelming majority of Arctic images show either icebergs taken from the decks of cruise ships or polar bears in Churchill, Manitoba.

The Arctic is visually so much richer than these two icons, but few eyes have gained enough experience to look beyond the obvious. The North remains one of the world's most expensive destinations. Many published Arctic photos come either from regional newspaper reporters or from one-off visits by photographers on magazine assignments. Few embrace the Arctic long term. Many "Arctic photographers" established their reputation based on one successful shoot.

Unfortunately, the northern polar regions have nothing to match the work of Herbert Ponting and Frank Hurley in the Antarctic during the Scott and Shackleton expeditions of the early twentieth century. The official photographers on most northern expeditions produced stuff of mainly historical interest: ethnographic portraits of local Inuit and gang shots of the ship's crew arranged like portraits of hockey teams taken at the end of the season. They may tell scholars something about clothing or whisker trends in that era—and it's great to see what a legendary figure like Hans Hendrik or a place like Etah looked like—but artistically they are miles from the timeless renderings of Hurley and Ponting.

Although I hadn't seen any good historic images of the Arctic before this project, little by little I stumbled on impressive singletons: some from Bradford's book, another showing the doomed Salomon Andrée's balloon, a fabulous shot of the giant dirigible that Roald Amundsen took to the North Pole, floating above a horse and cart before departure. One nineteenth-century Norwegian photographer did a good job on a cruise

right Buried by wind and water, caribou antlers poke eerily out of a gravel riverbed on Axel Heiberg Island.

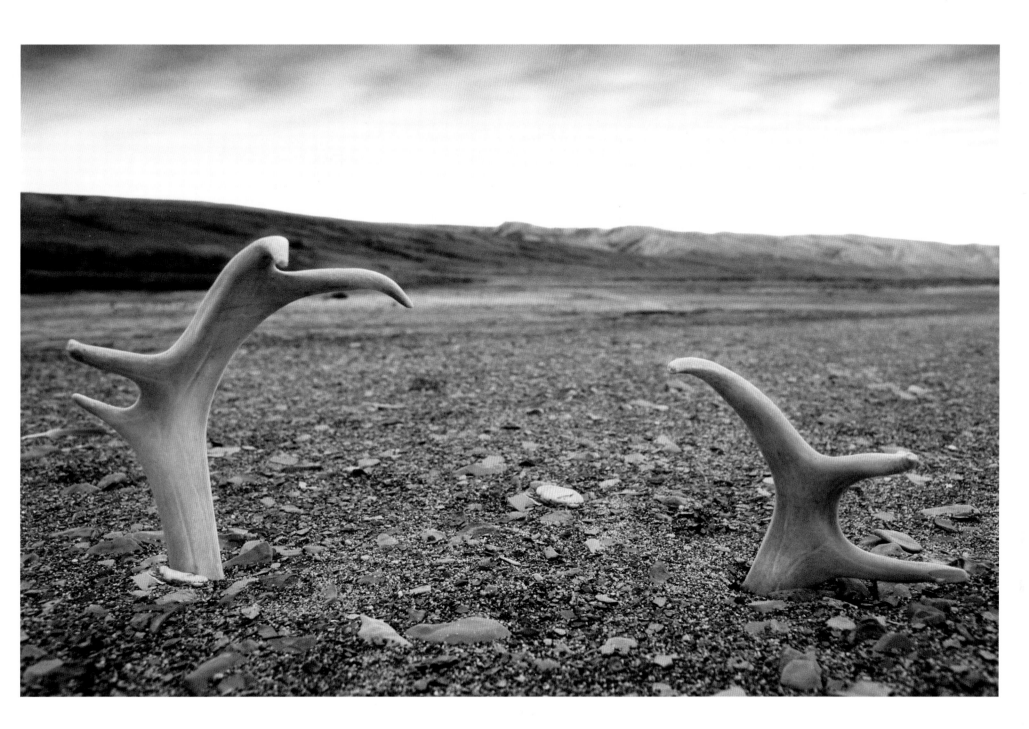

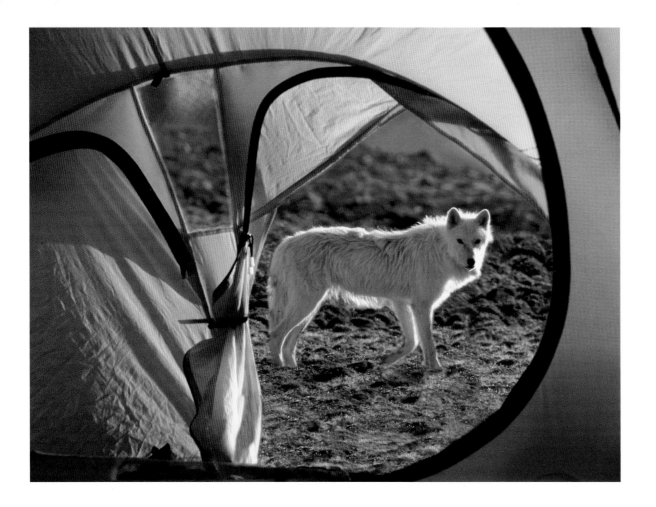

to Svalbard. Some early aerial photography compares to today's in sharpness and composition.

But where were the photographers who made the North their obsession? Did they even exist? Although that's clearly a matter of definition—do you include guys like Peter Pitseolak, with their flat documentary style?—for me, good Arctic photography began with Richard Harrington's sensitive portraits of the starving Inuit west of Hudson Bay in the late 1940s, followed by Fred Bruemmer's work in the 1960s and 1970s. Bruemmer is also a writer, and books such as *The Arctic* and *The Long Hunt* are as good narratively as visually. In his most active phase, Bruemmer spent up to six months a year on the land.

Like many Arctic photographers, Bruemmer eventually specialized in wildlife. Stephen Krasemann in Alaska, Dan Gurevich and Tom Mangelsen with Churchill's polar bears, Jim Brandenburg with High Arctic wolves, and recently, Norbert Rosing and Paul Nicklen have all raised the bar. Many had the backing of *National Geographic,* the only publication with enough money to fund in-depth Arctic photography. Some, including Bruemmer, tapped into government support or joined wildlife biologists. Today, as in the past, the real key to Arctic photography is using OPM—Other People's Money. Even William Bradford had a patron who paid for his cruise.

The club of Arctic photographers remains as small as it always has been. Tour guides have frequent access and sometimes a good eye, but their divided attention affects their work. Hobbyists who live up north develop specialties—one man in Finland photographs mirages; others in Yukon and Alaska focus on the northern lights. But apart from the wildlife shooters, the only others I'm aware of who work the Arctic as hard as I do is a pair of British photojournalists, Bryan and Cherry Alexander, who cover the entire circumpolar North, often traveling with native peoples.

To travel the High Arctic without a personal fortune, I have had to mine every opportunity. At first, I hitchhiked on half-empty planes, like Bruemmer and others of past eras did. Nowadays I accompany scientists, do magazine assignments, lecture on cruise ships, lead the occasional tour. I write for inflight magazines in exchange for airline tickets. I barter photos. I've flown with the military and with park wardens, sailed with the Coast Guard, snowmobiled with the Inuit. Many people have taken a personal interest in my work and helped me repeatedly.

I've had to be flexible: Often I head north with maps covering two or three possible routes and go wherever access first materializes. Once, a film company with a substantial budget did a documentary about my travels, and I had the unique experience of flying effortlessly to four or five places I'd always wanted to visit. More commonly, I buy a modest share of somebody else's airplane charter, but now a two-week commercial hiking tour to the national park on Ellesmere Island costs fifteen-thousand dollars per person, almost all of it air travel. Soon, the High Arctic may once again be the exclusive domain of institutional visitors—scientists, government employees—plus a smattering of wealthy tourists, as it was in Bradford's time. For now, one way or another, I somehow continue to get north.

left An arctic wolf wanders curiously past an open tent.

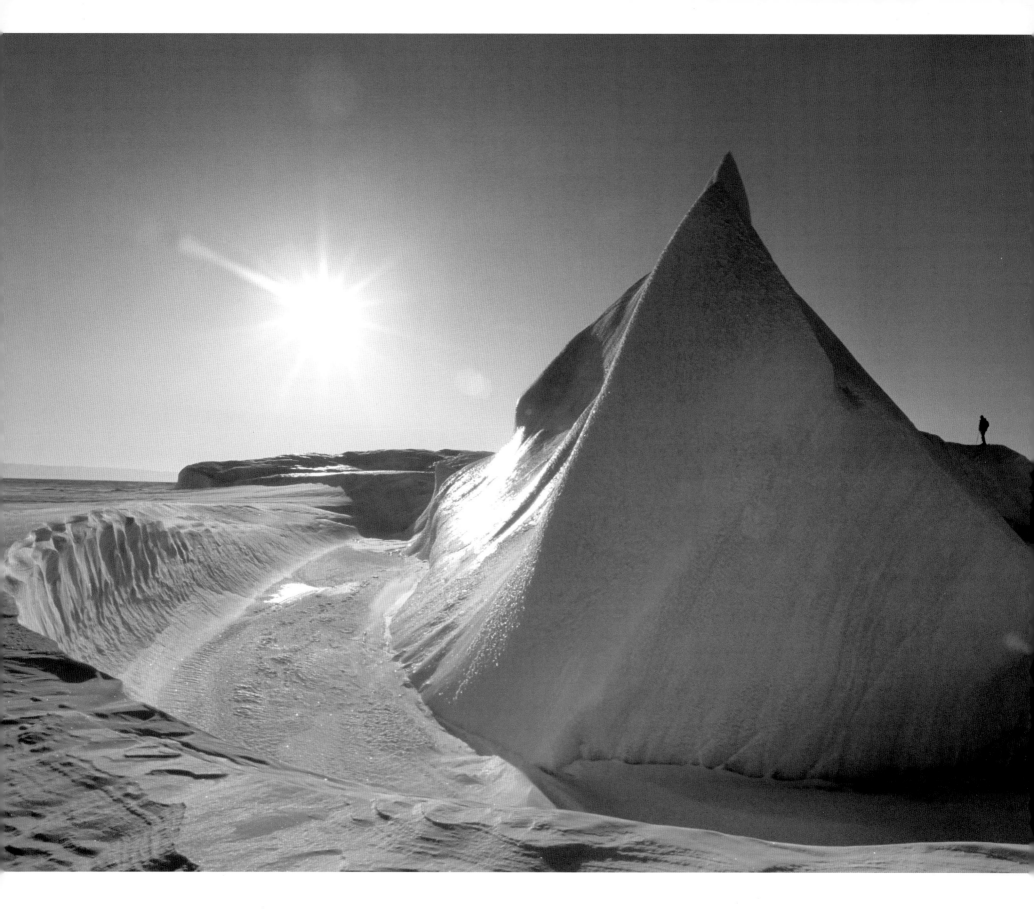

"**IT IS** not for the plane that we risk our lives," wrote author and mail pilot Antoine de St-Exupery. "Nor is it for the sake of his plough that the farmer ploughs. But through the plane we can leave the cities and their accountants, and find a truth that farmers know."

ACKNOWLEDGMENTS

LEARNED TO write and to travel by trial and error, but I learned photography through the generosity of other photographers. They acquired their skills the hard way and then shared their shortcuts with me. Anyone who strives to be competent in more than one field needs friends like these.

In particular, I'd like to thank Thomas Kitchin, to whom this book is dedicated. I would not be a photographer without him. The continuing generosity of Victoria Hurst, Darwin Wiggett, Janis Kraulis, and Daryl Benson likewise stands in sharp contrast to the older photographic tradition of hiding locations and techniques. Not only their work but their openness has been an inspiration.

My literary agent, Hilary McMahon at Westwood Creative Artists, gave an idea life by finding a quality home for it with Greystone. Editor Nancy Flight sharpened the early drafts, copy editor Lara Kordic minded my p's and q's where I failed to do so, and designers Peter Cocking and Jessica Sullivan tackled the jigsaw puzzle of elegantly combining

30,000 words with 170 photos. Large portions of this book were written at a cabin in the woods provided by the Leighton Studios program at The Banff Centre.

I'd like to thank my photo editor at Getty Images, Jane Perovich, and also Pierre Guevremont of First Light Associated Photographers.

Reproductions of Edward Moss's artwork on pages 18, 94 and 98 are courtesy of the Scott Polar Research Institute; Greely's execution note on page 26 is courtesy of the Stefansson Collection at Dartmouth College; and the historic imagery on pages 30, 83, 84 and 120 is public domain.

Of the hundreds of people who have helped my Arctic travels and research, I'd like to single out Robert Bryce, Kenn Harper, Susan Barr, Aziz Kheraj, Cameron Treleaven, Matthew Swan and Cedar Bradley-Swan at Adventure Canada, James Little at *explore* magazine, former editor Rick Boychuk and current editors Eric Harris and Dan Rubinstein at *Canadian Geographic,* Tom Koelbel at *Above & Beyond,* Petra Hilleberg of Hilleberg Tents, David Leach, Geoff Powter, Patrick McCloskey, Dave Reid, Alfred Duller, Jeffrey Qaunaq, Seeglook Akeeagok, and all the RCMP officers in Grise Fiord, and, of course, Bob Cochran, who returned home to Los Angeles haggard and limping from our latest expedition and had to field the question that all adventurers dread: "How was your vacation?"

My biggest debt will always be to Alexandra. She shares most of the summer journeys. As my favorite photo model, she's been on almost as many magazine covers as Kate Moss. She does most of our digital imaging; on this project, it took as many hours to put those RAW files and old slide scans in decent shape as it took me to write the text. She deserves a co-credit.

FOR MORE INFORMATION about expedition photography, Jerry and Alexandra Kobalenko, the High Arctic, and polar adventures, visit www.kobalenko.com.

INDEX

THE DAVID SUZUKI FOUNDATION

The David Suzuki Foundation works through science and education to protect the diversity of nature and our quality of life, now and for the future.

With a goal of achieving sustainability within a generation, the Foundation collaborates with scientists, business and industry, academia, government and non-governmental organizations. We seek the best research to provide innovative solutions that will help build a clean, competitive economy that does not threaten the natural services that support all life.

The Foundation is a federally registered independent charity that is supported with the help of over 50,000 individual donors across Canada and around the world.

We invite you to become a member. For more information on how you can support our work, please contact us:

The David Suzuki Foundation
219–2211 West 4th Avenue
Vancouver, BC · Canada V6K 4S2
www.davidsuzuki.org
contact@davidsuzuki.org
Tel: 604-732-4228
Fax: 604-732-0752

Checks can be made payable to The David Suzuki Foundation.
All donations are tax-deductible.

Canadian charitable registration: (BN) 12775 6716 RR0001
U.S. charitable registration: #94-3204049